W9-BWF-835

W116
S

The Art of Dressing Curves

The Art of Dressing Curves

THE BEST-KEPT SECRETS OF A FASHION STYLIST

Susan Moses

WITH JELANI BANDELE

FOREWORD BY EMME

HARPER DESIGN

An Imprint of HarperCollins Publishers

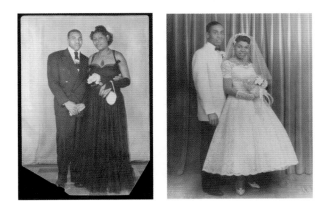

To my parents. Theodore and Virginia Moses.
and my grandparents Thomas and Susie Butler
for their love for one another and for me

Contents

Foreword

I'M HONORED TO WRITE THE FOREWORD TO *The Art of Dressing Curves* BY MY DEAR friend and curvy fashion confidante Susan Moses. In these pages she shares the knowledge and unique sensibility that has made her a highly successful, respected, and in-demand stylist in the industry—her ability to create art through fashion for every woman she dresses. Guaranteed, this important homage to all curvaceous women is the style bible for those who want the most out of life and to look their best getting it.

The publication of this book marks a time to celebrate, to leave the past behind and welcome the new breath of fresh air coming into fashion today for women with curves. In your hands is a wealth of invaluable advice to draw upon, whether you're getting ready for your moment in the sun—a cocktail party, a first date, or a job interview—or just dressing your sexy self for the day. For many curvaceous women, pulling together the look of the moment without being too trendy, pairing garments in the right colors for their skin tone, and adding a pinch of spice to keep things interesting without crossing the line for their size has long been a daunting and frustrating experience, for the industry has only recently acknowledged the fashion-consciousness of the millions of curvaceous women worldwide. So when I say that this book is not just another style guide but a vehicle that will propel you into the world of fashion in the close company of your most encouraging, fabulously dressed, very funny, longtime friend Susan Moses, I mean it.

I have been blessed to work with Susan for nearly two decades, but I feel we've known each other even longer. Being dressed by the well-respected and always in-high-demand Divine Miss M helped me set the stage early in my career as the world's first curvy super-model. With her guidance, I was able to project an inspiring image time and time again while posing for magazine covers and hosting television shows. She helped make it possible for me to hit the high notes, break down boundaries, unravel perceptions, and reframe the curvy conversation in the media. With her "go there" attitude, Susan's seemingly effortless way of pairing this with that always made it possible for me to make a statement—and the ability to do that only comes with many years of experience and an innately keen eye.

A visionary, Susan saw the white space for women with curves and filled it within the marketplace in her singular way. I have seen Susan weave her magic on set, making a model

into an industry name and helping a brand's garment sell out on television. I love hearing her exclaim "Why not?" while hidden behind a full rack of clothing, and I love watching her intense expression as her mind whirls while she's pulling looks together. She's always up for trying new things—and that attitude sets her apart from those who play it safe or are just not sure how to dress curvy models. In fact, she's always taken chances, and that has made her a standout in the fashion industry, which has embraced her new ideas. Within the close-knit fashion and entertainment circles, Susan is regarded as an überstylist and the fashion queen of self-acceptance.

In *The Art of Dressing Curves*, your wish is Susan's command. All her tricks of the trade for the women she serves—pop music and R & B darlings, country music royalty, and Hollywood icons, whom she styles for magazine editorials and advertising as well as for red-carpet, stage, television, and award-show appearances—are offered here, ready for you to apply to your own life. Every chapter provides the inside scoop on what makes these women look fantastic so you can too.

Susan helps you understand your shape and connects emotionally, realistically, and adventurously to what your inner fashionista has to say—and then allows her to finally come forth. Whatever your style—classicist, sophisticate, minimalist, maverick, or bohemian—Susan's got you covered. By absorbing her sage advice, your current fashion dilemmas will become nonissues as she shows you how to create a wardrobe that is compatible with both your body type and style mood on any given day. And since a girl can never have too many bags or shoes, Susan shares tips for finding those as well.

With *The Art of Dressing Curves*, you are in the best of hands. You can trust Susan's years of experience to stretch your limits, to show you the essentials every curvy woman needs for her closet, and to keep you in line from day to night, week after week, and for any special occasion. Susan's most precious style gems, offered in everyday language, sans fashionista jargon, help you to understand that fashion is not just about loving clothes, it's about knowing how to wear them.

A final word before you begin: guard your copy of this gorgeous book well. Once friends and family see how fabulous you look, they'll want to borrow your copy—permanently!

—EMME

Introduction

I WAS A LARGE BABY. WHEN I WAS BORN, I WEIGHED EIGHT POUNDS, SIX OUNCES, AND was twenty-one inches long, to be exact. In fact, my mother has told me that when I was only one day old, I looked more like one month. Whenever I look at my baby pictures, my pure innocence always speaks to me: there I was, just entering the world with no frame of reference for life, with no idea of what my gender, looks, race, and size would mean for me. I was a beautiful blank canvas waiting to be painted with all of life's colors.

And life delivered. When I was three and a half, my father died of kidney disease, which ignited a deep fear in me. I became very anxious about losing my mother and grandparents too; if I lost them, I realized I would be alone, with no one to love me. My mother and

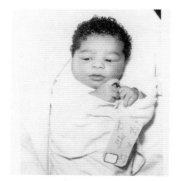

July 25, 1964: Here I am at one day old.

grandparents did much to make my siblings and me feel secure. At home my mother made sure to give each of us personal time and encouraged us to pursue our interests. We spent every summer in South Carolina with our grandparents, who lavished us with the same love and care we received at home. I am named for my grandmother and was very close to her. Then when I was eleven years old she died too. I was devastated.

My father, with his kind and gentle demeanor, always shown in a generous smile, and my grandmother, with her soft-spoken elegance, were always reliable sources of love and comfort. Their deaths, so early in my life, were painful. I didn't know how to manage my anguish, and from an early age I sought comfort in food, despite the fact that my mother stayed strong and was always there for us.

By the time I was twelve, my relationship with food became evident in my clothing size. Growing up in the Bronx, I was able to withstand the occasional teasing about my weight from kids on the playground or in class, thanks to my quick wit and the positive reinforcement I received at home from my mother—openly discussing my weight, exercising with me, and providing a healthy diet—self-esteem and confidence were never an issue. In fact, I didn't experience any serious negativity regarding my weight until the end of sixth grade, when I was eleven. My teacher told my best friend to deliver the message

that if I didn't lose weight before I entered middle school I wouldn't have any friends. In one sentence everything my mother had worked so hard to instill in me was shattered. I cried profusely as I relayed the incident to her. To this day I believe the depth of my pain came from the fact that it was my teacher who said such an awful thing, because she was the person I expected to uplift and encourage me, not break me down. After my mother paid her a visit, the teacher apologized, but the damage was already done. I no longer looked at myself with the same level of confidence, and long after her apology that cruel message played over and over in my head, leading to yo-yo dieting, an obsession with the scale, and, eventually, bulimia.

At sixteen, I fainted on a New York City subway platform and fell onto the tracks. I had not eaten anything all day and was severely dehydrated from purging; I was malnourished—but boy, was I thin! Had it not been for a man with whom I had locked eyes in the moment before I passed out, I am certain I would not be here to share my story. He jumped down to save me, managing to pull us both back onto the platform just seconds before the train arrived. I suffered a concussion, my face was swollen from the fall, and I had a gash above my left brow that required several stitches. My body and head ached for more than a month. Despite this nearly fatal accident, I still refused to eat. Nonetheless, this incident marked the beginning of my transition from starving teen to curvy, confident woman.

Finding my way back to a healthy mental and physical state was the most challenging thing I have ever had to do.

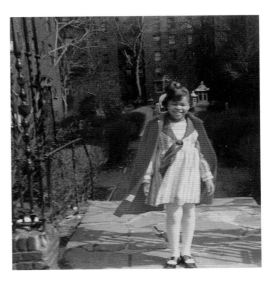

Sporting my Sunday best at age seven in the Bronx.

At the time, I was bulimic. My love/hate relationship with and dependency on food, and the binging and purging that came with it, was complicated by the false love I had for my new slimmer frame. I say false because I always felt like I was still too fat, and the deep anger and anxiety I felt about what my teacher said and anything else that made me feel insecure about my self-worth were still there. Maybe the teacher was right. Maybe I was destined to be a fat girl who has no friends and who no one likes.

Of course, the physical wounds from my fall healed, and the headaches slowly dissipated, but I was still in emotional pain. I went to a psychologist and a nutritionist to get help with my self-esteem, anxiety, and related food issues. I worked diligently to find again that vibrant eleven-year-old, the girl who loved to laugh, who enjoyed being with her friends and understood that her weight was not equivalent to her value as a human.

Fortunately, I come from a family that is steeped in faith, and that faith got me through those tough times too. Honestly, I don't remember how long it took me to fully recover and to stop obsessing about my body and my weight, but I do remember that after I fell on the tracks my family kept a very close eye on me and my eating habits. My mother, an avid reader, ordered some books that were part of a series of encyclopedias we owned. Five of the books were about beauty and culture around the world. I found them inspiring and read every one from cover to cover. I learned about women of all shapes, sizes, and complexions with different values and cultural rituals. In their stories I began to see myself in a more positive light and came to understand that I had potential too.

Looking back, falling on the train tracks may have been the wake-up call that saved my life. The fall forced me to deal with my eating-disordered behavior immediately. My struggle was difficult: I had to learn how to eat properly again, and as I put on weight, I had to learn to deal with the pain of how differently people treat you when you are not thin. During my purging I had gone down to a size 6 or 8, which is too small for my physical frame. After the bulimia came yo-yo dieting, weight fluctuations, and the noise in my head that allowed me to see only a fat girl in the mirror. But I never resorted to throwing up again. My therapy included journaling, which gave me the freedom to say what I needed to say without fear or filter, so I was able to "talk" myself back into good health and a positive outlook. When I entered college at eighteen I was still in therapy and still being monitored closely by my family. I gained the weight back slowly, and I don't think that I was what is considered plus size again until I was about twenty.

During college I worked part-time at two women's boutiques—A Different Step and La Rue des Rêves ("the street of dreams")—names that not only shaped my future but became synonymous with the story of my career. I was studying government and public administration, thinking

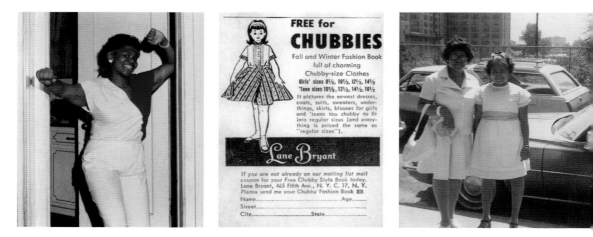

LEFT: I enjoyed being thin during my high school years, but I struggled hard with food and body image issues. CENTER: This advertisement for Lane Bryant's *Fall and Winter Chubby Style Book* always reminds me of my mom, who made shopping fun, and of my first feelings of excitement about styling and fashion shows. RIGHT: Mom and me, celebrating my fifth grade graduation in 1975.

I wanted to become a lawyer. Little did I know I would become a defender of curves and their place in fashion!

Actually, though, the beginning of my love for and understanding of the transformative power of fashion and the lesson "If there's a will, there's a way" came at age five. I was visiting my grandparents for the summer and wanted to accompany my grandfather, a truck driver, to work. The company he worked for had a policy of not allowing females on the trucks, but my grandparents and I got around that by dressing me up in my brother's clothes so that I could accompany my grandfather. Not only did the idea work, but wearing those clothes gave me a distinct boost of self-confidence and a feeling of pride.

I have my mother to thank for showing me the joy fashion can bring. Because I was a chubby girl, she saw to it that shopping was a pleasant experience for me from a very early age, and she also made sure I wore clothing of beautiful quality. One of my favorite stores was Lane Bryant, located in a stately townhouse on Fifth Avenue, directly across the street from the New York Public Library.

Lane Bryant's chubbies' department was fabulous. At times of seasonal change, before school began, and before the holiday season arrived, the store presented a fashion show featuring the latest trends. I, and other girls like me, received a special invitation to attend, and I had to RSVP, both of which thrilled me. The best part was that I had my own personal shopper who helped me season after season. After the show she would help me put together looks for school, holidays, or summer vacation. Shopping was fun and working with a stylist made me love fashion even more, two experiences I am sure influenced my career choice later on.

At La Rue des Rêves, my interest in and affinity for fashion grew. I had begun styling looks for the store displays and our clientele. Locals began calling me Dream Girl, in reference to the translation of the boutique's name. At the same time, I sought opportunities in other boutiques and areas of the industry. I got jobs dressing runway models for designers like Oscar de la Renta and Geoffrey Beene during Fashion Week and dressing showroom models during market week at Carolyne Roehm. I worked as a sales associate at Macy's and Bloomingdale's, as well as worked for a company that retouched photographs for major fashion editorials and advertising campaigns.

What I loved most, though, was working with models, which felt magical, almost like an extension of my favorite childhood activity, dressing my huge collection of Barbie dolls. The hair, the makeup, and the larger-than-life runway personalities—I loved it all. In fact, the more shows I worked, the clearer it became that I wanted a career in that festive, fast-paced environment. In my senior year, just weeks before I was to take my final exams, I decided not to finish school but to pursue a career in fashion full-time. Of course, this decision upset my mother, which made me feel terrible. Although I didn't tell her this at the time, I promised myself to do right by her, to make her proud.

Looking back now, I can't believe that I, a black plus-size young woman from the Bronx, was spending most of my time in a world where being thin and white were more than requirements, they were expectations. And yet I rarely thought about my own

dress size. I was secure with myself and fully accepted, at age twenty, that a size 2, 4, 6, or even 8, was not meant for me. I was at peace with myself and my body, which in a culture that values being too rich and too thin, may seem hard to believe. But I did learn a thing or two from observing and listening to these gorgeous women.

First, all women have insecurities, and second, it doesn't matter how beautiful the world tells us we are: we all feel what we feel about ourselves. Third, when you overcome a bad moment or a feeling of insecurity and find your champion spirit, it's empowering and life changing. The founder of Apple, the late Steve Jobs, may have expressed it best in his 2005 commencement speech at Stanford University: "Your time is limited, so don't waste it living someone else's life. Don't be trapped by dogma—which is living with the results of other people's thinking. Don't let the noise of others' opinions drown out your own inner voice. And most important, have the courage to follow your heart and intuition. They somehow already know what you truly want to become. Everything else is secondary."

I didn't have much money and I didn't know where my passion was leading, but I was willing to follow my instincts. It wasn't too long before I was tapped by a television network executive to create looks for the costumers of a leading television soap opera. Photographers began calling me to style rising runway stars for their portfolios and test shoots. One of the first, and most stunning, models I ever worked with was Tyson Beckford—yep, I worked with men too—who later became highly recognized for his Ralph Lauren campaigns.

In 1994, I received a call from Beverley Williams, the editor in chief of *Shade*, a new African-American lifestyle magazine, asking me to be the fashion editor. I was stunned. There was nothing in my résumé that included magazine work. But I took the risk: so far, every opportunity in my life had turned into a bigger and better one. I saw no reason for this one to be different.

At the magazine, I held model castings, visited showrooms, wrote editorial copy, and attended Fashion Week and all the other seasonal fashion events. Although exciting, the job was not always easy. Some in the Fashion District did not hide the fact that they couldn't care less about an African-American lifestyle magazine, even refusing to lend clothing for shoots. But others, like the designer and boutique owner Patricia Field, were intrigued and encouraging. When I met with her to discuss the magazine, she looked me in the eye and said she thought I had what it took to make my own imprint and endure. I will treasure that vote of confidence for the rest of my life.

My work at *Shade* enabled me to build a solid portfolio of work, a Rolodex of fashion industry contacts, and, unbeknownst to me, a host of creative executives in the music industry buzzing about the magazine's fashion pages, which led to gigs in the music industry. In the 1990s, R & B and hip-hop were burning up the charts. There were fresh new faces to promote, and for the labels, the talent's image was just as important as the music. Soon I was taking meetings at RCA, Atlantic Records, Elektra, and a host of other record labels.

When *Shade* folded in 1995 my fashion career took another giant leap forward.

Atlantic Records marketing executive Melody Johnson called and asked to see my portfolio. Although she wouldn't name her, she said she had a big newcomer whom they had done several unsuccessful shoots for. Would I want to give styling her shoot a try?

The next day I went to the Empire Hotel to meet this new R & B star. When the hotel room door opened, there stood Brandy, with Whitney Houston's "I Wanna Dance with Somebody" blasting clearly from her headphones. After I introduced myself, she leaped across the threshold, hugged me, and said, "I think that I will be your little sister." We had an instant synergy, and I went on to work with her for seven years.

Working with Brandy helped me understand the power of the stylist. There are very few professions that connect you to so many other cultural entities—music, art, publishing, film, and television—in the same way, or involve you in every stage of the creative process. I took meetings on Brandy's behalf and collaborated with magazine editors and the hottest video directors of the time as well as styled her

for major brands such as Skechers, DKNY, and CoverGirl, and eventually relocated to Los Angeles to be her personal costumer for the hit sitcom *Moesha*. Brandy's image, as well as her videos, were stylistically acclaimed and led to calls from other labels with young artists destined for the spotlight.

After six seasons as Brandy's personal costumer for television and her wardrobe stylist on all other projects for seven years, *Moesha* came to an abrupt ending—as did my styling position with the songstress. Brandy decided she wanted to move on and work with someone new. This was my first real bruising in the business, and it definitely hurt.

There's a converse belief that when things go bad, they get worse before they get better, and that certainly was my story. In 2001, when *Moesha* was canceled, I struggled through health challenges and the death of a dear friend. It was a rough patch, and thankfully I did not turn to food or past behaviors to manage my pain. In fact, to cope I would often turn to a fond memory: one morning as I was walking from my car on the

RIGHT: I styled Brandy's first *Vibe* cover, photographed by Cleo Sullivan, April 1998. FAR RIGHT: Having fun while preparing to shoot Brandy's video for her hit single, "Sittin' Up In My Room," from the *Waiting to Exhale* soundtrack, 1995.

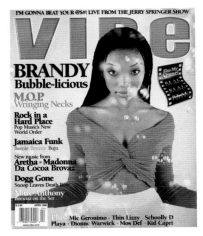

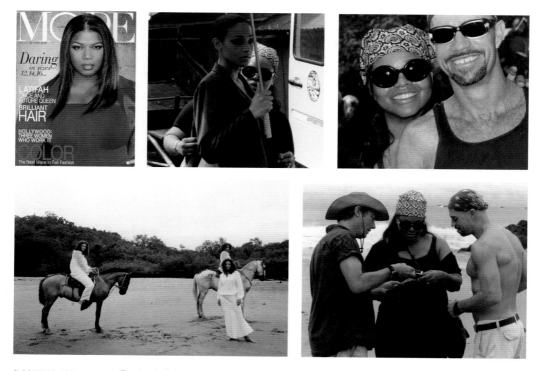

CLOCKWISE, FROM TOP LEFT: The iconic Queen Latifah cover I styled for *Mode*, October 1999; on location in Costa Rica in December 1999 for *Mode* putting finishing touches on a look; with my good friend art director Bill Swan; checking the light with photographer Didier Gault (left) and Bill (right); an outtake from the shoot.

Paramount studios lot to go to work on the show, Michael Douglas passed by and gave me a warm greeting. After returning his "good morning," I looked toward the hills and the famous Hollywood sign and asked myself, "God, does it get any better than this?" Unbelievably, things did keep getting better at that time, so I held on to the belief they would again.

One night, I was at a party, and as I was walking by a group of people in conversation, I heard a familiar female voice call out my full name. And then she proceeded to say, "I've got a lot of work to do. You think you got time to style a sistah?" It was Queen Latifah.

I met Latifah for the first time when I was the principal stylist on the remix video for Brandy and Latifah's hit collaboration, "I Wanna Be Down." Later I styled her for what became a cover for *Mode* magazine, a publication for plus-size women that presented them in highly fashionable editorial stories. *Mode* really spoke to my vision of bringing great style to curvaceous women and making plus-size fashion covetable, and I did a lot of styling for the magazine. After the *Mode* cover, Latifah had reached out to me to style her for events, but I always seemed to be booked. This time was different. We hugged, chatted, exchanged numbers, and the next day her handlers called my agent, and the rest, as they say, is history.

Queen Latifah is one of the most beautiful women in the entertainment

industry. She is not the size of the average Hollywood actress, and I knew that working with someone of her stature, both literally and figuratively, would be extraordinary and allow me to make a statement about my fashion vision for plus-size women, to push fashion boundaries. She had recently completed filming *Chicago* and had several other projects and major public appearances on the horizon. Styling her was going to be a big project, and I was ready to take big chances.

I went all out, dressing her in garments by a wide range of top designers, from Dolce & Gabbana and Roberto Cavalli to Donna Karan and Carmen Marc Valvo. I accessorized her in the opulent creations of some of the biggest names in the diamond industry too, from Fred Leighton and Lorraine Schwartz to De Beers and Chopard. It was exciting to see how well received she was on the red carpet, and it became clear we had struck a chord when those who normally designed missy and contemporary lines began to call with requests to design custom pieces for her future red-carpet appearances. But what I loved most was when the press ceased talking about her stature and focused on her beauty and style.

Not long after I had begun dressing Latifah, I received a call from Kathy Bates's assistant, who said the actress had admired the way Latifah was dressing and wanted to know if I had time to work with her too. For the 2003 Academy Award season I dressed Kathy and Latifah (both were nominated for Best Supporting Actress: Kathy for *About Schmidt*; Latifah for *Chicago*) for every party, luncheon, and event, including the ceremony itself. A camera crew followed me during the filming of the VH1 special *7 Days Left: Queen Latifah Goes to Hollywood's Biggest Night*, and I hosted a luncheon sponsored by *Vogue* with a few influential women in the film industry. It was an exhausting and spectacular time.

On the day of the Academy Awards, in the midst of being chauffeured between the two camps, I spoke with my mother. She said she had seen the television special and all the press, and that she had heard my joy when I spoke of my work. She expressed her pride in me and in the fact that I had been true to myself, acknowledging that the path I chose took a lot of courage. I could barely speak, as tears of great happiness streamed down my face. I knew then that I had found my place in the world.

I worked with Queen Latifah for six more years. I styled her for CoverGirl ads, films, music videos, magazine covers, and countless red-carpet appearances. I also became the creative director for her Curvation clothing line for plus-size women. I worked with Kathy Bates several times after the Oscars too. Because of their high visibility and the fashion editorials I did for *Mode*, I became the go-to girl for styling curvy women.

Styling has many lanes, and I found the one that's truly mine. Actually, I think it found me, disguised as two Oscar nominees who were not a size 2, 4, 6, or even 8. But more important, it gave me a clear mission: to dedicate my career to showing the world that there is a place in fashion for plus-size women. Over the years I've styled numerous vocalists, such as Wynonna Judd, Jill Scott, and Chaka Khan; actresses Nikki Blonsky, Mo'Nique, and Gabourey Sidibe; the first plus-size

supermodel Emme; and a host of other beautiful plus-size models and women.

Every woman has the right to feel good about herself and to look her best. Size should never be a roadblock to great style—that is why I wrote this book.

As a tall, full-figured woman, I understand the challenge of finding garments that fit properly. I also enjoy debunking old-fashioned and often outdated standards of what plus-size women should and shouldn't wear. Yes, there is an art to getting dressed based on one's body shape, personality, and the occasion, but there is no dictate for self-expression.

You have to be you—and style is 100 percent personal! It is your statement to the world, through fashion and beauty, about who you are. There is no true right or wrong when it comes to style; in fact, the only real truth is that defining the term *style* is somewhat elusive. A woman with great style is clear on what works for her: she has a fearless approach to dressing in a way that comes naturally, for as Bill Blass so aptly said, "Style is primarily a matter of instinct." Style is a distinct imprint that makes us feel and look confident. It's the sum of all parts, selected by you for you: from fabrics, patterns, and silhouettes to a distinct style of shoe or bag to a signature lipstick or perfume. Wearing what you love is a true form of self-expression and makes your confidence soar!

I was once hired to style a new client who had previously worked with various

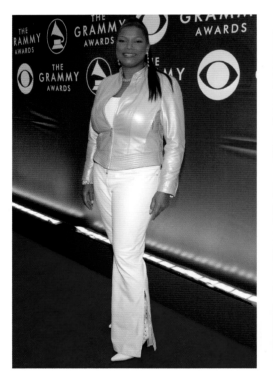

LEFT: Queen Latifah in Escada—a look that generated a lot of positive media buzz at the 2003 Grammy Awards.
RIGHT: Kathy Bates in an Eric Gaskins gown and coat on the red carpet at the 2003 Academy Awards.

stylists suggested by the producers of her television show. I was booked to style her for all of her press photographs and a commercial. During our initial meeting she confided that she shuddered whenever the word *stylist* was mentioned because her experiences had been horrible. She told me that the previous stylists didn't consider her body shape and the colors she liked, and they never provided garments that covered her upper arms, which were a concern for her. During her consultation I took measurements, talked about the colors she loved, and listened carefully to get to know her.

When the fitting day arrived, I could see she was nervous and quiet, so I didn't do much talking either. I normally start client fittings with the most casual looks, but that day I decided to start with the most elegant instead, as she had told me that cocktail and evening looks had been the most challenging. I put her shapewear, shoes, and a lovely royal-blue dress in her private room. As she entered she said nothing, and neither did I. She took about twenty minutes to get fully dressed, and another five to look at herself in the full-length mirror. When she was done, she could barely speak and there were tears in her eyes. I thought I had done something wrong.

Then she said, "Finally, someone really sees me; I feel so beautiful."

The rest of the day was a cinch. Her confidence soared in front of the camera and she was able to be every ounce of her amazing self. I think of this moment often because it exemplifies the courage it takes to see and accept who we are. When I style models, the expectation is for them to be chameleons, adapting readily to the fashion editorial, becoming what is needed for that particular story. Conversely, when I am styling an actress, songstress, or even a politician, my job is to enhance her curves and all of her style personality to show who she really is. The same thinking applies to you. When you get dressed, your confidence has to be fueled by loving what you're wearing, feeling attractive in it, and knowing that it clearly reflects who you are. Yes, the right dress for the right occasion, in the perfect color, and the most figure-flattering silhouette is important, but so is expressing yourself. What is always at the core of cutting-edge style and a captivating presence is you!

For inspiration, just look at Oprah Winfrey, Adele, Melissa McCarthy, and Lena Dunham, among a host of other highly accomplished full-figured women. They are extraordinary, and the common thread connecting them is their self-knowledge and self-acceptance. Tenacious and courageous, they did not permit the world to deem them invisible due to their size. Had they not done so, we might not have ever experienced their great talents. They are a profound confirmation that you have to believe that you are exactly right as you are.

Embrace your curves. Be bold about your fashion desires and unapologetic about your figure. Curvy confidence at its very best will have an extraordinary impact on your entire life. When you know who you are and you live in your own stylistic truth, you will be amazed by how much you inspire others and what you will be able to accomplish.

My hope is that *The Art of Dressing Curves* will help you see and believe in your beauty—inside and out. Let's get started!

In life,
as in art,
the
beautiful
moves in
curves.

—EDWARD BULWER-LYTTON

1
Body Talk

YOUR REFLECTION IS PERFECTION

I finally realized that being grateful to my body, whatever shape it was in, was key to giving more love to myself.

—OPRAH WINFREY, *O, THE OPRAH MAGAZINE*, AUGUST 2002

TALL AND THIN YET CURVACEOUS LIKE AN HOURGLASS, WITH WHOLLY SYMMETRICAL facial features to boot—these characteristics have long been held as classical ideals of beauty despite the fact that it is the rare woman who embodies them. The majority of the world's women are not model size or even a 6, never mind the fact that the modeling industry thrives on girls who are in their teens and early twenties to tell us what is beautiful and fashionable. The world's increasing preoccupation with flawlessness and agelessness has only increased in a greater struggle for self-acceptance among women of all ages and races. Body shaming, its insidious presence lurking ubiquitously in the media—from articles about food, health, and exercise to fashion commentary—is damaging for all women.

Fuller-figured women bear the brunt of the abuse, often insulted and humiliated by strangers, friends, work colleagues, and family members—intentionally or not. Unfortunately, and more important, many women who have had these negative experiences have also been complicit in them through self-degradation as a means of self-protection.

It is not easy to tune out the demeaning commentary, but it can be accomplished when one has confidence, respect, and love for one's own body. Let's face it, you can pull on the best shapewear, and adorn yourself in stunning clothing and accessories, but only inner confidence and self-acceptance can make you shine. You need to appreciate and respect your body as it does you.

It's time to make peace with your body and give it the love and the respect it so richly deserves. Your body has had to put up with a lot of extraordinary judgment that has not only come from strangers but also, sadly, from you too. You may have turned your back on your body and abused it or talked down to it. You may have wished that certain parts were different from the way they are naturally, and you may have even surgically altered them, or wanted to, to conform to some foreign ideal. You may have gotten angry at your body when you didn't fit into a new dress or an old pair of jeans the way you wanted to, and, most important, you may not have treated your body the way it treats you.

Through it all, your body has been there for you. It has never stopped breathing. It has picked you up when you have fallen. It healed when you were hurt or ill. It accepted your strengths and weaknesses and carried you no matter the numbers on the scale.

PAGE 22: This image of model Marquita Pring by Sølve Sundsbø was featured in *V* magazine's January 2010 "Curves Ahead" issue, a publication that marked a groundbreaking moment where high fashion acknowledged the beauty of curvaceous women.

I don't fixate
on other people's
opinions of
my body.

—Gabourey Sidibe, *Interview*, 2009

It's time to respect your body for all the incredible things it does for you every day without hesitation. It's time to be able to walk by a mirror and look at your body with pride and speak to it with love and kindness. To stop comparing it to an unattainable ideal created by the media, fashion designers, advertisers, and other purveyors of female beauty. Your body deserves to be loved in the way it has loved you unquestionably all of your life.

I promise you: learning to love yourself and your natural body shape is the key to confidence. It took me a while to get there myself, from being a chubby child to a bulimic teen to the full-figured woman I am today. When I was able to acknowledge all the precious gifts my body had given me, I stopped fighting with it, hating it, and blaming it—and you can too. Too often the ways of the world make it difficult to appreciate your unique attributes, especially your curves. But in reality, the world has nothing to do with it. It's time to stand tall, look in the mirror, and acknowledge your beauty, value, and humanity with pride.

The Art of Dressing Curves is here to help you. Through the lens of my personal experience and work as a stylist, I will share with you the keys to impeccable style, which always begins with what lies beneath the clothes themselves. To that end, we will work from the inside out, first exploring the intersection where body type, shapewear, and bras meet to lay a solid foundation on which to build a spectacular wardrobe and fashion statement that says, "I've arrived!"

Then you'll discover how to put together a wardrobe that works, beginning with fifteen essential items, expanding on that to reflect your personal style through signature looks and a range of accessories. Along the way we'll deconstruct some myths about what a curvy woman wants and needs, likes and loathes. And I'll also give you the low-down on getting red-carpet glamorous for a big night. It's a magical voyage through the wonderful world of fashion from which you will emerge victorious.

Body Typology
WHAT'S YOUR SHAPE?

OPPOSITE: Gabourey Sidibe, photographed by Peter Chin for *Ebony*, March 2010. PAGES 28–29: This image by photographer Beate Hansen is all about joy and confidence—and exemplifies that beauty comes in all shapes and sizes.

With women size 14 and above ripping up the runway like never before, the major increase in fashionable clothing for curvy women, and all the media coverage on the subject, voluptuous women are making it clear that their bodies are fierce and worthy of great fashion. But to enhance your figure through clothes, you need to know what body type you have—and that applies whether you're curvy or not.

Think of it this way: Just as one shade of lipstick suits your complexion, certain silhouettes and fabrics naturally flatter your figure. Knowing your body shape and understanding the basic rules of what enhances it is vital to laying the foundation for self-confidence in the form of a wardrobe that serves you long and well. Understanding your body shape enables you to choose the right foundation garments to maximize your best assets and camouflage or smooth out trouble spots, and, similarly, to select the most flattering fabrics and silhouettes to do the same. As a stylist, assessing a client's body type is the first thing I do: for me, it is a tried-and-true process that helps me offer clients security, confidence, and exceptional style. And more important, understanding your body shape empowers you: once you understand it, you'll be able to wield transformative powers like a magician, creating positive illusions and making problem areas disappear at will.

While a quick online search will reveal a superfluity of body shapes—bearing names from fruit to architectural details—there are five core ones: hourglass, triangle, rectangle, inverted triangle, and oval. Your body shape is determined by genetics, bone structure, and how your muscle and body fat are distributed, not by your weight. If you lose or gain weight your body shape generally remains the same. You may believe your shape is similar to other women you see or know, but it's in the recognition of the subtle differences that will help you make a final determination. In actuality, the rectangle is the most common shape, followed by the triangle, the inverted triangle, oval, and, last, the hourglass.

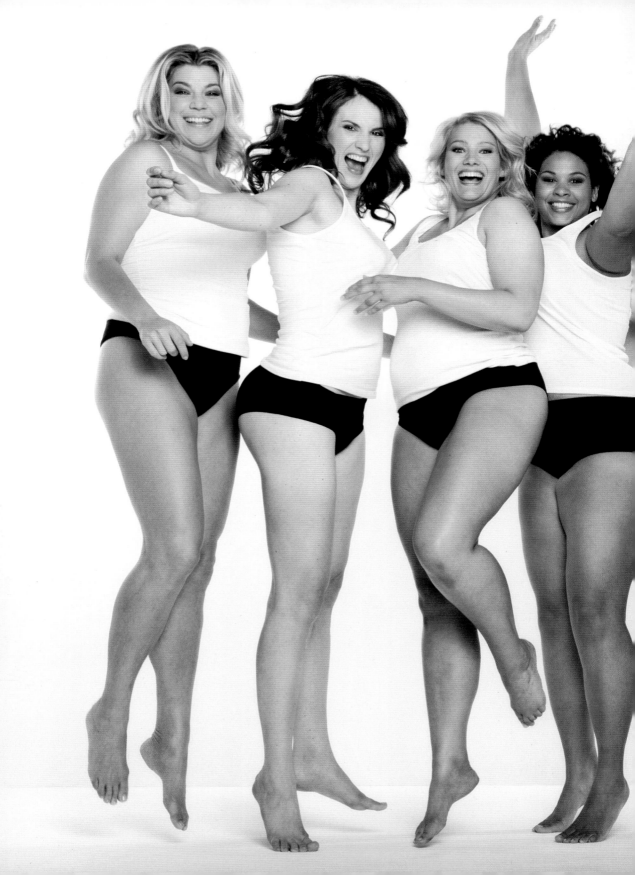

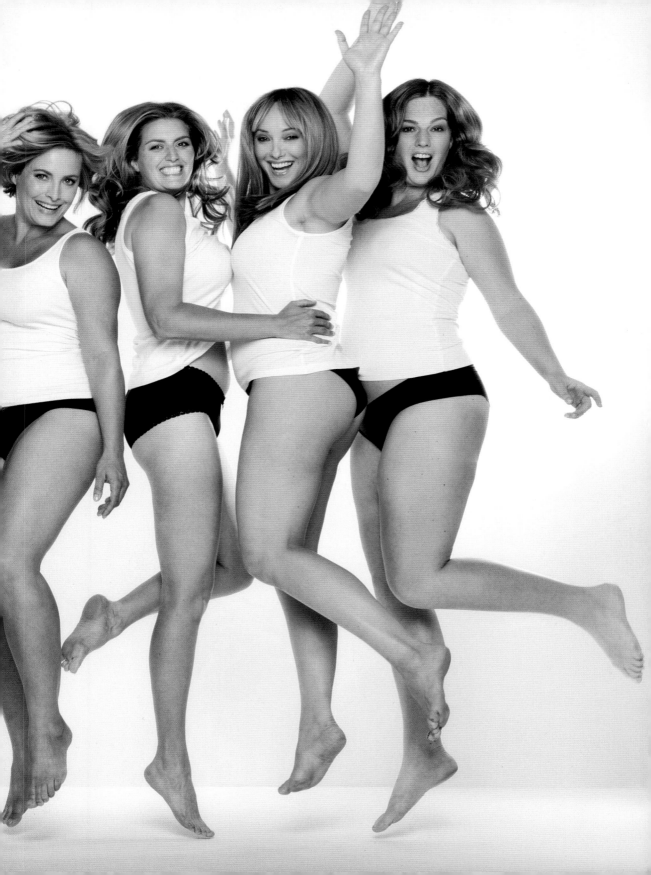

FIGURING IT OUT

Identifying your body shape is the first step to understanding the rules of proportion in dress; begin by standing in front of a full-length mirror dressed only in a regular bra and panties and examine the contours of your body. Note the following on a piece of paper:

- The visual curve of your waistline. Is there a lot of definition or very little?

- The protrusion of your buttocks and breasts: do they project far from your body, creating distinctive curves; modestly, creating minimal curves; or very little, almost creating the appearance of being flat?

- The width of your hips as related to your waist: do you see a lot of curve? A little? Or barely none at all?

- The width of your shoulders as they relate to your hips: are they narrower, wider, or are they about the same?

- Last, take an overall look at your entire body at once to see how your waist, shoulders, and hips line up overall: What is the widest? The narrowest?

Connect the dots from shoulder to waist to hip: you should see the geometric shape your body resembles. Now take some measurements. With a cloth tape measure, measure the width of your shoulders and the circumference of your bust and hips at their widest points as well as your waist. Write down these four measurements, then compare your observations and measurements to the descriptions listed here to discover your body shape. Online you can use body-type calculators that accept the data and provide you with an instant answer.

The Hourglass

The hourglass is the most balanced body shape: the bust, waist, and hips are proportional to one another—it's the basis on which designers create perfectly symmetrical looks. This body shape is often mimicked through strategic seaming design details, cinching with belts, and the use of undergarments, such as corsets. It is the least common shape, yet 36–24–36 is widely held up as the feminine ideal.

PHYSICAL CHARACTERISTICS: A well-defined waist that is approximately eight to twelve inches smaller than the hip or bust measurement; the bust and shoulders are the same or very close in width as the hips.

DRESSING GOAL: Most garments have been designed with this body shape as the prototype, so finding balance through clothing is not a challenge.

DRESSING CHALLENGE: Silhouettes that disrupt the hourglass's naturally balanced proportions, such as a dolman sleeve top with a full bottom, are usually not flattering.

FLATTERING SILHOUETTE: Wrap dresses and body-conscious clothing.

HOURGLASS SISTERS: Marilyn Monroe, Anna Nicole Smith, Brigitte Bardot, Christina Hendricks, Sofia Vergara, and Beyoncé.

The Triangle

The triangle body shape is referred to as low balance because the lower portion of the body is much larger than the torso. When seated, a woman with a triangular body shape is often thought to be smaller than she is until she stands up.

PHYSICAL CHARACTERISTICS: Large hips, buttocks, and thighs are the hallmarks of the triangle shape, and this is where she carries most of her weight. The shoulders, bust, and upper torso measurements are significantly smaller than those of the lower part of the body. This body type may have sloping shoulders and the breasts are often small, although breast size does not dictate body shape.

DRESSING GOAL: To add volume to the upper torso.

DRESSING CHALLENGE: Pants and skirts can be difficult to find, as the waist to hip ratio is pronounced.

FLATTERING SILHOUETTE: A-line dresses and skirts; blouson tops.

TRIANGLE SISTERS: Mo'Nique, Mindy Kaling, Khloe Kardashian, Lena Dunham, Kelly Clarkson, and Jennifer Lopez.

All shapes. All sizes. All relevant.

—JES BAKER, *THE MILITANT BAKER*, NOVEMBER 5, 2014

FLATTERING SILHOUETTE: Flair skirts, A-line dresses, and wide-leg pants.

INVERTED TRIANGLE SISTERS: Wynonna Judd, Amber Riley, Raven-Symoné, and Sherri Shepherd.

The Rectangle

The rectangle shape is considered the most athletic-looking figure, and it is also the most common body shape among women.

PHYSICAL CHARACTERISTICS: The rectangle has very little waist definition, narrow shoulders, and very straight hips. The circumference of the bust, waist, and hips are

Inverted Triangle

The inverted triangle shape is often referred to as "high balance," as the torso is not only much wider than the bottom, but the visual line of the silhouette reaches its broadest point at the shoulders and the full bustline.

PHYSICAL CHARACTERISTICS: Your bust measurement is larger than your waist and hip measurements, and visually you appear narrower at the hips than the shoulders.

DRESSING GOAL: To minimize the torso.

DRESSING CHALLENGE: Finding button-down shirts and blouses that don't make you appear larger.

very close in measurement, and the waist will generally measure one to eight inches smaller than the bust. Rectangles may have a flat bottom and small breasts, but not always, as breast size does not dictate body shape.

DRESSING GOAL: To add volume to your upper and lower body to create a more curvaceous appearance.

DRESSING CHALLENGE: Finding garments to define your waist and add shape to your bust line and hips.

FLATTERING SILHOUETTE: A-line dresses.

RECTANGLE SISTERS: Meryl Streep, Kelly Osbourne, Adele, Cameron Diaz, Sheryl Crow, and Hilary Duff.

The Oval

The oval body shape is also referred to as an apple because of the roundness in the stomach area. The most common attributes of women with the oval body shape are very shapely legs and ample cleavage.

PHYSICAL CHARACTERISTICS: A full bosom, narrow hips, small bottom, and a very full midsection that is its largest in its lower portion; the waist is the widest part of the frame, measuring larger than the bust and hips, and is undefined; bust and hip measurements are very close in size; shoulders may slope.

DRESSING GOAL: To contour and smooth out the midsection.

DRESSING CHALLENGE: To find tops and dresses that are comfortable through the midsection.

FLATTERING SILHOUETTE: Empire dresses and tops.

OVAL SISTERS: Melissa McCarthy, Rebel Wilson, Queen Latifah, Beth Ditto, and Retta.

Now that you've identified your body shape, you'll be able to make informed decisions about enhancing your figure's strong points and minimizing areas you find challenging. But before we go there, let's talk about shapewear, which is essential to achieving a clean silhouette for women of all sizes and shapes.

2

Shapewear

JUST BREATHE!

My grandson's mad at me now. I squandered—
he thinks—his college fund on Spanx. It's a lot,
but there's a lot going on here.

—JOAN RIVERS, *LATE SHOW WITH DAVID LETTERMAN*, FEBRUARY 26, 2013

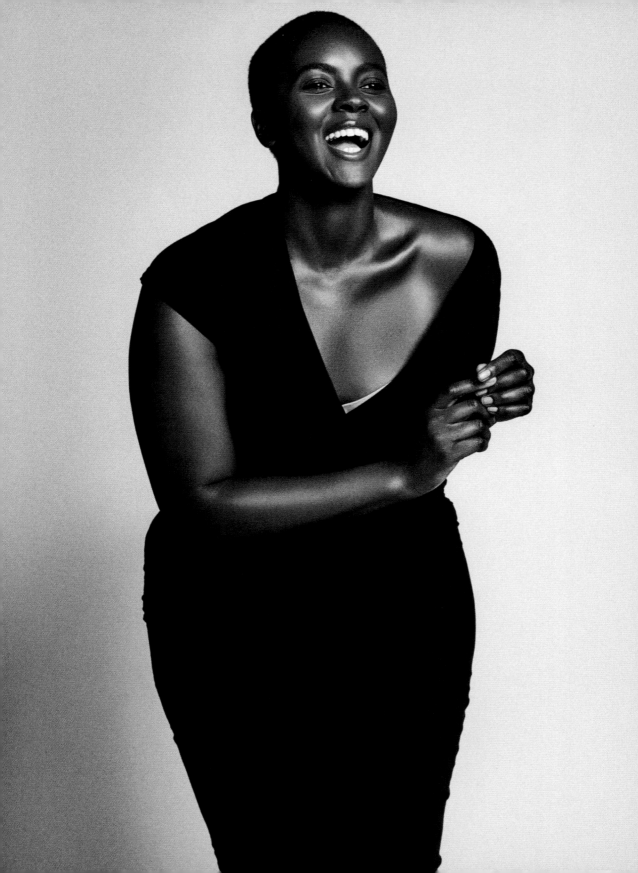

SHAPEWEAR IS LIKE AN AMERICAN EXPRESS CARD. I DON'T LEAVE HOME WITHOUT mine, and neither should you. As a stylist, my first order of business with any client is to build a shapewear arsenal. I often have this conversation in a one-on-one setting, but it was during my tour as a spokeswoman for Penningtons, Canada's largest plus-size retailer, that I was able to share the importance of investing in good shapewear with large groups of women. During the Style Study workshops I led, I always began the conversation with the importance of what lies beneath clothes.

During those tours I met many women who confessed they did not see the importance of wearing shapewear. The majority of them said they thought shapewear looked uncomfortable and just couldn't imagine wearing it on a daily basis. I explained that sometimes a bra and panties are not enough to wear to look one's best, and that as larger women we need the smoothing and the extra support. I kept it real by including myself in the conversation, explaining I have a very full bosom and spend a great portion of my day standing, so I wear a back-smoothing control tank top to give my shoulders, back, and bust more support. When the women asked what size I normally wore, I told them that I liked my tank top a bit snug so that I know it's really working. I'm old school. I believe that it's okay to suffer just a little for fashion and beauty.

Many of the customers thought I was a bit crazy, but once I got them into the dressing room, properly fitted for a bra by a professional and into some shapewear, the immediate response was positive. The first thing the women noticed was how smooth their bodies appeared under their clothes, and second, how they were suddenly standing more erect. Even the women who had back issues said they felt some relief. When I dressed them in the latest seasonal looks, there was a sudden need to show me their best runway strut. I even overheard some whisper, "Maybe this stylist isn't so crazy after all." These experiences always took me back to the early lessons I learned from the queen of lifting and separating, my own mom.

My mother believed that a good foundation was essential to being well dressed and looking refined, and she made a believer out of me. Shopping for undergarments with her normally took an entire afternoon and was just as important as shopping for a coat, a pair of shoes, or a special-occasion dress. She would explain what to look for regarding design details, such as strategic double seaming and satin panels for tummy control, and how undergarments should fit, especially when it came to smoothing and contouring curves. This is a ritual she continues to this very day. When she shops at her favorite intimates

boutique she's always greeted with, "Mrs. Moses, will you be interested in the Lexus or the Cadillac today?" This of course, is in query to the quality she's looking for and how much she plans to spend. It's always the newer luxury model—the Lexus.

As a youngster I thought my mother made way too much of purchasing, caring for, and storing undergarments, but today I understand that something worn so close to your body should be delicately kept to preserve it. When I think of my healthy obsession with shapewear, I know who to thank: Mom!

Foundation Garments for Your Body Type

As far back as the sixteenth century, strong stuff—cages, wire, rubber, whalebone, and horn—has played a significant role in the garments women wear under their clothes, all with the intention of building a platform on which their outerwear could stand in its finest form. Corsets prepped the waist for a smooth finish, while bras lifted the breasts. Cage crinolines and bustles boosted the derriere, and girdles flattened the tummy. Throughout the last four centuries women have given as much attention to what's under their clothing as they have to fabric, silhouette, and style alternatives.

Today, there are many options to accommodate clothing choices, from basic T-shirts to body-conscious dresses, skirts, and gowns—and the fabrications are softer. Additionally, undergarments are no longer unmentionable. Celebrities now credit what lies beneath for their seamless perfection on stage, on the big and small screens, and on the red carpet. An on-camera declaration of being cinched, courtesy of Spanx, has become the norm in Hollywood. What a great moment for women around the world to get the inside scoop on what lies beneath some of the showstopping gowns on the red carpet!

You may think that shapewear is just for the curvaceous, but this level of openness allows all women, regardless of their size and body shape, to recognize there are times when they too need a little lift, control, and support. Shapewear is meant to enhance your body, accentuate your good areas, and control challenging ones. And today's shapewear has come a long way from the dowdy underwear it used to be—it's sexy!

STYLE BEYOND SIZE

Size
Shape
Attitude
Love it,
Work it,
Wear it

special section:
great
hair
now!

Spring F

Red Hot Torch
From Billie Holiday t

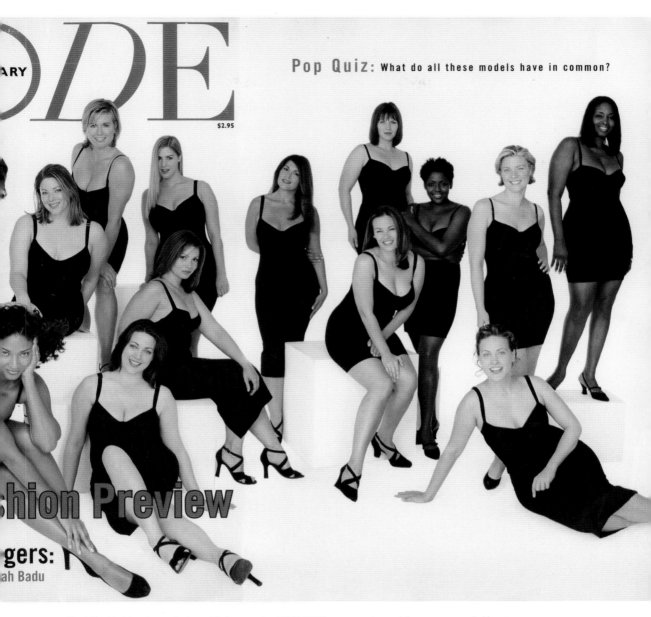

ODE

ARY

$2.95

shion Preview

gers:
ah Badu

Short-lived but iconic nonetheless, *Mode* magazine (1997–2001) was once deemed the curvy woman's *Vogue*. This February 1998 cover featured the industry's supermodels of the day and marked the beginning of a major shift—from frumpy to fabulous—in shapewear design.

Without proper foundation there can be no fashion.

—CHRISTIAN DIOR, *THE LITTLE DICTIONARY OF FASHION*, 1954

WHAT YOU NEED TO KNOW ABOUT SHAPEWEAR

WHAT IT IS.
Shapewear is the collective name of undergarments formerly called foundations. All forms of shapewear are about creating a silhouette, whether de-emphasizing or accentuating curves.

WHAT IT DOES.
Shapewear provides support and smoothing where it's needed, conceals cellulite, conquers muffin top, positively enhances curves, and improves the fit and line of clothing.

WHY WEAR IT.
Lifting, cinching, and smoothing may sound more like construction work—and it is—but let's make it sound pretty and call it high-end architecture. You want your breasts and bottom to cantilever off your torso just right, with your back softly sloping and your hips and waistline curving like a Norman arch on a building in Vienna. Yes, you want to look stunning!

WHAT'S TRENDING.
Breathless, not breathtaking, is what comes to mind when we think about foundation garments. Fortunately, we've come a long way from the heavily structured and intricately designed undergarments of the past. While beautiful, they were apt to create unattractive lines and shapes onto clothing if not fitted properly. Modern technology has made lifting and separating a lot more pleasant and undergarments a lot more functional and fabulous.

Shapewear has evolved extensively in its fit, fabrication, and function and renders much more comfort and a fully refined look. Designs provide the needed effectiveness through the use of smoother, stronger, and lightweight fabrics. In addition to holding and molding the body comfortably, contemporary shapewear allows for better contouring where it's needed while providing a natural appearance. Innovative advances have also created fabrics that are thinner, have temperature control, and stronger elastane, a synthetic fiber with the ability to recover from stretch. Some designs are lovely enough to be worn as outerwear.

FIGURE CONCERNS, SHAPEWEAR SOLUTIONS

- **Waist, abdomen, posterior, hips, lower back, and mid-back:** Body briefer
- **Waist, tummy, derriere, hips, thighs, and back:** Full-body shaper
- **Waist, tummy, derriere, hips, and thighs:** Control half-slip, control biker shorts, control capri shaper
- **Waist, upper and lower back, tummy, and bust:** Control tank top and torsette
- **Tummy, derriere, and hips:** Regular control briefs
- **Waist, tummy, buttocks, hips, and lower back:** High-waist control brief
- **Bust, waist, back, hips, and thighs:** Full control slip
- **Upper torso, waist, and tummy:** Waist cincher

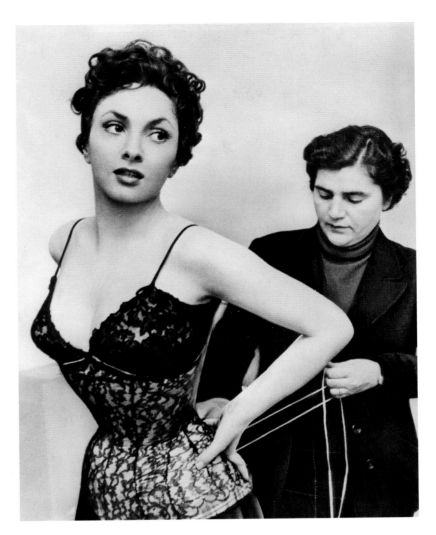

Gina Lollobrigida gets laced into a corset for her first American film, *Crossed Swords*, 1953.

WHERE TO BUY IT.

You can purchase shapewear at department stores, lingerie boutiques, and online stores. Many department stores and boutiques provide professional consultations and fittings. In addition to convenience and privacy, shopping with e-tailers offers an enormous amount of style and color options and extensive product information, including everything from the percentage of infused fabric content to garment design features.

WHAT TO LOOK FOR WHEN BUYING.

Give color and texture serious consideration before buying. This is especially true if you are buying shapewear for the first time. In fact, start with the basic colors—black, white, and skin tone. Look for fabrics without texture, embossed designs, or lace embellishments, as those cause visual interruption underneath body-conscious silhouettes and sheer fabrics.

Getting Started

PREPARING TO INVEST IN SHAPEWEAR

Buying shapewear is a little bit like buying clothes, but not exactly. Sure, both have to fit, but that's where the similarity ends. Shapewear has the added responsibility of serving as the foundation for everything you wear, ensuring your clothes hang properly and that you look flawless.

Buying shapewear is an investment. And I must emphasize *invest*, because it never pays to skimp on shapewear. You may be hesitant to spend big for pieces that are not outwardly visible, but it's absolutely necessary.

Why? First, modern shapewear is the easiest way to enhance your figure, lifting and smoothing areas that sag or protrude. Second, it improves the fit of everything you wear. One of the best things about shapewear is the way in which it makes a full figure look its best. Think of it this way: the goal is not to hide your shape but to define and refine your assets.

THE REALITY CHECK

Before buying shapewear, let's do what I refer to as the "Reality Check." You'll look in the mirror and determine the areas of your body you need to target, determine if you're short- or long-waisted, identify your body shape, collect all the necessary measurements to buy shapewear that fits perfectly, and do some research to find out what your friends are wearing and what's selling in stores and online.

Look in the Mirror

Wearing regular panties and a seamless bra without padding, stand in front of a full-length mirror. This is honesty time. View yourself from the front, back, and both sides. Zoom in on all those areas you've always found challenging to dress and look for things you may not have noticed or just ignored in the past. I'm talking about back rolls, thigh and buttock dimples, a protruding lower tummy, and sagging skin around your knees.

PREPARE TO INVEST IN SHAPEWEAR

- Look in the mirror wearing regular panties and a seamless bra without padding.

- Determine where you need control and shaping.

- Know your waist length.

- Determine if your waist is short or long.

- Take your measurements and write them down.

- Have these figures on hand to buy shapewear in the right size.

- Do your research.

- Learn about the best-quality products and bestsellers.

OPPOSITE: Corsets were once utilitarian, and the Spirella Corset Company (1904–1989) was queen. The company was known for its individual made-to-measure corsets, which were fitted by a corsetiere who went door to door selling the goods, not unlike an Avon Lady. Here Marilyn Monroe gets into a Spirella corset for the film *The Prince and the Showgirl*, 1957.

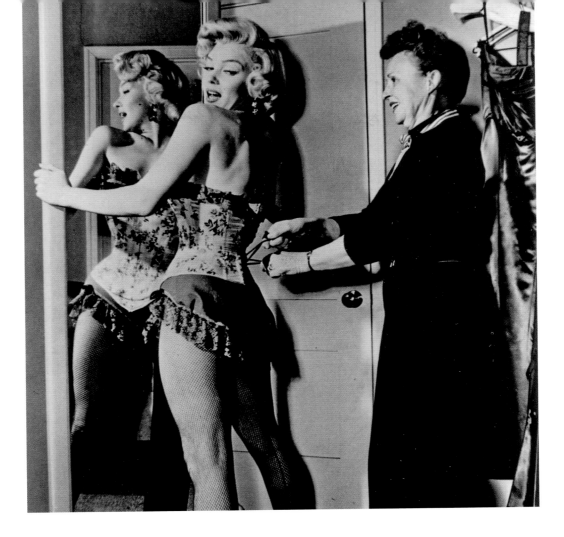

While body shape is not an indicator of the exact shapewear you will need, knowing the characteristics of your shape can guide your focus a little more accurately to challenging areas. A woman with a curvy hourglass shape, for example, might need a little overall compression to tighten her silhouette above and below the waist, while a woman with an oval body shape may need shapewear to create more of a waist and compress her stomach. If you're having trouble, refer to "Body Typology" on page 27.

Once you've identified your trouble spots, make a list of the areas you want to control and enhance first, then prioritize! Give each area a number, starting with the number one as the most important. This will make it easier to identity which shapewear you need to purchase.

Determine If You're Long- or Short-Waisted

Taking vertical measurements will determine whether you are long- or -short-waisted. Some shapewear is available in several waist length options, so you'll need that information to purchase a size that truly fits. Take control briefs, biking shorts, and shaping hosiery, for example. Each stops at three different areas on the torso: the natural waist, mid-waist, and right under the bust. Vertical measurements are important when purchasing a corset, as they too come in more than one waist length.

The easiest way to take your vertical measurements is to stand straight, then measure the distance from the top of your shoulder to your natural waist, and then measure the distance from your waist to the bottom of your buttocks. If the distance from your shoulder to your waist is shorter than the distance from your waist to the bottom of your buttocks, you are short-waisted. If the distance from your waist to the bottom of your buttocks is shorter than the distance from your shoulders to your waistline, you are long-waisted. If both measurements are equal, you are vertically balanced.

> ## When a woman becomes her own best friend, life is easier.
>
> —DIANE VON FURSTENBERG

Take Bust, Waist, and Hip Measurements

It's vital to know the exact measurement of your bust line, waist, and hips. It's also a good idea to know the measurement of your upper arms, lower waist, high hip, and thighs. To take accurate measurements, you'll need:

- A seventy-two-inch cloth tailor's measuring tape. A cloth tape is easier to maneuver because it won't slide as much as a plastic one.

- A full-length mirror to help you see that you are measuring the correct areas and that the tape is level as you wrap it around each area. When you take your measurements, make sure the tape is not too loose or too tight.

- A pen and a pad of paper. You must write down the measurements as you go along. Don't rely on committing measurements to memory!

Professional measuring is generally done for bra fittings, although there are boutiques and department stores that will measure your total body, meaning bust, under bust, waist, hips, and any other measurement pertaining to a shapewear purchase. If you are buying shapewear along with a bra, some stores also offer measuring services because there are a large number of shapewear garments that have bras attached to them. If you prefer to be measured by a professional, make an appointment with the store's in-house fitting specialist. She will take your bust, waist, and hip measurements.

When scheduling a fitting, ask if you will be measured undressed or clothed. If undressed, wear a dress so you will only have to take off one garment. If clothed, the dress shouldn't be tight but fitted enough for the fitter to see your body, and for you to be able to see if the shapewear is providing the right support should you decide to try on a few pieces. Also, choose a dress in a thin fabric so volume won't be added to your frame. If you will be measured wearing underwear only, wear a bra with no padding and regular panties, not control briefs.

BUST MEASUREMENT

Place and hold one end of the tape measure to your breast at the nipple level. This is the fullest part of your bust. Bring the remainder of the tape under your arm, around your back, and across your breasts to meet the other end of the tape.

UNDER-BUST MEASUREMENT

You will need to put on a good bra so that your breasts are out of the way and you can take a true under-bust measurement. Then place the tape directly under your bust and bring it around your back to meet the other end of the tape. Bust and under-bust measurements help determine your true bra size, which is important to know when you purchase shapewear with a built-in bra.

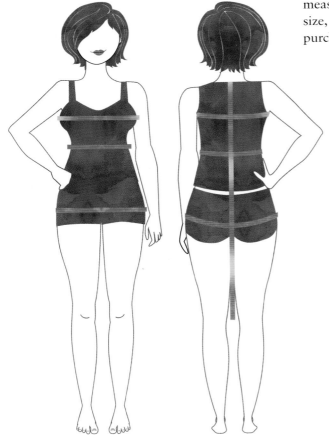

To get accurate bust, waist, hip, and vertical measurements, place a tape measure as shown here.

HOW TO DETERMINE YOUR TRUE BRA SIZE

- Your under-bust measurement is your bra size.

- The difference between your under-bust measurement and your bust measurement determine your cup size.

- If your under-bust measurement is thirty-four inches and your bust measurement is thirty-six inches the difference is two inches. A two-inch difference indicates that you are a B cup. A difference of three inches is a C cup, and a four-inch difference is a D cup.

- For more detail on determining your correct bra size, see pages 77–78.

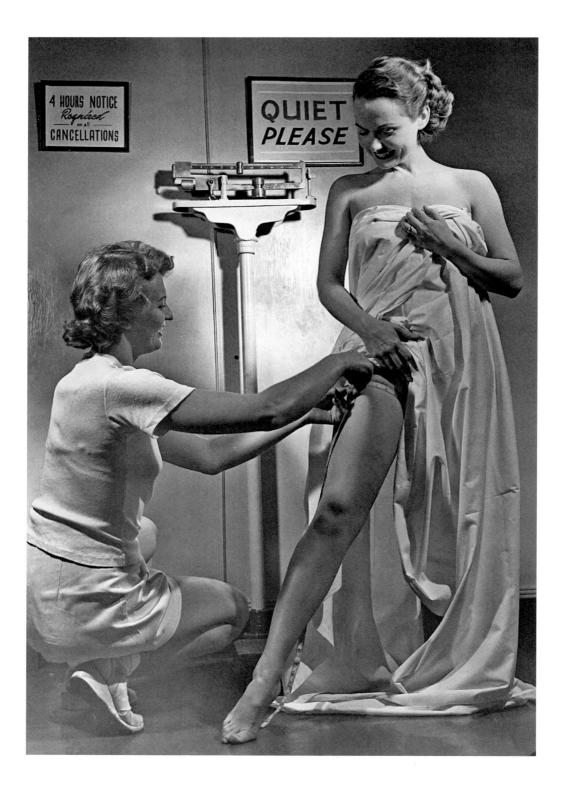

WAIST MEASUREMENT

Your natural waistline is right below your rib cage and usually one to two inches above your navel. Place the tape above the center of your navel, then wrap it around your waist to meet the other end. Don't suck in your stomach or arch your back. This is a trick sometimes used to get a smaller measurement. Doing so will be counterproductive.

LOWER WAIST MEASUREMENT

Your lower waist is about two inches below your natural waistline if you're short-waisted and about three inches below your natural waistline if you're long-waisted. Align the tape with the center of your navel and wrap it around until the tape meets the other end.

HIP MEASUREMENT

Stand with your side facing a full-length mirror when you take this measurement. This will help you make sure the tape remains level across your bottom.

Place the tape on one hip at the level of the fullest part of your buttocks. Wrap it across your buttocks and around the front of your body to meet the other end of the tape.

HIGH-HIP MEASUREMENT

Place the tape at your side, three to four inches above your hips. Bring the tape around your body to meet the other end. Make sure to keep the tape level.

THIGH MEASUREMENT

In a standing position, measure the circumference of the fullest part of your thigh, bringing the tape measure from back to front. Measure both thighs, and use the largest measurement when purchasing shapewear.

UPPER-ARM MEASUREMENT

Place the tape on the front of your arm at the fullest part. Bring the tape around to meet the other end. Measure both upper arms and use the largest measurement when purchasing shapewear.

HEIGHT AND WEIGHT

Your height and weight are also important to know when you're shopping for shapewear. Many brands list the size of their shapewear based on these numbers. This is especially true of shaping hosiery. The more you know about your body, the better prepared you will be to make the right shapewear purchases.

OPPOSITE: Knowing your measurements is vital to buying clothing—from shapewear to an evening gown—that fits.

PAGE 49: You can always create a smooth, curvy look in a fitted knit dress with the right shapewear, such as a control full slip paired with a seamless or minimizer bra.

DO RESEARCH

Word of mouth has long been one of the most trusted modes of product information and purchasing influence. And it has been amplified by pop culture actions—re-tweeting, sharing, and hashtag creation, and new millennium buzz words—transparency and full disclosure. As a result, there is no shortage of sharing information and opinions. Take advantage of these trends to learn which shapewear products and brands to buy. Talk to friends and professionals to learn about features and benefits.

Ask your most-pulled-together girl-friends to share their shapewear secrets. You want to know what brands they are wearing, what their shapewear is success-fully controlling and contouring, and what the shapewear costs. You may find that your needs are similar, especially if you have the same body type. Then ask your girlfriends to recommend some of their favorite stores and Web sites. These con-fidential discussions can yield extremely helpful information.

If you decide to shop in a boutique or department store, speak candidly with the sales staff. Ask for the truth about the fit, features, and benefits of the brands they carry as they relate to your size and the areas of your body that need control. Remember, you want the truth, not the sell, because your lift and cinch is serious business.

If you decide to shop online, be sure to have all your measurements on hand. Bear in mind that one size does not fit all, and every brand has its own signature designs and technology. Read lots of product reviews on both the shapewear brands and items you are considering. Women tend to be brutally honest when it comes to giving their opinions about shapewear, and I have personally relied on reviews when shopping online. Look for comments that indicate the garment is true to size and how the women feel about the fit. You also want to take notice of comments about fabric durability, comfort, and feel. And last, pay attention to what reviewers say about customer service and reordering. All of this may seem like a lot to do, but the more information you have in hand the more you'll save in time and money.

TIGHTER IS NOT MIGHTIER: A CAUTIONARY TALE

It's a common belief that the tighter the shapewear the better the results. This is not true. Wearing shapewear that is too tight is counterproductive because doing so actually creates unsightly lumps, rolls, and bulges where they didn't exist. Shapewear should be worn slightly snug, not supertight.

Wearing foundation garments is about hold-ing you together, not squeezing you together! So beware the sausage-casing effect! When worn too small, for example, a control brief creates lumps and rolls at the waist and the highest part of the hips; a high-waist brief creates bulges around the high part of the hip, under the bust, and at the bandeau at the back of a bra; a control capri shaper creates bulges at the waist and around the knees; and a waist cincher causes bulging in the lower abdominal area, and creates rolls on the upper back.

There's no wrong way to be a woman.

—Denise Bidot, plus-size model, Popsugar.com, July 2015

PREPARATION STEPS FOR THE SHAPEWEAR VIRGIN

If you are new to buying shapewear, it's a good idea to research and purchase your collection in two phases. Good-quality shapewear is not cheap, and there is a lot to choose from. The goal is to buy what you need for control and enhancement first, and add what you want for additional support later, so consider well what you saw when you looked at yourself in the mirror and the priority list you made during the Reality Check. Then choose shapewear garments in versatile colors and cuts accordingly.

An annotated list of shapewear essentials and additional pieces is included in this chapter to help guide you. You probably won't need every item listed, but the selections are broad enough to ensure you get adequate coverage. And that's the name of the game!

Phase One

The following list includes shapewear that provides coverage and comfort for daily wear and an evening out on the town. Read about the details of these pieces in "Shapewear Essentials: Must-Haves for Every Closet" on page 54 and do the prep work outlined in detail on pages 42–48 before you buy.

The most essential item for any woman buying shapewear is either a body briefer that has a seamless underwire bra for contouring from bust to buttocks, or a full-body shaper that will shape and provide support from the bust to the knees. After that, you will need:

- A control tank top for entire upper body support

- Regular control briefs and high-waist control briefs for tummy, hip, and derriere control

- Biker shorts or control shaping capris for thigh smoothing

- Control full slip to flatten the tummy, which also provides back smoothing, waist nipping, and firming of the hips and derriere

Phase Two

You can add items from this second grouping to build a collection with fuller coverage and to guarantee that you have the extras necessary for special-occasion dressing. With these extra pieces in hand, you'll also now have enough shapewear to wear in combination for additional support. These include:

- A torsette for upper-body shaping, which also enables you to wear the bra of your choice

- A control half-slip to flatten the stomach, firm the buttocks, and minimize saddlebags

- A waist cincher to create or accentuate an hourglass figure

- A high-waist control thong to eliminate panty lines, contour the waist, and flatten the stomach

- A strapless or convertible control full slip to wear with strapless evening dresses

- An upper-arm shaper for firming and control

- Shaping hosiery to smooth and control hips, buttocks, and thighs

TIPS FOR PUTTING ON SHAPEWEAR

Shapewear is not something you put on in a hurry. Most pieces are easy to put on, but some require a little more patience and taking your time.

BODY BRIEFER

Open the crotch, step inside, and then close the crotch opening. Pull the straps up and over each arm. Trying to snap or hook the crotch after putting on the briefer can be difficult.

CONTROL TANK

Put your head and both arms through the openings first. Then while the body of the fabric is resting around the top of your bust, slowly pull it down, and smooth it out.

CONTROL BIKING SHORTS AND CAPRIS

The more control these garments offer, the more difficult they can be to put on. Here's the method: sit down on the edge of your bed or a chair and put both legs through the openings at the same time. Then, still sitting, shimmy the pants up, alternating between legs. This will ensure they are even around your knees and thighs. Stand, and then pull them all the way up and smooth them out around your hips and thighs. A word of caution: never attempt to put on control biking shorts or capris when you have just come out of the shower. A wet body only adds to the difficulty. Make sure you are completely dry!

PREPARATION STEPS FOR THE SHAPEWEAR VETERAN

If you already own shapewear, know what brands you like and where to buy them, follow these four steps to take your collection to the next level.

INVENTORY YOUR COLLECTION

Lay out your shapewear on the bed or hang it where it's visible—on a rack, in the front of an open closet, or on the shower curtain rod. Determine if you already own the five essential pieces recommended to the shapewear virgin in Phase One on page 50.

CHECK THE CONDITION OF YOUR SHAPEWEAR

- Make sure there is good light in the room and inspect each item closely.

- Look for fraying, tears, and holes.

- Pull the garment to and fro vertically and horizontally to make sure the elasticity is still strong.

- If you're assessing a garment designed to control more than one area, make sure the control is still good everywhere.

DO A SHAPEWEAR FITTING

- Stand in front of a full-length mirror and try on each piece.

- Check from every angle to make sure it still fits properly and provides the control you need.

- Put on a garment you generally wear with this shapewear.

- Look closely, again from all angles, to see if the shapewear is still providing the expected effect.

PART WAYS AND START OVER

- Discard any item that has lost its elasticity, is frayed or torn, or no longer provides control in all areas.

- If an undergarment is still in good condition, or what we in the business call gently worn, but is too small or too big, donate it. This suggestion refers to anything without a crotch or a bra, such as a tank top, slip, or waist cincher.

- When buying shapewear garments in styles you haven't previously owned, choose those that extend the coverage of other garments in your collection. If you own a control brief and a control full slip, for example, add a high-waist control brief and control half-slip to your collection.

> Shapewear is the canvas and the clothes are the art.
>
> —Sara Blakely, Spanx founder,
> *Vogue*, April 2012

Shapewear Essentials

MUST-HAVES FOR EVERY CLOSET

To follow is an annotated list of essential items for the shapewear wardrobe and what you need to know about them. Some shapewear can be difficult to put on at first, but once you've done it a few times, it becomes second nature. For those trickier items, you'll find tips on the best way to put them on properly here and in "Tips for Putting on Shapewear" on page 51.

FULL-BODY SHAPEWEAR

Every body shape can count on full-body shapewear to provide control, contouring, and smoothing for the torso, hips, thighs, and buttocks.

Full-Body Shaper

A full body shaper is the way to go for a seamless appearance and firm control—it's a must!

WHAT IT IS: The full-body shapewear is a body suit that extends to right above the knees.

WHAT IT DOES: This shaper multitasks on many levels. It nips the waist, lifts the buttocks, slims the thighs, and shapes the bust. Wearing a full-body shaper means you don't need to worry about shifting body parts, cellulite, or a protruding abdomen.

STYLE OPTIONS: Full-body shapers are designed in torsette style, and some have hook-and-eye front closures. They are also available with an underwire bra and adjustable and convertible straps.

HOW TO WEAR IT: A full-body shaper can be worn with dresses and skirts that reach the knee and below, and with blouses and pants too. It's also great under waist-defining dresses. If chafing on the inner thighs is a problem, this garment is a great alternative to a full-body slip.

HOW TO BUY IT: Full-body shapers with the bra attached are sold according to bra size. The open bust style is generally sold in 1X, 2X, and 3X sizes, which translates to American sizes 14/16, 18/20, and 22/24.

BODY SHAPE AND BENEFIT: Hourglass, triangle, oval, inverted triangle, and rectangle shapes can all reap the benefits from the full-body shaper because it controls and contours the entire upper body. The level of control you choose depends on your needs.

Control Full Slip

WHAT IT IS: This slip, made of tightly woven, stretch microfiber, and with a built-in bra, has elastane strips sewn on its underside at mid-thigh or into the hemline at the knee to prevent it from shifting position or riding up under skirts and dresses.

WHAT IT DOES: A control slip flattens the stomach and provides back smoothing and waist nipping. This slip also makes the hips and derriere appear firmer.

STYLE OPTIONS: The control full slip is available in mid-thigh or knee lengths and in several styles: open-bust; seamless, with soft flexible cups; with an underwire bra; and with detachable straps. The open-bust control slip offers greater flexibility in terms of the neckline options for the outer garment and allows you to wear different bra styles to accommodate your wardrobe.

HOW TO WEAR IT: There is only one reason not to own a control full slip: you don't wear dresses or skirts. It works well under fitted shifts, wrap and cocktail dresses, dresses with a defined waist, skirts, and blouses.

HOW TO BUY IT: Brands size undergarments differently. To ensure a good fit, have your bust, waist, and hip measurements handy and know your dress size. Slip size is closely related to dress size, and online sellers frequently use these measurements to help buyers make a selection. When shopping in a store, take the time to try on slips. If the size is correct, the fit will be smooth all around, and the straps will lay softly across your shoulders, not dig into your skin.

BODY SHAPE AND BENEFIT: All body shapes will benefit from the way in which the control full slip contours the entire upper body.

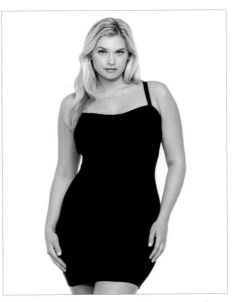

A control full slip will give you perfect support and a sleek look in your most fitted dresses. And all the seaming and contouring will also give you an extra bit of sexy sass.

DO YOU SPEAK SHAPEWEAR?: TERMS TO KNOW

COMPRESSION AND SUPPORT
The terms compression and support are often used to describe shapewear. The difference between the two is the level of pressure built into the garment. Compression garments contain a higher level of pressure and therefore have stronger holding power. They are also engineered to provide uniform pressure, while support garments generally apply pressure to a single area.

CONTROL
All shapewear does not offer the same level of control. The full-body shaper, for example, maintains consistency in all-over shaping but provides different levels of holding power based on the control level you choose. The most beneficial levels, for a seamless appearance, are moderate, firm, and extra-firm. Moderate is generally the control level of choice for everyday wear; for formal wear and tighter-fitting garments, you may want firm or extra-firm, depending on the garment and your comfort level.

ELASTANE, LYCRA, AND SPANDEX
Elastane, Lycra, and spandex are synthetic fibers known for their exceptional elasticity. These primary fibers are infused into nylon and cotton to make shapewear, and enable these undergarments to cling to the body comfortably. Another benefit of these fibers is the durability they lend to garments, which is essential to endure pulling and tugging.

Elastane is characterized by its ability to revert to its original shape after stretching. Spandex, also known by the brand name Lycra, has exceptional elasticity as well, and is stronger and more durable than natural rubber. Both fibers are blended into other woven and natural fabrics to make them stretchable, able to dry quickly, and less likely to wrinkle. There are also a few new spandex cousins on the market. One is called Lycra Xtra Life.

In an effort to invent the newest and best "weapons of mass reduction" companies are employing various infusion techniques for their designs. Thus, each one of the shapewear giants are using different amounts of fiber in garments, and the variety of who uses what and how much is large. Additionally, manufacturers use strategic engineering techniques to ensure maximum compression. The amount of spandex in shapewear garments varies from brand to brand and can range from 7 to 23 percent. The higher the spandex percentage, the greater the contouring, support, and smoothing capability of the garment.

NONBINDING
Nonbinding is a manufacturing technique used to create waistlines and leg openings of shapewear garments without bands; this method of construction prevents rolling at the waist, knees, and thighs.

CONTROL LEVEL AND EFFECT

- **Lightweight:** Smoothes lines and is not very tight
- **Moderate:** Flattens protruding areas, covers unsightly lines, and provides more compression
- **Firm:** Comfortably smoothes curves and minimizes sagging
- **Extra-firm:** Provides the highest level of holding and shaping

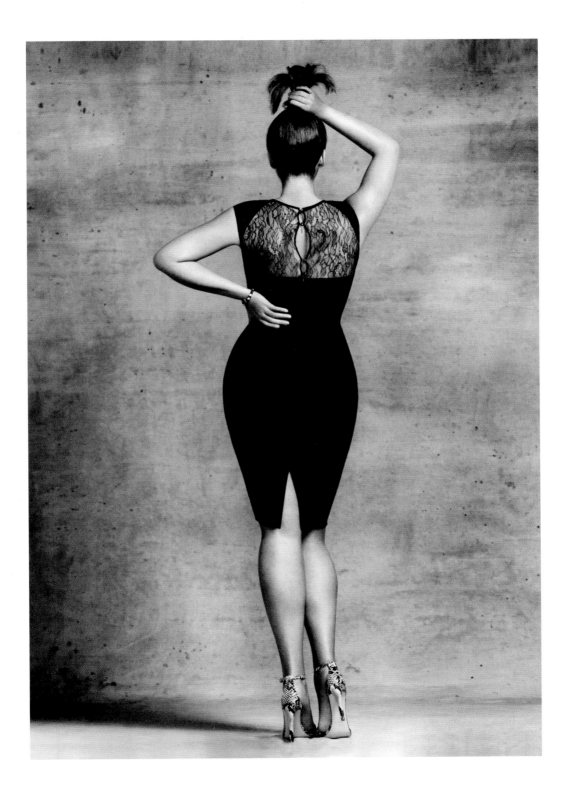

Upper-Body Shapewear

My years of dressing curves confirms that the upper body is, in most cases, the greatest area of concern. While this may hold some importance for the hourglass, oval, triangle, and rectangle body shapes, it is especially true for the inverted triangle body shape.

Whether sitting or standing it is important to have smooth, clean lines. Here is a list of upper-body shapewear that provides smoothing and a polished look.

Body Briefer

WHAT IT IS: The body briefer is a very fitted one-piece bodysuit with a bra. It is made of nylon, cotton, or lace and strengthened by Lycra.

WHAT IT DOES: This garment provides 360 degrees of control while smoothing, firming, and contouring the body from bust to buttocks. It enhances the shape of the breasts, contours the waist, flattens the stomach, and renders major back support. Body briefers are designed with a built-in underwire bra, adjustable straps, and strategic vertical seaming that starts right beneath the bustline to deliver additional contouring throughout the body. This garment is one of the best for a fuller figure.

STYLE OPTIONS: These gems are available in strapless, wireless, open-bust, full-bottom, and thong-bottom styles.

HOW TO WEAR IT: Body briefers work well with dresses, particularly those that call for a defined waistline, suits, and pants. If you own a lot of body-conscious knitwear and lightweight skirts and dresses, consider a thong-bottom body briefer to avoid a panty line. Wear a strapless body briefer if this is your go-to evening wear silhouette. If you favor revealing necklines or have special needs regarding the type of bra you must wear, choose the open-bust style.

HOW TO BUY IT: Buy a body briefer in the same size as your bra. If your bra cup is larger than a D, purchase a briefer with wide straps for better bust support and comfort. For ultimate tummy control, buy a body briefer with double compression front panels, and for everyday use, a model with straps, an underwire bra, and a full bottom. When purchasing an open-bust version, know your true measurements: bust size to ensure a good fit across the back; waist and hip measurements for proper fit in those areas; and dress size because some brands use it as an extra size reference.

BODY SHAPE AND BENEFIT: All body shapes can benefit from a body briefer; it controls and contours the entire upper body.

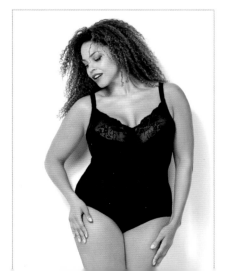

The body briefer is a great alternative to a full body shaper and accommodates hosiery easily.

Control Tank Top

The control tank top, worn under fitted knit tops, button-down shirts, and T-shirts contours and maximizes upper body support.

WHAT IT IS: This is a fitted top made of a combination of cotton/Lycra and nylon/elastane. It is the Lycra and elastane infusion that gives the control tank top its firming support power.

WHAT IT DOES: A control tank top works wonders for the entire upper body. It provides bust shaping, back smoothing, muffin-top elimination, waist contouring, and tummy flattening. The tank top also provides back support. If you have an issue with bulging in the front and back of your underarms, control tank tops will quickly smooth that out. Some styles offer the bonus of strategic double seaming in the front and back, which gives the midsection and bust more definition.

STYLE OPTIONS: Control tank tops are sold in a variety of strap widths, and some are adjustable. Control tank tops with strategic seaming for extra upper-body contouring are also available.

HOW TO WEAR IT: Wear control tank tops under T-shirts, tailored button-down blouses, and cardigans. The fabric may seem strong enough for you to wear this top without a bra, but I don't recommend it. If you have large breasts, opt for a wider strap for more support and wear a seamless bra under the tank top for maximum support. If low-cut tops are a favorite, choose a control tank with a V-neck or slightly scooped neckline.

HOW TO BUY IT: Look for control tank tops that are made of lightweight compression fabrics, as these have holding power. If a tank is made of cotton or nylon, you want an infusion of strong fibers such as Lycra, spandex, and elastane blended in to give significant shaping and support. You may be tempted to purchase control tank tops in vibrant colors or pastels, but before you play with color, make sure you own at least two of the three basics: black, white, and skin tone.

BODY SHAPE AND BENEFIT: Oval, inverted triangle, and rectangle body shapes benefit most from this back-smoothing, tummy-flattening, and waist-contouring garment.

LOWER–BODY SHAPEWEAR

The beauty of lower-body shapewear is that it is designed to sculpt, tone, and lift everything from the waist down. Here is a list of shapewear garments that target specific issues to help you look your absolute best in skirts, dresses, jeans, and trousers. Triangle, hourglass, and oval body shapes should give this section their full attention.

Control and High–Waist Briefs

WHAT THEY ARE: The control brief is also known as a panty girdle. The better brands are made of 80 percent nylon and 20 percent elastane, which makes the garment very supportive with regard to strength, stretch, and recovery to its original state.

WHAT THEY DO: Vertical double seaming in the front flattens the stomach; in the back, it lifts the derriere. Curved side seams help hips maintain a natural shape. The control brief reaches your natural waist and provides lower tummy, hip, and buttocks control.

STYLE OPTIONS: There are two—one that comes up to the natural waist and one in a high-waist style that reaches the under bust. High-waist briefs are comfortable, made with the same fabric, seaming, and panels as regular briefs, and provide the same control, plus a more contoured waist. It also provides lower-back support.

HOW TO WEAR THEM: A control brief is a great undergarment for knits, skirts, and trousers. A high-waist style is a good choice to wear under high-waist pants and skirts or any garment that is fitted in the torso, such as a fit-and-flare dress.

HOW TO BUY THEM: Take your hip, natural waist, high-waist, and under-bust measurements with you when purchasing control and high-waist briefs. Packaging frequently uses these measurements to help you determine the proper size. Read the label for control levels, which range from light to extra-firm. If you're new to buying shapewear, try on different control levels to determine which offers you the best control and comfort.

BODY SHAPE AND BENEFIT: Every shape can win with control briefs. For the hourglass and triangle body shapes, briefs provide smoothing and tummy control, while women who are ovals, inverted triangles, or rectangles benefit from a little waist contouring, although these three body shapes need to make sure to purchase the garment at a waist length that is high and fitted enough to do the job and not roll down.

OPPOSITE: Control and high-waist briefs, which can be worn under trousers, skirts, and dresses, are comfortable and provide waist, tummy, and derriere control.

Control biker shorts (this page) work under trousers as well as fitted dresses and skirts to give thighs a smoother, more streamlined appearance, while the control shaping capri, similar to leggings, provides extra smoothing under leather pants (opposite), fitted jeans, and trousers.

Control Biker Shorts

WHAT THEY ARE: These shorts have nonbinding (no-band) leg openings, which prevent the appearance of visible lines across the thighs. They are available in nylon and cotton with the infusion of spandex.

WHAT THEY DO: Control biker shorts provide shaping and smoothing for the stomach, derriere, hips, and thighs. These shorts are also the perfect solution to the chafing caused by the inner thighs rubbing together. A bonus of control biker shorts is they provide great lower back support.

STYLE OPTIONS: The shorts are available in two lengths: mid-thigh and right above the knee. Biker shorts, like control briefs, can be purchased with an extended waist if lower- to mid-back smoothing is needed.

HOW TO WEAR THEM: Wear control biker shorts with pants, capris, skirts, and dresses. When wearing this shapewear with skirts and dresses, be sure to check the length of your outer garment to avoid undergarment exposure.

HOW TO BUY THEM: Have your waist and hip measurements handy to determine what size you need in a control biker short.

BODY SHAPE AND BENEFIT: Every shape can benefit from these shorts in the desired compression for hips and thighs, but the triangle body shape may get the most benefit from this item if purchased with medium compression to provide more balance with the upper body.

Control Shaping Capri

WHAT IT IS: A control shaping capri, looks just like capri leggings. The difference is that the shaping capri is engineered to control curves from the waist to the knees. The capri is made of power mesh and nylon or a cotton and Lycra blend.

WHAT IT DOES: The control shaping capri makes the entire lower half of the body appear firmer and shapelier. It conceals cellulite and annihilates muffin top. The strategic panels flatten the stomach and contour the waist. The capri also contours the hips and thighs and gives a significant lift to the derriere.

STYLE OPTIONS: This garment is also available with a high waist. Some capri shapers are designed with sheer nylon legs so they can be worn with more fitted and light-colored garments.

HOW TO WEAR IT: Wear this shaper with midi- and maxi-length skirts and dresses, slim-cut pants, and skinny jeans.

HOW TO BUY IT: When purchasing a control shaping capri, have your waist and hip measurements handy, as sizing is usually based on them. Choose capris with strategic shaping: sculpting thigh panels, hip seaming, and tummy control panels.

BODY SHAPE AND BENEFIT: Every shape can benefit from the control shaping capri, although the triangle body shape may get the most from it if purchased with medium compression for more balance with the upper body.

Shaping Hosiery

WHAT IT IS: Shaping hosiery includes sheer panty hose, fishnets, and opaque tights infused with Lycra. The bandeau (the wide strip sewn below the waist of panty hose to lend extra support and flatten the belly) in shaping hosiery is invisible, a plus for a seamless appearance.

WHAT IT DOES: It provides control and smoothes the buttocks, hips, and the full leg.

STYLE OPTIONS: It is available footless, with a high waist, and with nonbinding (no-band) waistbands that prevent the top of the hosiery from rolling down or digging into the skin.

HOW TO WEAR IT: Shaping hosiery can be worn under everything, even with shorts.

HOW TO BUY IT: When shopping for hosiery, make sure you know your exact height and weight, as sizes are listed on the packages by letters that correspond with these measurements.

BODY SHAPE AND BENEFIT: This is every shape's friend for support and shaping from the waist down.

You've got to have style: It helps you get down the stairs. It helps you get up in the morning. It's a way of life.

—Diana Vreeland, *Rolling Stone*, August 11, 1977

LAYERING SHAPEWEAR
When One Garment Is Not Enough!

Remaining seamless is cloaked in the art of layering. When vocalist Adele discussed the 2012 Grammy Awards during a *Today* interview, she admitted, "I had three or four pairs of Spanx on that night."

Who would have known?

No one. The secret to layering success is making sure each of your garments fit properly. If any piece of your shapewear is too tight, you will not achieve the desired effect. Some items are tricky to get into. See "Tips for Putting on Shapewear," page 51.

Here are a few of my favorite tried-and-true layering combinations. They really work!

Two pieces of advice: 1) Be mindful: if shapewear is too tight you will create bulges and rolls and ruin your look; and 2) Remember: when layering, less is more. Generally two layers are enough.

Adele in Armani Privé on the red carpet at the 2012 Grammy Awards.

FIRST GARMENT	SECOND GARMENT	RESULT	WORKS WELL UNDERNEATH
High-waist control thong	High-waist shaping hosiery	Shapes and smoothes the waist, buttocks, and thighs	Skirts, dresses, wide-leg pants, tailored trousers
Body briefer	Soft-cup seamless control slip	All-over contouring and smoothing	Dresses, gowns, and skirts
Control briefs	High-waist control biker shorts or high-waist capri shaper	Extra control in the waist, tummy, and thighs; conceals panty lines	Maxi dresses and skirts, midi skirts, gowns, and pants

ADDING TO YOUR SHAPEWEAR ARSENAL

Once you've built a collection of shapewear essentials, it's easy to add pieces to pair and layer for even greater support and control. For tips, see "Layering Shapewear" on page 65.

Torsette

WHAT IT IS: A torsette is a control tank top with an open bust.

WHAT IT DOES: It defines the waist, flattens the stomach, and controls natural back fat and spillage that can occur above the bra band. A great benefit of the torsette is that it allows you to wear the bra of your choice underneath, an especially significant plus if you have very large breasts.

STYLE OPTIONS: Torsettes are available with front closures or as pullovers. Some styles include firming tummy control panels, curved side seams for contouring, and built-in side panels that offer additional bust support. Styles with extra-wide shoulder straps are available too.

HOW TO WEAR IT: Torsettes work well with any dress or blouse with a V-neck or a

A torsette is a great choice for wearing with a garment with a revealing neckline or unusual shoulder cut, as it enables you wear the appropriate bra and gives you waist support at the same time.

revealing neckline as well as with fitted silhouettes.

HOW TO BUY IT: Look for a torsette made of a lightweight to moderate compression fabric. If a torsette is made of cotton or nylon, choose one with an infusion of strong fibers such as Lycra, spandex, or elastane to provide significant shaping and support.

BODY SHAPE AND BENEFIT: For oval, rectangle, and inverted triangle body shapes, this is great for torso shaping, back smoothing, tummy control, and additional bust support if needed.

High-Waist Control Thong

WHAT IT IS: A high-waist control thong is a brief that covers the stomach, waist, and lower back, but leaves the buttocks exposed.

WHAT IT DOES: It offers waistline, stomach, and lower-back control while eliminating panty lines. The close-fitting high waist helps keep the thong in place.

STYLE OPTIONS: This garment is available in a style that sits about an inch or two above the waist and one that reaches the under bust. High-waist control thongs are available in various levels of control. Firm or extra-firm are the best options for torso control and for holding the thong in place.

HOW TO WEAR IT: A high-waist control thong is the perfect undergarment to wear with most fitted dresses, gowns, skirts, and trousers. Wear shaping hosiery over the thong for buttock support.

The high-waist control thong is perfect for wearing underneath fitted skirts, pants, or dresses. If a thong makes you feel too exposed, you can add a layer of high-waist hosiery, which will also help smoothe out your derriere.

HOW TO BUY IT: Look for a thong with seamless construction to prevent lines on outer garments, and a 20 percent elastane content to provide good support.

BODY SHAPE AND BENEFIT: Every shape can benefit from this garment. If you need additional buttock support, layer the thong with light compression hosiery for added control.

Waist Cincher

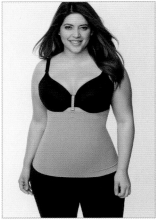

The waist cincher provides a perfectly controlled contour under dresses and suits.

WHAT IT IS: The waist cincher, also called a waist nipper, is a comfortable, modern-day answer to the corset. It's made with flexible spiral boning; light, breathable fabrics; and flat panels.

WHAT IT DOES: It accentuates a natural hourglass silhouette or nips and contours the waist to create one.

STYLE OPTIONS: Waist cinchers are available in three lengths: under bust to lower waist, under bust to high hip, and natural waist to high hip. The cincher that covers the under bust to the lower waist is the best choice if you are short-waisted. The full-torso length, which is from the under bust to the high hip, is for a woman who is long-waisted and wants total torso shaping. Last, the cincher that covers the area from the natural waist to the high hip is a zone-targeting garment for those who need a bit more smoothing in that area.

HOW TO WEAR IT: A waist cincher can be worn under a blouse, dress, gown, or suit. It can make a fashion statement when worn on the outside as an accessory: a beautifully structured black cincher over a tailored white shirt with black tuxedo pants is a great look.

HOW TO BUY IT: Vertical measuring is key when purchasing a waist cincher to ensure its proper length regardless of the style you choose (see page 44). A waist cincher can be uncomfortable if it is either too long or too short. When shopping for one, avoid embossed patterns, embellishments, or visible hook-and-eye closures to prevent imprints on your outer garments.

BODY SHAPE AND BENEFIT: This garment is great for the rectangle shape because it contours the waist. Oval shapes benefit most from buying a vest-style waist cincher, with a high back for extra smoothing, shaping, and control. The waist cincher also works well for inverted triangles, but it shouldn't be worn too tightly or it can make this body shape appear larger across the bust, back, and shoulders.

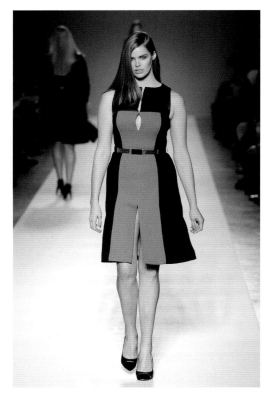

Control Half-Slip

WHAT IT IS: The control half-slip is a lower body shapewear garment that covers you from your natural waist to your mid-thigh or your knees.

WHAT IT DOES: It provides the lower body with a firm, seamless look by controlling the stomach, buttocks, and saddlebags. The control half-slip has horizontal seams under the derriere that provide a very visible lift. It is a great option if back smoothing or upper torso shaping is not a concern. Silicone grippers at the hemline prevent the slip from riding up under dresses and skirts.

STYLE OPTIONS: Control half-slip options include a built-in panty and firming panels for full tummy control. Like much of today's shapewear, the control half-slip is also designed with an extended waist.

HOW TO WEAR IT: This is a very comfortable shaping garment to wear under all skirts and dresses.

HOW TO BUY IT: For accurate sizing, you must know your waist and hip measurements.

BODY SHAPE AND BENEFIT: This slip benefits all shapes for tummy, waist, buttock, and thigh control and shaping.

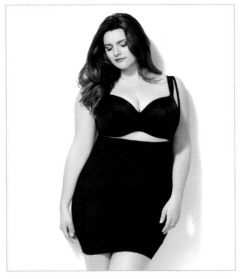

Sometimes a full control slip feels like just too much. For a dress that is looser on top but fitted at the waist, the control half slip is the best shapewear choice.

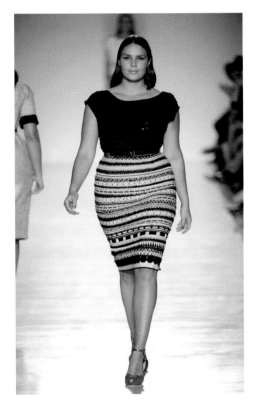

> Your clothes look better—that's the whole point. And you look more confident.
>
> —TIM GUNN ON WEARING SHAPEWEAR, *HUFFPOST LIVE*, FEBRUARY 23, 2013

Upper-Arm Shaper

WHAT IT IS: This is a compression sleeve that fits securely over the arms. The arm shaper is available in cotton, lace, and mesh strengthened with Lycra.

WHAT IT DOES: This is the solution to lack of firmness in the upper arm—and it really works! This shaper provides upper arms with a smooth and firm appearance.

STYLE OPTIONS: Upper-arm shapers are available in two styles. One is similar to a shrug; the sleeves are attached to a panel that sits across the upper back and shoulders. There are also individual shapers that slip onto the arm. Although they are called upper-arm shapers, they are available with full, three-quarter, and elbow-length sleeves.

HOW TO WEAR IT: Wear upper-arm shapers with fitted and sheer sleeves, or tailored jackets.

HOW TO BUY IT: Have someone take your upper back measurement, from shoulder to shoulder. Jot down this number, along with the measurement of the circumference of your upper arm. Keep these measurements handy when you shop.

BODY SHAPE AND BENEFIT: Doesn't apply.

───────

Breathe easy. Your knowledge about accentuating, smoothing, and controlling your curves just got a major boost. Let's move on to bras and what they can do for your confidence and fashion presentation.

SHAPEWEAR DOS AND DON'TS: A Cheat Sheet

DO . . .

- Decide how much control you need. All shapewear is made with different levels of control, so read the labels carefully.

- Be clear on what your figure concerns are to select the right shapers for those areas.

- Follow the care instructions. Washing and drying shapewear at high heat breaks down its fibers and destroys the fit. It's best to hand-wash shapewear and let it air dry.

DON'T . . .

- Buy shapewear that is too small or too large. Shapewear should be comfortably snug. If it is too small, it will be uncomfortable, create lines and bulges, and possibly interfere with your circulation. If it's too large, it will not provide support, will shift on your body, and bunch up under outer garments.

- Rely on photos on packaging or in advertising, as they're sometimes retouched or shot from deceiving angles. More important, the model may not have your body shape or be your size. Use your true measurements and try on the garment to ensure a proper fit and effect.

- Be intimidated by extensive seaming; it is not an indication of discomfort. Strategically placed in garments to create and enhance shape and to provide support, seams are a girl's best friend.

OPPOSITE: The upper arm shaper does exactly what its name implies. It's a good option under fitted tops and dresses like the classic black turtleneck dress on the opposite page.

3

Bras

THE MIRACLE WORKERS

My God, I want to speak of noble things and here I am telling stories about bras.

—Albert Cohen, *Belle du Seigneur*, 1968

THE MAJORITY OF WOMEN WORLDWIDE ARE WEARING THE WRONG SIZE BRA—and they don't know it. Various studies have confirmed that most women are wearing bras with cups that are too small, bands that are too large, or both.

Wearing a proper-fitting bra is vital. While shapewear of all sorts can help to achieve a cleaner, smoother silhouette, a bra is the most important undergarment of all. Not only will a bra that fits poorly or is inappropriate under a garment ruin a fashion look completely, but it adds years to your appearance. It can also contribute to a multitude of physical problems: back, shoulder, and breast pain; rashes and abrasions; bruised shoulders; and bad posture. A quality bra in the right size contributes to clean lines and a polished appearance, and makes the difference between woeful and wow!

Bras do not have the same relationship with body shape as shapewear does, simply because there is not a direct correlation between body shape and the size and shape of a woman's breasts. Bras that help both lift and minimize may be good for some women with inverted triangle, oval, and rectangle shapes, for example, because there is a tendency for these body types to have a fuller bust, but this is not always the case. Ultimately, your bra choices will be based on breast size and the garments you wear.

Many times I've had to tell a client that she's wearing the wrong size bra—information that's not always easy to receive. I once had a client, a well-known actress—I'll call her Ellen. Ellen was tenaciously attached to a particular brand and unshakably convinced that she was a particular size; she was also wholly convinced that her bra straps needed no adjustment. This was a huge problem for me as her stylist, as no matter how glamorously I dressed and accessorized her, the outfit always looked less than perfect due to her bra.

After watching several beautiful ensembles destroyed by an ill-fitting bra, I planned an intervention. I invited her to lunch and a visit to one of my favorite exclusive boutiques. Luck was on my side. She agreed and never asked what kind of boutique we were going to—and I didn't tell her. My goal was to put her in the hands of one of my most trusted fitters and let her see the results for herself in a three-way mirror. The consultation consisted of the usual questions, the taking of measurements, and an explanation of why it might be time for Ellen to try something new. Then the fitter asked her to take a 360-degree look at herself in the mirror while wearing her current bra. She didn't tell Ellen why, but I knew: she wanted her to see that a difference was about to be made. To make Ellen feel like part of the process rather than someone being handled, I then asked her to choose a few bras in her new size.

When she turned to face the mirror after putting on one of the new bras she exclaimed, "I look like I've had a boob job!" We all laughed. My styling mission was accomplished, and Ellen strutted out of the store with ten new bras, all in the right size.

OPPOSITE: Candice Huffine, photographed by Joshua Jordan for her Elena Mirò capsule collection, #LovedByCandice, 2015.

Ellen's problem is a very common one, particularly among women with large breasts. During this fitting, I discovered she wasn't so much attached to the brand of bra but to the size she wore in that brand. She feared that changing brands would increase the size she needed, and that made her very uncomfortable. Put simply, she did not want to wear a larger size bra. But I'm telling you, just as I told her, the most important thing about a bra is the fit—and the size is no one's business but your own. Your bra size is a secret between you and your fitter, and there's no shame in it!

Preparing to Bra Shop

Unlike their predecessors, which were mere pieces of cloth designed primarily to cover the breasts, contemporary bras are technologically designed undergarments that play the ultimate supportive role in personal presentation, and that support is built into the cups, straps, and bands.

Today much of the technology applied to shapewear has also been applied to bras. This crucial undergarment is available in luxe, breathable fabrics, with moisture-wicking properties and cushioned straps. Brands are offering fashion-forward designs, even strapless—to lift and hold a more ample bosom comfortably. In fact, the fastest-growing segment in the bra market today is size DD and up. And unlike in days gone by, when the best a woman with large breasts could hope for was a bra that looked like her grandmother's, today's bras are fantastic.

Next to jeans, a perfect-fitting bra may be the most challenging item to purchase for all women. For curvy women, the task can be even greater, but there are solutions. Purchasing a bra does not have to be daunting, and building a bra collection that supports your daily wardrobe is achievable.

Before you start shopping for bras, you need to do the following: examine how your bras fit; measure yourself or get a professional fitting to determine your true bra size; know what bras you need; and do research to find out what's available and what's selling well among women who share your breast size.

EXAMINE HOW YOUR BRAS FIT

To determine whether your bra fits you properly, try on the two bras you wear most often, then stand in front of a mirror. Check the straps, cups, and band of each for one or more of the following issues, any of which indicates that it doesn't fit properly:

- The straps dig into your shoulders.
- Your breasts spill out of the sides of the bra.
- Your breasts point downward.
- Your breasts flow over the front of the cups.
- The bra band feels really tight or is too loose, constantly rising up your back.

Additionally,

- Try on a loose-fitting top with each bra to see if the front of your breasts are creating an imprint on the garment; if they are, the bra is too small.
- Do you appear to have one large shelf of breast rather than two separate ones? The latter is what I call the "uniboob," the frequent outcome of a poorly fitting bra that pushes the breasts very close together rather than separates them.

If any of these applies to you, you are wearing the wrong size bra and you need to replace it immediately.

GET MEASURED

Taking your measurements or having a professional bra fitting is the next and most important move. If you decide to measure yourself, here's how to do it in seven easy steps.

1. Get a pliable, seventy-two-inch-long measuring tape, preferably made of cloth.

2. Stand in front of a mirror that allows you to see your entire upper torso.

3. Put on an underwire or wire-free bra without padding. The fit should be snug, not tight.

4. Make sure your breasts are not sagging. If they are, adjust the straps.

5. Measure your band size first. Place the tape against the front of the bra band, directly under your bust and across the very top of your rib cage. When the tape is around your back it should lay evenly across the bottom of the bra clasp. Be sure to keep the measuring tape level as you bring it around to meet the other end of the tape measure. This measurement is the circumference of your torso. Write the number down. If it's an odd number, round up to the next even number as your band size. For example, if the measurement

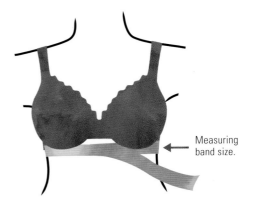

Measuring band size.

is 35 inches, your band size is 36. If the measurement is an even number, then that number is your band size.

6. Measure your bust. This step is a bit more involved and needs to be followed carefully. It's best to take this measurement when you feel very true to size, that is, not bloated or premenstrual. First, standing erect in front of a mirror, place the tape at nipple level (the fullest part of the bust), and bring it around your back. Make sure the tape remains level all the way around. Hold the tape gently, allowing a little bit of slack. Be careful not to hold it too loosely or pull it too tight. Where the tape meets at the front is your bust measurement.

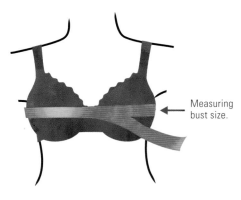

Measuring bust size.

7. Do the math. Subtract your band measurement from your bust measurement. The difference is used to determine your cup size. Here's how it works. If you measure a thirty-four-inch band size and a thirty-six-inch bust size, the difference is two inches. A one-inch difference indicates you are an A cup; a two-inch difference, a B cup; a three-inch difference, a C cup; a four-inch difference, a D cup; a five-inch difference, a DD cup: and a six-inch difference, a DDD cup. Use this pattern of one-inch increments to determine your cup size.

If you don't want or feel confident enough to measure yourself, consult a professional. Many lingerie boutiques or lingerie sections in department stores offer bra measurement as a free service—and many women find it invaluable. Inquire at your favorite shopping spots or do a quick online search to find stores that provide this service. It may seem time-consuming, but if there were ever a time to invest in yourself it's now—and not only that, the entire measuring and fitting process should take only about fifteen minutes.

Wear or bring along a fitted shirt so that you can see the true fit of the bras and how they affect the look and fit of your clothing. If you have T-shirts that you wear often or a dress or top that has an odd neckline or silhouette detail, such as a racer back or a cold shoulder, bring those as well. Finally, professionals know most women are a little nervous when they come in for a bra fitting, so they put forth a great effort to make it a pleasurable experience.

Cup Size Conversion Chart

IF BAND MINUS BUST IS…	USA	UK	AUS/ NZ	EUROPE/ FRANCE
Less than 1"	AA	AA	AA	AA
1"	A	A	A	A
2"	B	B	B	B
3"	C	C	C	C
4"	D	D	D	D
5"	DD or E	DD	DD	E
6"	DDD or F	E	E	F
7"	G	F	F	G
8"	H	FF	G	H
9"	HH	G	H	J
10"	J	GG	J	K

Here's what to expect:

- The fitter will ask what size you currently wear, the style you are looking for, and the brands you like. She will escort you to a private or semiprivate dressing room, where you will remove your outer garments.

- She will take your measurements in the same room.

- She may measure you twice, once with your old bra, and again with a bra that fits you better.

Once you have a bra that fits, put on the top you wore to the store or the one you brought with you so you can see the improved fit.

DETERMINE WHAT YOU NEED

Realistically, you need a basic collection of bras for everyday wear, at least a week's supply—that's a bra for every day, not a bra for every week, because bras need twenty-four hours after wearing them to regain their supportive shape. Like shapewear, it's important to begin with the essentials; you can always add to your collection later (see "Six Essential Bras for Every Woman" and "Adding to Your Bra Collection" on pages 83–89 and 90–92).

The first step is to evaluate the condition of your bra collection and throw out those items that are in poor condition. Take out all the bras in your collection and lay them out so you can see them easily.

- Check the elasticity of the straps and bands. Bras with frayed straps and bands that have lost their elasticity will no longer support your breasts and should be tossed.

- Check the firmness and shape of the cups. If cups have become shapeless, are coming apart at the seams, or have molding that is lumpy, the bra will also not provide proper support and should be removed from your collection.

- Make sure the underwire is not bent or missing. If either is true, the bra needs to go.

- Examine each bra for fraying, holes, and tears—and if you find them, throw out the bra.

Once you've thrown away the bras that are in poor condition, you'll need to evaluate your needs based on the silhouettes and necklines you wear most often. Separate your good bras by style: padded, underwire, strapless, and so on—and lay them out on the bed.

Next, take inventory of your wardrobe, noting the necklines, shoulder cuts, and silhouettes you wear most often, sorting the garments in the following order.

- **NECKLINES**: If you frequently wear T-shirts, blouses, dresses, and jackets with low necklines you will need a seamless bra with a plunging neckline and a full-coverage seamless bra with a deep V.

- **PLUNGING NECKLINES**: For deep front- or back-plunging necklines, there are specially designed bras, including long-line strapless styles, to wear under such tops and dresses. Because these are not everyday bras, look for this undergarment

at specialty boutiques to increase your chances of finding a wider range of options. Bring the garment you need the bra for with you to make sure the bra fits properly and remains hidden under the garment.

- **SHOULDER CUTS**: Racer back, halter, and cold-shoulder tops don't seem to be going anywhere anytime soon. If you wear these shoulder cuts or would like to try them, all you need is a convertible or strapless bra. If you have large breasts and are not yet comfortable with the idea of wearing a strapless bra, the convertible bra is for you. The straps can be attached to the bra to mimic the silhouette of the top and stay hidden.

- **SILHOUETTES**: Line up the clothing in your closet to get a visual representation of what you own in abundance. Make sure to do this with all clothing under which you will wear a bra, but more specifically: blouses, T-shirts, sweaters, dresses, and jackets. Follow the same procedure for your special-occasion and workout clothing too. The silhouettes and primary fabrics in your wardrobe are important to consider: if you wear a lot of fitted silhouettes or tops made in thin, sheer, and even slightly sheer fabrics, invest in more than one style of seamless bra and steer clear of heavily textured and patterned bras as they will disrupt the smooth fit of the outer garment. Reserve the beautiful array of colored and textured bras for wear with darker clothing and those made of thicker fabrics.

FROM LEFT TO RIGHT: Models Justine LeGault, Marquita Pringe, Ashley Graham, Candice Huffine, Elly Mayday, and Precious Lee, photographed by Cass Bird for Lane Bryant's stunning "I'm No Angel" campaign, 2014.

I think it is what is worn underneath
that really inspires a woman to feel beautiful
in her clothes—that inner secret glamour.

—Alice Temperley, Marieclaire.co.uk, September 25, 2013

Elizabeth Taylor and Richard Burton at the Academy Awards, 1970. Here's a perfect example of a bra doing its job: yes, Elizabeth Taylor's dress is exquisite, but what makes it so memorable is how the actress looks in it, her bosom supported beautifully.

- **SPECIAL-OCCASION BRAS**: If you have a very active social life that requires you to wear cocktail dresses and gowns, invest in a strapless or convertible bra to accommodate the shoulder treatments of evening wear. You can also benefit from a corset, a long-line bra, or a push-up bra for dresses with cleavage exposure or that require extra waist cinching and smoothing.

- **ATHLETIC BRAS**: If you work out regularly and wear a variety of tops, put one or two good sports bras on your priority list. Choose one with regular straps and one with convertible straps to accommodate racer back and halter designs.

Evaluate your list of needs against what you currently own, and write down the styles you need.

DO RESEARCH

As with buying shapewear, there's nothing like good honest conversation about bras with other women of your build, from problems they have with fit to brands they believe really support their curves. Ask them about a favorite boutique, department store, or e-tailer that caters to their needs well.

You will save a lot of time and money if you do legwork before you head off to the larger stores. First, call customer service to find out what brands and sizes they carry. If you want a professional fitting, ask if they provide this service. Read online reviews about customer service to determine if the store is plus-friendly. Review the store's Web site to learn about return policies.

If you'd like to shop online, it's easy enough to do a search to find an e-tailer that specializes in plus sizes. The key is to read product reviews thoroughly and focus on those pertaining to the quality and the fit of the brands in addition to those that focus on customer service. I personally have relied on reviews and found them very helpful regarding the consumer experience with both the product and the seller. Also make sure you are clear on the site's return policy. Before buying anything online, make a list of bras to try based on your research, then go back and review those items comparatively in terms of quality and your wardrobe needs before buying anything.

Six Essential Bras for Every Woman

CURVY CONFIDENTIAL

SLEEPING IN A BRA

There's been a great deal of talk about the pros and cons of sleeping in a bra. Some experts say it's a good thing for women with cups larger than a D; others say it's not good for anyone. Studies have shown that sleeping in an underwire bra can impair the blood flow and lymphatic drainage, which leads to discomfort, chronic inflammation, and fluid retention. Then there's the issue of gravity. Some say wearing a bra to bed plays no role in offsetting it; others say it does. So the jury is still out. My advice: if you are going to sleep in a bra, avoid the possible health issues related to wearing an underwire and choose a soft-cup, wire-free bra.

Over the years, I have seen my share of both bra size and bra style mishaps, especially with large-breasted clients. One such experience occurred while I was working with an actress who had a starring role in the sequel to a popular movie. We were in the early stage of our working relationship, so it was important for her to feel confident in my skills and to look spectacular for her premiere red-carpet appearance.

I'd found for her a gorgeous, cold-shoulder cocktail dress, with ruching, which is always a curvy girl's best friend, and jeweled embellishment. We had a perfect fitting, and she was happy: afterward, we reviewed the accessories and undergarments she needed for the big night. The actress told me she owned a bra with straps she would be able to wear, assuring me I didn't need to bring an additional one for her. Normally, I do a second fitting once the alterations are completed, with all the accessories and undergarments, but this time I couldn't, as she had no room in her schedule.

On the day of the premiere, as she was getting dressed, we realized her bra straps were too wide for the dress and would be a total distraction to the entire look. She immediately panicked and announced she would not attend the premiere. That, and my disappointing a client over a bra, was not an option as I saw it. When I told her she needed to wear a strapless bra, the doubt and fear in her eyes were almost palpable. I understood, and recalled the uncertainty I felt the first time I wore a strapless bra myself, but I couldn't stay in this moment of fear with her. I thought, "Lights, cameras, and an ill-fitting bra? No way!"

Training and years of experience has taught me to overprepare, so when a client tells me she doesn't need something, I bring it anyway. I dug into my kit and as I pulled out a strapless, well-structured corset, the actress stood even more stiffly, her eyes opening even wider. This fashion emergency was about to turn into a total fashion fiasco!

After some coaxing, I finally persuaded her to give the corset a try. She was not convinced, though, until I closed

the last hook-and-eye clasp, and the dress was on. Then she relaxed and was sure of herself once again. The support of the corset showed in her confident red-carpet strut, and she had a great evening.

Many women have had bad experiences with a strapless bra, especially if they are larger than a D cup. And many women have had bad fashion experiences simply because they were unprepared. It's important to organize your undergarments so that you are always ready to get dressed. Follow my rule: be prepared. If I hadn't been, my client would have missed what turned out to be a wonderful moment for her on the red carpet—and the same thinking applies to you on the red carpet of your life! A bra in the right style that fits well is important for all women—it enables us to have great fashion moments daily.

HOW TO BUILD A BRA COLLECTION

- Buy basic colors first: black, white, and neutrals.

- Invest in these six essential bras: seamed, sports, strapless, push-up, long-line, and minimizer.

- Make sure you have bras that accommodate your lifestyle: work, formal wear, sports, and so on.

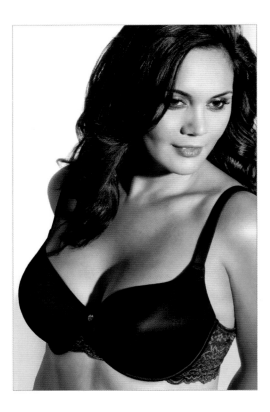

1 THE SEAMLESS BRA

The seamless bra is the most essential one in any collection. It's simple and versatile—and it is the one you will wear most.

STRUCTURE AND STYLE: The seamless bra has smooth, preformed round cups and is sold only with an underwire. These bras are available with a contoured style, which offers a bit more coverage, or with a plunging décolletage. A good option for women with a fuller bust is the seamless bra designed with elastane fabric on both sides of the cup. The fabric covering the inside of the cup is the same as that on the outside of the bra. The second lining will provide additional support, and together the lining and the cup ensure your nipples will never show through.

BENEFITS AND BEAUTY: This bra does its job without adding any fullness to the breasts, thereby creating a more natural appearance. Thanks to cutting-edge technology, seamless bras with great fit are available up to a size H cup.

BUYING IT: This bra is the workhorse of every intimates collection, and you will rely on it for its versatility. When shopping for it, bring along a favorite T-shirt and blouse to make sure it fits just right.

WEARING IT: Seamless bras look great where you want a very smooth look, such as under T-shirts, thinner and fitted tops and blouses, and lightly woven knits.

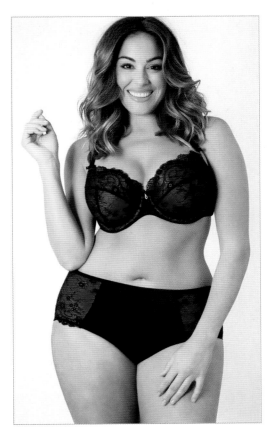

2 THE SEAMED BRA

Every woman should own a seamed bra for the lift and structure it adds to the bust line. It is a must if you wear a D cup or larger.

STRUCTURE AND STYLE: What makes a seamed bra different from a seamless bra is the strategic cup seaming, which adds more structure to the bust line. There is no pre-formed cup in a seamed bra. All the work of maximizing the lift and the shape of the breasts is steered by the seams at the side, center, and across the cups. Seamed bras are available with or without an underwire.

BENEFITS AND BEAUTY: The seaming is what makes this bra so useful, and designers have also made this detail a part of its beauty. Seamed bras do more than enhance the lift of the breasts; they also provide great support. For women with a full bust, an underwire style takes support a step further.

BUYING IT: Seamed bras are offered in a mix of mesh, lace, and stretch nylon. This blending of fabrics is lovely, but the first choice, especially when you're just beginning to build a collection or are buying a large quantity of bras at one time, is an unembellished fabric in a neutral hue.

WEARING IT: Seamed bras look terrific under a suit, and they perform beautifully under heavier garments and layers.

3 THE STRAPLESS BRA

Finding a strapless bra with perfect fit cannot be a hurried purchase, and in this case it pays to think ahead. Even if you don't think you need one, you should have one. Trust me, there will come that day when you will find you need it!

STRUCTURE AND STYLE: A strapless bra is exactly that—a bra without straps. However, clear convertible straps may be attached for wear with intricate necklines and design details. Although bra technology has come a long way, this bra can still pose a fit challenge for women with a fuller bust. If finding the right strapless bra seems elusive, a strapless corset is a great alternative.

BENEFITS AND BEAUTY: The support of a strapless bra comes from its wide bandeau, boning, strategic seaming, and underwire. Additionally, the boning in the cup shapes the breasts, while silicone strips reduce slippage.

BUYING IT: Look for a wide bandeau, underwire under the arms and in the center front, silicone strips along the inside, strategic seaming in the cups, and the ultimate support detail, boning in the cups. If the fit is good, but support is still a concern, purchase invisible convertible straps. In addition to the reinforcement, the straps also offer the option of wearing a variety of necklines and design details—cold shoulder, racer back, halter—while maintaining a refined look.

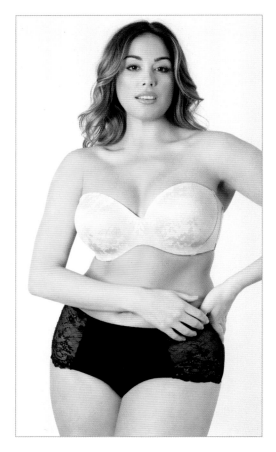

WEARING IT: Years ago the strapless bra lived solely in the domain of after-five cocktail dresses and evening gowns. Today, plus-size clothing is sexier, and much more cutting-edge, and may require a strapless bra for daytime attire as well.

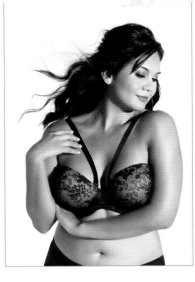

4 THE CONVERTIBLE BRA

The convertible bra makes designs with various shoulder cuts available to all women.

STRUCTURE AND STYLE: A convertible bra has detachable straps that may be configured to accommodate the design details of outer garments.

BENEFITS AND BEAUTY: An exposed bra strap is a distraction and can ruin the look of any outfit. A convertible bra solves that problem. Convertible bras with an underwire are perfect for women with a cup size of D or larger, because it provides additional support.

BUYING IT: When purchasing this bra style look for the same design qualities as a strapless bra.

WEARING IT: This is an option for strapless dresses, gowns, and tops for women with smaller breasts. If you frequently wear tops or dresses with revealing shoulder, back, and neckline details, such as halter, racer back, crisscross, and one-shoulder silhouettes, look for a bra with modifiable clear straps that can be either removed or adjusted.

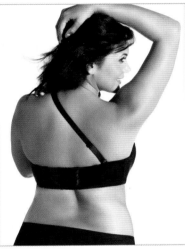

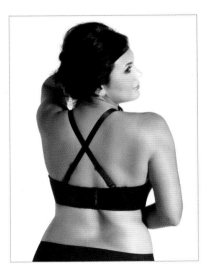

5 THE SPORTS BRA

Every woman who works out needs a sports bra for support and protection.

STRUCTURE AND STYLE: Sports bras are designed to minimize breast movement during exercise. This item is essential for all women, particularly for those who wear a D cup or larger. Designs that have compression and encapsulation—two distinct cups—are also very important for women with a fuller bust because they lessen the bounce during exercise. Encapsulation also prevents the tearing of healthy breast tissue, which is especially important if you participate in high-impact workouts.

BENEFITS AND BEAUTY: As with other bra styles, the technology behind sports bras has evolved. Some designs look like a regular bra with seaming, while others have underwire. There are styles that provide back smoothing, and those with substantial adjustable straps.

BUYING IT: When purchasing a sports bra, consider the vigor of the sports activity for which it will be used. When trying one on, make sure it provides maximum coverage. Your breasts should feel secure, but the straps should not dig into your shoulders. In fact, it's a good idea to purchase styles with wide straps for extra comfort and control. Look for the latest high-tech fabrics, such as Coolmax and Supplex, as they have moisture-wicking properties that dry five times faster than sports bras made of cotton. Quick-drying fabrics eliminate under-bust chafing.

WEARING IT: A sports bra looks well under the latest, high-tech workout tank tops, T-shirts, and jackets. It is not designed for daily wear.

6 THE MINIMIZER BRA

Buttons make a comeback when you add the minimizer bra to your arsenal. With this item, you can say good-bye to bust line gap! Because women who are inverted triangles or ovals are smaller in the lower part of their bodies, they benefit from wearing this bra as it helps to visually balance their proportions.

STRUCTURE AND STYLE: This strategically seamed bra is available in long-line and strapless styles, and in a variety of fabrics.

BENEFITS AND BEAUTY: The minimizer is the bonus bra among the essentials and designed to give the appearance of a smaller bust. It does so by reducing your breasts' projection, that is, the forward distance of your breasts from your chest wall. By shifting the breast mass toward the underarm it also changes the shape of your breasts. This is a great bra for a little reduction for those who wear a DD cup or larger. Wearing a minimizer will reduce the bust by one and a quarter inches or even more.

BUYING IT: Purchase a minimizer in the same size as other bras. Beware: a smaller size will not provide greater results, only a horrible fit. When shopping, bring a shirt or blouse that always gaps across the bust

to try on with the bra. The difference will be apparent immediately.

WEARING IT: Minimizers work especially well under button-down shirts, fitted blouses, dresses, and jackets.

Adding to Your Bra Collection

Women's wardrobes are versatile and our bra collections should keep up. Once you have all the essentials, it's a good idea to add a few more styles to the mix. Long-lines, soft cups, push-ups, and corsets all have a rightful place in a well-dressed woman's wardrobe.

THE LONG-LINE BRA

Sadly, the long-line bra is one that most women have forgotten or deem too old-school, but all women should own one, as its structure offers the benefits of both a bra and shapewear. The good news is that some of the best intimate designers are making long-line bras again, and this time in lightweight fabrics with improved seaming and more comfy straps.

Three body shapes really benefit from a long-line bra. With it, ovals appear flatter in the torso and inverted triangles appear smoother from the under bust to the high waist. The bra's contouring gives rectangles a more shapely appearance.

STRUCTURE AND STYLE: The long-line bra extends down to the waist, making it a combination of bra and shapewear.

BENEFITS AND BEAUTY: The long-line bra has always been a good choice for women who wear a D cup or larger. The extended area of this bra reduces the tummy, waist, and lower back, creating a smooth line and awe-inspiring contouring. This bra shapes the upper torso better than any other bra style and helps to eliminate stress from other areas, such as the shoulders.

BUYING IT: If you find that the band at the bottom is too tight when trying on a long-line bra, select one that is a band size, not a cup size, larger. For example, if you are a 40D, try on a 42D. A band that is too tight will create rolls at the waist.

WEARING IT: Long-line bras work well under tailored garments—and everything else. When you look at iconic fashion photos of women in the 1950s, they always looked secure, refined, and confident; yes, elegance was the look of the day, but it was the long-line bra, fashionable at the time, which created that smooth, seemingly perfect contour.

THE PUSH-UP BRA

If you need or want to create the illusion of a larger bust size and cleavage, the push-up bra can help you achieve that. You are probably wondering why I am talking about a push-up bra in a book for curvy women. It's because one of the biggest myths about curvy women is that we all have a large bust. I have had clients who wore a size 18 dress and a B cup bra. A push-up bra is perfect for those who want to balance their curves for a better-proportioned appearance.

STRUCTURE AND STYLE: Push-up bras have padding at the bottom of the cup, and some of the new designs have padding on the outside edges of the cup.

BENEFITS AND BEAUTY: The bottom of the cup lifts the breasts, and padding on the outside edges of the cup increases the cleavage. This bra raises the barometer reading of any outfit to sexy.

BUYING IT: When trying on a push-up bra, make sure your breasts are pushed upward and inward to optimize your breast size and cleavage. Nonetheless, your breasts should not spill over the cups.

WEARING IT: Push-up bras are good to wear with any tops or dresses that reveal décolletage.

THE SOFT-CUP, WIRE-FREE BRA

Experience has taught me that most women love underwire bras because they make them feel more secure, lifted, and defined. But it's also shown me that the women who don't like them, *really* don't. For the latter group, there is the wire-free bra.

STRUCTURE AND STYLE: This bra is engineered to provide full coverage and support without the underwire. Some styles have

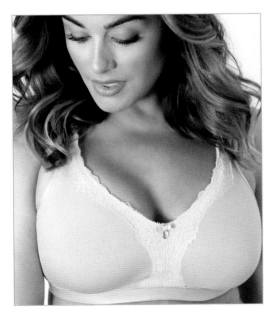

seaming for enhanced bust shape and structure. Most are designed with wide straps, and some have front hook-and-eye closures.

BENEFITS AND BEAUTY: This bra provides full breast coverage, comfort, and support. It is an essential for breast cancer survivors who love underwire bras but can no longer wear them. If you have to make a switch from a favorite bra for medical or other reasons, the soft-cup, wire-free bra still provides the same design integrity.

BUYING IT: Before buying, try it on with a few tops to be sure it's providing the desired look.

WEARING IT: This bra works well with layered looks and looser, less structured silhouettes such as blouson sweaters, swing tunics, and peasant tops.

THE CORSET

For centuries, the corset has gone in and out of vogue, but it is always welcomed upon its return. Many women fear it will be uncomfortably tight, but when worn properly, this is not the case. The corset is a very reliable bra.

STRUCTURE AND STYLE: Corsets are structured, form-fitting garments available in a variety of fabrics, and technology has also made them comfortable to wear. The corset's spiral vertical boning through the waist and cups makes it a sound and reliable foundation garment. Corsets are available with and without straps.

BENEFITS AND BEAUTY: For curvy women with really full breasts there's no better bra in terms of lift, security, and bust and torso shaping.

BUYING IT: When considering a strapless corset, look for the length specifications, as this garment varies in length. Depending on the style, it will reach from your bust to your high hip, or to the bottom of your stomach, or just below it.

A corset that fits will have a length that matches your vertical measurements, as discussed in the shapewear chapter on page 44, A corset that fits properly is not too long or too short: the bottom should sit comfortably at the high hip, located three to four inches below the waist.

WEARING IT: A corset always works well under gowns and dresses, especially for extra cinching and smoothing. To push the envelope and have a little fun with fashion, you can also wear a stylish corset under an evening suit or well-tailored, button-down blouse.

OPPOSITE: Model Inga Eiriksdottir, photographed by Joshua Jordan for *Yo Dano* magazine, January 2010.

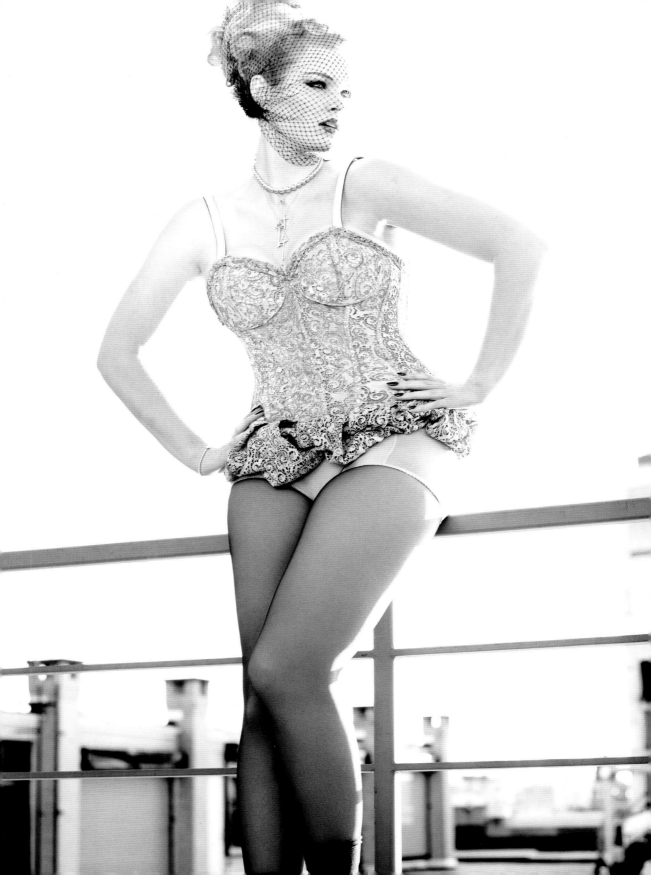

ACCESSORIES

While I am an advocate for getting just the right bra fit straight up, life isn't perfect. You may find a bra you really love, but it's not making it all the way around your rib cage, and one or two more rows of hooks could get the job done. Or maybe you have found one you can't live without but the straps are just too narrow. There's no need to let these small challenges stand between you and the style you love. There are bra accessories to get you lifted in the style you desire.

BRA EXTENDERS

Extensions are not just for your hair. Hook-and-eye extenders are designed to comfortably get you into a bra that fits everywhere except around your rib cage.

MOISTURE-WICKING BRA LINERS

These liners are great for preventing skin irritation and chafing under your breasts. The liners fit neatly under your bra and absorb all under-bust perspiration. They're great anytime and provide you with a little extra protection during a workout.

FASHION FORMS

These comfortable little pads are my personal favorites. You can attach them to your straps to prevent stress marks on your shoulders. They are invisible under clothing.

HOLEY CUPS

If you are smaller on top, want to appear fuller, with a bit more cleavage, you can use holey-cup inserts to get the desired effect. These gems create figure-flattering balance and can comfortably add a full cup to your bra size in an instant.

STRAP SOLUTIONS

These little, heart-shaped closures are designed to convert regular bra straps into a racer back, allowing you to wear that new-occasion top you had to buy. This device also provides the bonus of a generous lift.

MODESTY PIECE

This item, also called a tucker, has been around since the eighteenth century. Its purpose is to delicately cover the cleavage at the office, in a place of worship, or at any other place or event that requires modesty.

It's Time to Go Shopping!

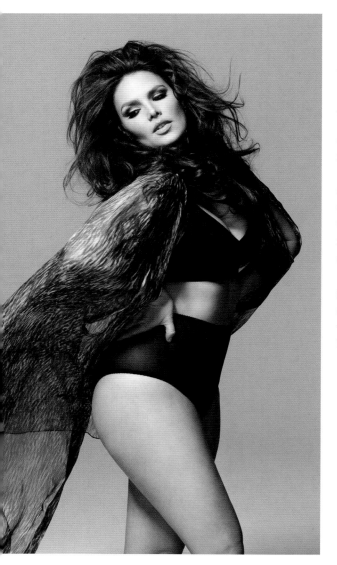

You've got everything in the bag except the bra—you know your bra size, your vertical length for a corset, which bras you need for everyday wear and for special occasions, and what bras are available. It's finally time to go shopping.

Before you do, though, check the list you made of your needs, prioritize each bra by number, and bring it with you. Good bras are expensive, so this step is primarily for financial reasons. Prioritizing and planning will allow you to make sure the essential bras most compatible with your wardrobe are purchased first.

A word of caution: all those beautiful bras have a very good chance of seducing you! Walking through lingerie departments and boutiques, with all that lace, jacquard, and fancy embellishments can be bewitching and lead to some poor decision making. Color is another tempting factor too. So beware—and focus!

Rebuilding a bra collection means starting with the essentials and neutral colors—black, white, nudes, and skin tones. You will get the most benefit from neutrals because they go with almost everything.

Shop for quality, not by price. It's a fact: good-quality bras cost more, and they are well worth the investment, for you will have a collection that lasts longer, fits better, and offers excellent support.

WHAT TO WEAR WHEN YOU GO BRA SHOPPING

When shopping, wear or bring along a fitted shirt so that you can see the true fit of the bra. If you have T-shirts that you wear often, or a dress or top that has an odd neckline, bring those as well.

Bra shopping for a fuller figure used to be disheartening. Not only were the options few, but style was out of the question. Today, there are many style choices and attractive, well-made bras in cup sizes far into the alphabet. Going beyond an E cup, which is the equivalent of a DD, has become standard in retail inventory, and most of the better department stores and lingerie boutiques now sell bras that are designed for curves.

Bring your bust and torso measurements and your bra list to the store. Before looking through the merchandise, talk candidly with the sales staff. Ask about the advantages, disadvantages, and details about the brands they carry as they relate to your size and needs. Remember, you want the truth, not the sell.

Try on a variety of brands and take a good, hard look from all angles in front of a three-way mirror to determine which models offer the best fit and support. Before making a final decision, try on a top—or whatever clothing you have brought with you—with each bra to ensure that it achieves the desired effect. Check to make sure you are getting adequate lift, that your breast shape looks natural, and that your breasts are fully covered by the cups. If you're not sure of the fit, solicit the opinions of professionals in the store—that's what they're there for!

SHOPPING ONLINE

If you prefer to shop on line, be sure to read product reviews on two or three different Web sites, focus on those reviews pertaining to the quality and the fit of the brand. For additional information about a brand, you can use your favorite search engine to discover other sites where it is sold and/or reviewed. There is great value in this process, as most women are brutally honest when they review an

DOES THIS BRA FIT? A Checklist

Make sure the band and cups are the correct sizes and that the underwire placement is right.
Here's how:

THE BAND SIZE IS CORRECT IF:

- The band is firm around your body.

- The band is horizontal at the back.

- Two fingers fit under the band.

THE CUP SIZE IS CORRECT IF:

- Each breast is smoothly encased in the cup with no wrinkling fabric.

- Neither breast is spilling outside or over the top of the cup.

THE UNDERWIRE PLACEMENT IS CORRECT IF:

- The underwire is not pushed away from your body in any way.

- The wires are flat in front between your breasts.

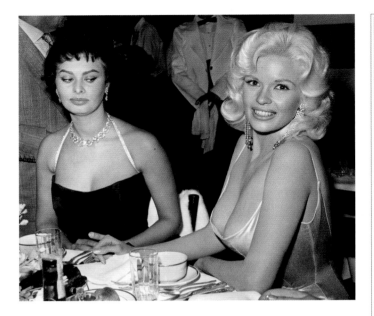

item, so you will very likely get the truth about the consumer experience for both the product and the seller.

On Web sites, bras are usually separated into categories. Generally speaking, you'll be looking for "plus-size," "full-figured," or "curves" tabs, which will then lead you to a drop-down menu listing bras by style. You can choose a bra from your list and check out the details—available colors, fabrication, sizes, and so on. Online sellers are usually very thorough, so information such as hook count, benefits, and similar products is almost always listed. And be sure to get the lowdown on the return policy.

Once you have the bras in hand, try them on in front of a large mirror with good lighting. Follow the same procedures as suggested for in-store shopping on page 97. If you feel you need another set of eyes, ask a friend who knows what to look for regarding proper bra fit.

———

Once you've built an essential bra collection consisting of versatile pieces that truly fit, you are going to be more comfortable than ever before—the days of spillage, shoulder-digging straps, and hiked-up bra bands are over. With a great shapewear and bra arsenal, you'll feel more confident and look your best in your new style choices. Let's get down to clothes!

ABOVE, LEFT: *It's my party—and I'll side-eye if I want to....* In this famous 1957 photograph, Sophia Loren gives Jayne Mansfield a good leer during a party held in the Italian actress's honor. To deflect attention from Loren, Mansfield arrived at the party last and once seated, leaned over the table so that her breasts spilled almost completely out of the dress—a "wardrobe malfunction" that was printed in newspapers the world over the morning after.

4
Wardrobe Essentials

FIFTEEN TIMELESS PIECES
FOR EVERY BODY TYPE

It's better to have fewer things of quality than too much expendable junk.

—RACHEL ZOE, GLAMOUR.COM, 2010

W E'VE ALL BEEN THERE, STANDING FORLORNLY BEFORE A CLOSET bursting with clothing, shoes, and bags, some not worn in several years; some with the price tag still on and never worn; and some worn for an evening or even ten minutes and never put on again. We all know that overwhelming feeling of sartorial despair—or even utter desperation—of having a closet full of clothes that seems somehow empty of options.

Fortunately, getting dressed without drama is achievable and straightforward: the key is to own good-quality, timeless items, or what I like to refer to as wardrobe essentials. Wardrobe essentials are just that: they're the pieces that always work as trends come and go. Collectively, they form the cornerstone of your closet, taking you from work to play and from day to evening from season to season.

For curvy women, the real secret to pulling together a flawless look effortlessly is to own these essential items in silhouettes that reveal your best features and conceal those areas where you need more coverage, as well as create the illusion of balanced proportions, whether that's via a single garment or two garments working together.

Fifteen Easy Pieces

In 1985, Donna Karan introduced her "Seven Easy Pieces," a mix-and-match wardrobe concept that revolutionized fashion at the time. Karan thought women needed a basic wardrobe that would make their lives easier—a selection of high-quality options that in combination made it easy to go from day to night, traveled well, and were easy to maintain. The idea of versatility and utility was so brilliantly on the mark, it continues to influence fashion today—and it's certainly influenced my way of thinking, except that my number is fifteen.

There are four criteria each item must meet to be considered a wardrobe essential.

- **IT REFLECTS YOUR PERSONAL UNIFORM**
 The item must fit into what I refer to as a personal uniform—that is, the silhouettes and styles you wear most often because they flatter you, are comfortable, and truly reflect your style.

- **IT'S A NEUTRAL COLOR**
 Black and other neutrals—beige, ecru, ivory, taupe, gray, and white—are a great place to start when building a wardrobe, because they never go out of style. They can be mixed and matched, which automatically expands your wardrobe options. Neutrals also extend your dressing options further, as you can wear them easily with other colors and prints.

- **IT'S MADE OF HIGH-QUALITY FABRIC**
 The garments upon which an entire clothing collection is built should be of high-quality natural fabrics: cotton, wool, and silk. All three are static resistant, so they don't cling. Wool and silk absorb moisture, and cotton maintains its shape and doesn't pill. However, a solid wardrobe may also contain synthetics, such as viscose and cotton/rayon/polyester blends that combine the best qualities of all three fibers: absorbency, sheen, and strength. And who doesn't love an infusion of Lycra! Avoid acrylic, as it pills, as well as any fiber with poor absorbency, such as polyester and nylon, particularly if you live in a hot climate.

- **IT FLATTERS YOUR BODY SHAPE**
 The silhouette, or shape, of a garment, is key to a good fit and enhancement of your curves, so the silhouettes you choose must be appropriate for your body shape—all of which will be detailed for your specific body type later in this chapter.

Here are the fifteen items that should form the basis of any versatile wardrobe, followed by specific recommendations for each body type.

1 THE CLASSIC WHITE SHIRT

The white button-down shirt has always been an essential wardrobe piece, but today this practical essential is available in show-stealing styles. In addition to the basic button-down, there are highly fashionable selections, including wraps and peplums, as well as those with ruffled necklines and dolman sleeves, making it easy to find a style that suits your shape. A high-quality white shirt is typically 100 percent cotton, but today an infusion of Lycra (usually 5 to 7 percent), provides a little wiggle room. This little tweak enhances the comfort of cotton and makes this classic curve-friendly. If you don't like white, buy this go-to shirt in ecru or black.

2 THE OCCASION TOP

Everyone needs an occasion top, and by that I mean a top that makes a strong fashion statement and doesn't need much else in terms of accessorizing. Occasion tops are great for times when you don't have a lot of time to plan what you're wearing and want to look modern and effortlessly well pulled together. They can be worn with all the lower-body essentials pieces listed here, can easily move from day to evening, and work for casual and dressier occasions. When looking for an occasion top, go for something in an easy-to-care-for fabric—such as cotton, rayon, or a polyester/cotton blend—that is contemporary and shows a little skin, like a V-neck or cold shoulder style. Make sure the top flatters your upper torso and fits easily around your midsection when you are seated. Look for distinctive details to make this top a showstopper, such as an interesting sleeve style, an embellished neckline, or shoulder pleating.

3 THE BLACK SKIRT

Every woman looks fantastic in a classic, black pencil skirt, whether knee-length or midi. This skirt is a traditional essential, although today the rule, at least in my book, has evolved to include a black skirt that flatters your shape, whether it's A-line, pleated, flounced, or pencil. This wardrobe essential can be worn professionally and leisurely, and is the perfect choice for days when you want to expose a little leg but don't want to wear a dress. Purchase this staple in a lightweight wool for year-round wear—and make sure it's lined too. In fact, a lining with a little spandex will heighten the great work your shapewear is already doing for your figure.

Simple black skirts are endlessly versatile: they can be paired easily with blouses, sweaters, or blazers; worn with booties, flats, or pumps; and they work 24/7.

4 THE DAY DRESS

For comfort and style, there is nothing like an easy-to-wear day dress. A simple silhouette in a print or an interesting color can work from morning to last-minute evening plans. Whether you choose an empire waist, A-line, or sheath, the length and pattern should flatter your body shape. You might want to consider a dress that makes a strong statement through its cut or pattern in case you don't have time to accessorize. A bit of your personality should be reflected in your choice, with an abstract print or your favorite color, and a great neckline to show off a conversation-worthy necklace. A length to the knee or just below will make it appropriate for the workplace and give you some flexibility with shoe height.

CURVY CONFIDENTIAL

STYLE HAS NO SIZE LIMIT

Never let your dress size curb your fashion discoveries and choices. Much of what shows up on the runways in New York, Tokyo, Milan, and Paris can be modified for your curves. One of the most iconic dress silhouettes, Diane von Furstenberg's wrap dress, reveals just the right amount of décolletage and is a very flattering design for women size 14 and above. All hail the wrap dress, and how it loves our curves!

5 THE BLACK DRESS

No wardrobe is complete without a black dress, as it is singularly right for many occasions. The black dress should be a classic silhouette, either a sheath or an A-line, so that it can be dressed up or down, worn with or without a jacket, and go from day to evening. Look for details such as pleating, tone-on-tone embroidery, and strategic seaming. Last, if you love a little bijou, be sure the dress has a jewelry-friendly neckline.

CURVY CONFIDENTIAL

BUY IT ONLY IF YOU LOVE IT

When you're shopping, pay attention to your likes and dislikes. This sounds obvious, but the truth is, if you're shopping in a hurry because you're in a pinch, it's easy to buy an item out of anxiety. Likewise, just because an item is on sale doesn't mean you should buy it either. More often than not, impulsive or close-enough-but-not-quite-right clothing usually ends up living in quiet desperation at the back of your closet, taking up precious real estate, and never again seeing the light of day. So if you don't love something, don't buy it. It's that simple!

6 THE BLACK PANT

When it comes to selecting a good pair of black pants, take a cue from the details of sharply tailored menswear. A high-quality pair of black pants with clean lines, a flat front, and faux pockets is impressively chic and versatile. Style options include wide leg, slight boot cut, and straight leg. When trying on pants pay attention to the hips, crotch, and waist to make sure the fit is smooth, with no bunching around those areas.

7 GOOD JEANS

Jeans play a pivotal role in day-to-day dressing because they can be worn with just about anything and on almost any occasion. They've come a long way from outdoor workwear to a contemporary wardrobe essential, making room for chic high-low ensembles.

For plus-size women, jeans were once one of the most challenging wardrobe staples to find, as companies used to grade up the pattern from a straight size without giving consideration to those with curves. Today, though, options are now available in denim with precision tailoring, mid-to-high waistbands for more tummy support, waist sculpting, curved waistbands for a more comfortable fit and less gapping, and strategic seaming for hip and thigh sculpting. When shopping for jeans as a wardrobe staple, think versatile: avoid those with excess whiskering (the light horizontal streaks across the thighs), loud embellishments, and other bells and whistles. A dark, inky blue is a great choice, and if you're not a fan of blue, get them in black.

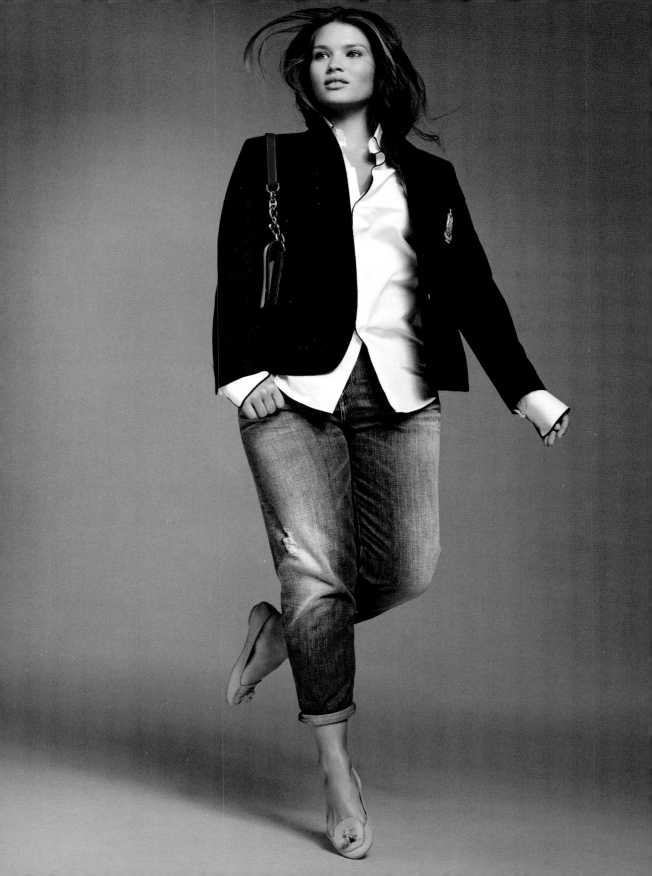

8 THE BLAZER

A blazer is a key wardrobe item, whether in fabric for the traditionalist, or leather for those who like things a little more cutting-edge. A blazer is a perfect fit when it hits the most figure-flattering point of your hip, which depends on your body shape and height, doesn't pull across the back, and there is no stress across the bust line or at the button holes. Standard lengths are right below the waist, the high hip, and the actual hip line. Sleeve length is also important; a sleeve should hit a little bit above the top joint of your thumb if you're standing with your arms at your sides, and your wrist should be covered. An essential blazer should be black, navy, or a neutral in the khaki family.

9 THE TRENCH COAT

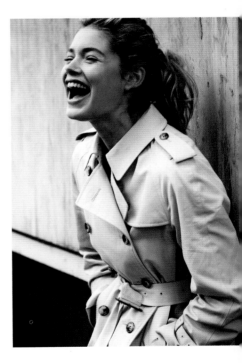

Originally designed for army officers in World War I, the trench coat never goes out of style. It looked as good on Kerry Washington in *Scandal* as it did on Marlene Dietrich in *A Foreign Affair* more than sixty years before. Once worn mainly in rainy weather and made of waterproof, heavy-duty cotton, gabardine, or poplin in khaki, the trench coat has been reinterpreted by designers in a variety of fabrics, colors, styles, lengths, and design details. Choose a trench coat in a weight that can be worn year-round or perhaps one with a liner for colder weather. A classic cut in a color that complements your work and casual clothing is the best choice, and knee-length is the most flexible option. When purchasing a trench coat, always try it on with a sweater or blazer, as you want to be able to wear it on cooler days and still have a good fit.

10 THE BLACK LEATHER BAG

You're taking this baby to work, lunch, dinner, and on weekend outings, and you want to be able to pair it with just about everything in your closet. That's a tall order, so don't buy just any old bag. Even though this purse is for everyday use and should be practical with fairly classic lines, it should have some details that amp up its "it" factor. Unless you work in a high-fashion or festive environment, leave the handbags embellished with plumes and lots of sparkle for the evening. For daytime, seek out interesting textures, sturdy handles, and chic hardware; and yes, size matters.

HANDBAG SIZE AND YOUR FRAME

When shopping for a handbag, try it on, then look at yourself in the mirror from different angles to get a good idea of how the bag looks in relationship to your body. In your hand or on your shoulder, the bag should be visible. If it doesn't have much visual impact, it's probably too small for your frame. A bag that is too small can make you look larger, as if you are carrying your little sister's purse. So think about balance: if you have broad shoulders and narrow hips, try a large handheld purse to add weight to your lower body. And if you have a straight figure, a medium or large round purse can be used to give you the illusion of curves.

11 BLACK PUMPS

When it comes to shoes, you get what you pay for. Never skimp on comfort, quality, or fit. You can't go wrong with a classic well-made black leather pump; whether you choose a platform, kitten heel, or stiletto, consider a fairly neutral height (about 2.5 inches) that works with skirts, dresses, and pants and that you truly can walk in.

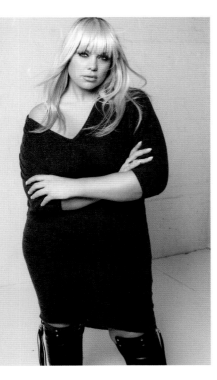

12 KNIT DRESS

A V-neck or turtleneck knit dress is a winner in the wardrobe. Wear it with a blazer, a drape-front cardigan, or layered with a beautiful pashmina. It is texture that makes the knit dress interesting and layering adds to its dimension. Well-crafted knits are not only comfortable but also travel well, making them a must for every wardrobe. Knits can be challenging for a curvy figure because the cling factor is greater. Knits should silhouette—not hug—your body. Always wear a knit dress with appropriate shapewear.

13 WINTER COAT

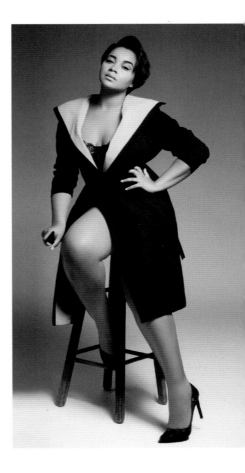

Winter coats are an essential for those who live in a cold-weather climate. If you do, options for style and warmth are greater than ever, and you don't have to trade one for the other. A button-down tweed, a double-belted cocoon, and a peacoat are just a few styles that are great for curves.

Length is a major purchasing factor. Car coats are great for those who are constantly on the go. A coat that grazes the knees works well if your wardrobe consists mostly of pants. If skirts and dresses are a big part of your wardrobe, then opt for a full-length or a midi coat. Choose silhouettes that have a clean line and don't add volume to your figure, and be sure the coat is roomy enough for a heavy sweater or wool blazer.

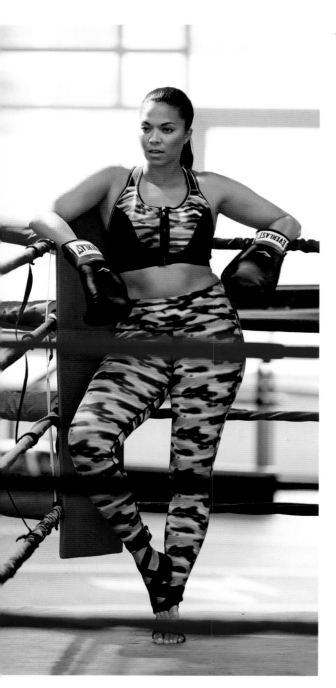

14 ATHLETIC WEAR

Today's athletic wear is more stylish and figure flattering than ever, as designers are using high-tech fabrics with shapewear strength and strategic seaming. Purchased in the appropriate size, this outerwear can offer the lift and tuck of underwear.

When buying athletic wear, consider the frequency and level of your workouts. Look for moisture-wicking properties to keep you dry, particularly if you plan to exercise outside. The type of workouts you do are an important consideration in terms of selecting the density and coverage of tops and bottoms too. Avoid athletic gear with a sloppy fit. Pieces with style that allow you to see your curves and the movement of your body will enhance your confidence.

Here are some items to get your athletic-wear collection started: A fitted tank top that holds firmly at the high hip will enhance the work already being done by your undergarments, but do not rely on the bra shelves in the tank top to replace a proper-fitting sports bra. Capri or regular-length leggings provide moderate control and smoothing for the stomach, buttocks, and thighs; leggings with the best fit normally contain 14 percent Lycra and provide extra firming support. A light-weight athletic jacket made of Lycra, with moisture-wicking properties, will keep you dry and warm after a workout. Jackets with strategic seaming, with or without a hoodie, are very flattering on curves.

15 SWIMWEAR

In the past there was a swimwear void for curvy women. But it's a new day! Modern swimsuits in plus sizes are available in all the latest styles, in both prints and vibrant colors, and designed with much of the same technology applied to shapewear. Many designs, from a high-waisted two piece to a body-skimming swim dress, incorporate power-stretch lining for smoothing and contouring, underwire bras for a proper lift as well as ruching, interesting necklines, and strategic seaming details to enhance, reveal, and conceal.

Before shopping for a swimsuit, consider how often you will wear the suit and what for. Are you going to swim or sunbathe only? And if you're going to swim, will you be swimming a lot? Are you swimming for leisure or exercise? The answers to these questions will determine how many suits you'll need, as swimsuits made for working out and those made for lounging by the pool offer different levels of support. Consult "Swimwear for Every Shape" on page 175 to help guide you to the most figure-flattering silhouettes before you go shopping. And when you do, have your bust, waist, and hip measurements handy. Tags sometimes contain size charts based on these measurements, and some bikini tops are sold in bra sizes.

We're not throwing shade, but we're definitely throwing curves.

—LINDA HEASLEY, LANE BRYANT CHIEF EXECUTIVE OFFICER, *NEW YORK DAILY NEWS*, APRIL 6, 2015

Your Curves, Your Closet

ESSENTIALS FOR YOUR BODY SHAPE

Transformation has always been my thing. As a child I loved magic. No matter how many times I saw a rabbit emerge from a top hat, I was transfixed. As a stylist, I get excited when a back roll disappears or a pair of breasts that were almost invisible transform to look-at-me cleavage.

Dressing well is about both illusion and reality, in that you accentuate and enhance what you've really got and use illusions to create what you don't or camouflage what you don't love. Choose the right silhouettes for your body shape and voilà: a woman with an hourglass figure reveals perfectly aligned proportions when she finally takes off that muumuu. A jaw-dropping empire dress instantly removes the tummy from the center of the oval woman's universe, while a fit-and-flare skirt puts some hips on a woman who has an inverted triangle body shape. A woman with a rectangle figure pulls on a peplum blouse or jacket and instantly has curves—and a little froufrou around the neckline can make a triangle woman's shoulders and hips look like twins.

SHOP AT THE TOP OF THE SEASON

Whether you are reestablishing your wardrobe essentials or adding to your personal fashion story, the best time to shop is at the top of the season. In other words, even if you are still wearing winter clothing, and the spring collection has just hit the selling floor, it's time to take a look because this is when seasonal collections are freshly merchandised and displayed. Going shopping at the top of the season also gives you a chance to think about new styles and colors and to review your wardrobe accordingly.

Of course, if you don't want to purchase items at full price, you can window-shop first and wait for a sale—although you might not get what you want, and if you really love something, don't wait. But if you have a relationship with a sales associate, you can certainly ask her to give you a call the first day of the sale and to put your size on the side. It never hurts—but it's not a guarantee either.

CURVY CONFIDENTIAL

DRESS THE REAL YOU

Don't fall prey to dressing a perception of yourself! Perception dressing leads to two extreme problems: either believing you need to cover up the real you by wearing loose-fitting silhouettes and clothes that are too big, or squeezing yourself into clothing that is much too small because your self-image is linked to a size you desire to be rather than the size you are. Neither approach is figure flattering, and both telegraph that you are not comfortable with yourself.

When you dress for your shape, you accept your body honestly. And when you dress your physical truth, you celebrate your beauty and look your radiant best.

THE BEST NECKLINE FOR YOUR SHAPE

When shopping for a blouse, dress, T-shirt, or sweater, a critical element to consider is the neckline. A great neckline can make a difference between a look that enhances your figure and one that detracts from it. The right neckline can elongate your neck and torso and highlight your décolletage. Here are the best necklines for each body shape.

HOURGLASS: Because you have natural balance, you can wear all the universal necklines: sweetheart, scoop neck, V-neck, and square.

INVERTED TRIANGLE: Your get-dressed strategy is to de-emphasize your upper torso, so V-necks and deep scoop or U-necks are the most flattering options.

OVAL: Your strategy is to de-emphasize your midsection and define your curves. Scoop, square, and wide V- or U-shaped necklines are your best bets.

RECTANGLE: Your goal is to appear more curvaceous: boat neck, sweetheart, square, and wide V- or U-shaped necklines can help you do that.

TRIANGLE: You want to add volume to your upper torso for balance. Your best necklines are boat neck, wide V- or U-neck, square, and sweetheart.

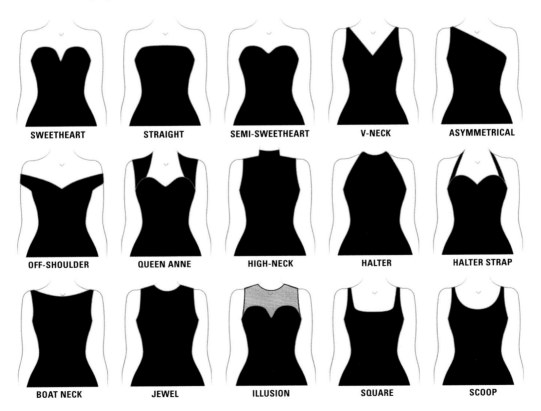

SWEETHEART	STRAIGHT	SEMI-SWEETHEART	V-NECK	ASYMMETRICAL
OFF-SHOULDER	QUEEN ANNE	HIGH-NECK	HALTER	HALTER STRAP
BOAT NECK	JEWEL	ILLUSION	SQUARE	SCOOP

1 THE HOURGLASS'S CLOSET

The hourglass shape is voluptuous times two. The trick for you is to choose clothing that accentuates both the top and bottom of your body proportionally. You don't have to create shape; you were born with perfectly balanced curves defined by a small waist.

Your challenges are fewer than they are for women with other body shapes, but there are still silhouettes that flatter your figure the most. When you get dressed there are a few things to keep in mind: do not cinch your belt so that it is visibly tight. Pay attention to necklines and hemlines: there's nothing wrong with a little reveal, but you don't want to be overexposed. And finally, stay away from voluminous silhouettes. Your primary goal is to maintain balance.

Hourglass Wardrobe Essentials

CLASSIC WHITE SHIRT: You can wear form-fitting tops easily, so wrap blouses, tailored button-down shirts, and any style that is nipped at the waist will flatter you.

OCCASION TOP: Look for soft feminine silhouettes as well as fitted V-necks and scoop necks with shaping details such as strategic seaming and flattering necklines. If you don't like having your arms exposed, go for three-quarter sleeves as a long-sleeve alternative.

BLACK SKIRT: With your shape, you have many figure-flattering style options for the black skirt, but always choose the classic pencil first. Later you can add the gore, the flounce, and the half circle.

DAY DRESS: Look for dresses that are nipped at the waist, such as shirtwaists and fitted sheaths that graze the knee.

BLACK DRESS: You have lots of options: seamed fit-and-flare dresses, wrap dresses, A-line dresses, and fitted sheaths keep your curves balanced.

BLACK PANT: Boot cut, straight leg, and pants fitted in the leg are all good choices. A tailored black pant with a high waist and faux hip pockets is great: the high waist complements your natural shape, and the boot cut or straight leg keeps you balanced and sleek.

GOOD JEANS: Boot-cut, straight leg, and skinny jeans are all great styles for you. The boot cut and the straight leg keep hips and thighs in balance, because they have some volume in the lower leg. Also look for mid-rise jeans that hit right above the hips—a good choice for a smooth line. If you opt for skinny jeans, do not wear them with a tight top. You will look more balanced in a looser top that just skims the body. Last, pay attention to the size of your pockets. Hourglass shapes generally have a full derriere, and small back pockets will only make the buttocks appear larger. Choose jeans with medium-size faux back pockets. The pockets don't have to be plain; in fact, some topstitching detail can be quite flattering.

Your dress should be tight enough to show you're a woman and loose enough to show you're a lady.

—Edith Head, *The Dress Doctor*, 1959

BLAZER: You can't go wrong with peplum jackets, princess-seamed jackets, or any fitted blazer that defines your waist and shoulders.

TRENCH COAT: Your figure was made for the classic trench. A coat with structured shoulders, often including padding, a belted waist, and an A-line or tapered bottom is the perfect style for you.

BLACK HANDBAG: A shoulder bag that hits the hip or a large bag with handles are in proportion to your figure.

BLACK PUMPS: Shoes that are pointy or slightly oval at the toe elongate your legs and make you appear taller and leaner. For more comfort, look for platforms with the same toe shape or wedges that are not too wide or bulky across the front of the shoe. Chic will be more flattering than chunky.

KNIT DRESS: Jersey, ribbed, or interlock knits are all very sexy on an hourglass figure, but keep in mind, if they are worn too tight, very sexy may quickly become very distasteful. Also, look for knits that are not too thick but sturdy with good shaping details.

WINTER COAT: A fitted and/or belted style, with strong shoulders and vertical front or back seams works perfectly for your well-balanced figure. Choose the length that works for your lifestyle.

ATHLETIC WEAR: If your workout requires long pants, straight leg and boot-cut styles work well for you. When purchasing athletic jackets, T-shirts, and tank tops, purchase styles with strategic seams at the waist and shoulders for definition.

SWIMWEAR: Choose one-piece bathing suits with a banded or wrap waist and a scoop or V-shaped neckline. Also stick with one-piece suits, tankinis, and bikinis that are the same color or pattern across the bust and hips. Straps should sit in the center of your shoulders. All of these details keep your shape balanced.

2 THE TRIANGLE'S CLOSET

Like the hourglass body shape, the triangle has a defined waist and a full bottom. The difference is in the upper body, which is visibly smaller. The get-dressed goal for the triangle shape is to add the illusion of volume to the upper body, define the waist, and de-emphasize the lower body to create a more balanced figure. Your shape-shifting goals are not impossible to achieve, but there are a few things to keep in mind as you establish your essential wardrobe. When purchasing skirts, jeans, and trousers, you should invest in tailoring those items, because your waist is disproportionate to your hips and thighs, making an unattractive waist gap inevitable. Additionally, two-piece outfits will require special consideration. Because your bottom half is larger than the top of your body, you will have to buy a larger size in some garments to accommodate your bottom half.

Generally, your shoulders are narrow and your upper arms may be heavy, so it's important to pay close attention to the fit of the arms when trying on tops and jackets. Purchase dresses and tops with structured or princess shoulders to accommodate larger arms and achieve a more balanced appearance.

Triangle Wardrobe Essentials

WHITE SHIRT: Shirts with a darted waist, wide necklines, and subtle bust and shoulder details create the illusion of a larger upper body and give your figure more balance.

OCCASION TOP: Create a figure-balancing illusion with flutter and kimono sleeves, neckline embellishments, horizontal details across your shoulders, and a nipped waist. These features will draw all eyes upward, taking attention from your hips.

BLACK SKIRT: When it comes to choosing a skirt, you have many options. Look for those with asymmetrical hems in fluid fabrications, a gored skirt fitted at the hips with a subtle flare, or an A-line skirt. All three will minimize your hips.

DAY DRESS: A dress that is off the shoulder, or has a boat neck or a wide neckline, a gently nipped waist, and a fluid bottom is always a great choice. Look for midi-length dresses or those that graze the knee. Don't be afraid of bright colors or an interesting pattern, but look for silhouettes with strategic seaming in fabrics that don't create volume.

BLACK DRESS: Dresses with a wide-scoop or sweetheart neckline give the illusion of a broader upper body. If you have small breasts, a padded, seamless bra will further enhance the illusion. Wrap dresses, or any dresses that define your waist, as well as asymmetrical or fluted hemlines are also great for minimizing fuller hips and thighs.

BLACK PANT: Choose tailored pants that fall straight from the widest part of your hips, with a flat front and a seamed or pressed crease in the leg. These details create a seamless vertical line.

GOOD JEANS: Straight leg and modified boot-cut jeans in a dark hue with simple stitching create a long, lean, leggy appearance. It's the volume of these jeans, from the knees down, that keeps your hips in balance. Purchase jeans with large back pockets; if the pockets are too small they will make your bottom appear larger.

BLAZER: Choose a blazer with structured or princess shoulders and wide lapels to emphasize your upper torso, making it look more proportional to your hips. Blazers or jackets that are fitted to the waist are also flattering for your shape.

TRENCH COAT: Look for belted styles with structured shoulders and A-line bottoms. Styles that are hip length or graze the knee look great on you. Stay away from large obvious pockets at the hip because they will add volume to that area. Bust pockets or any detail at the bust will help to create a more balanced figure.

BLACK LEATHER BAG: A medium or large shopper, hobo, or satchel bag is a great choice for you because these bags hit right at the waist, balancing the hips with the upper body.

BLACK PUMPS: Wear slightly oval, open-toe, or pointy shoes. The shape of the front of the shoe will elongate your legs and give you a leaner appearance. If you prefer less height, go for the kitten heel, as you will still get a visible lift.

KNIT DRESS: A fit-and-flare dress with a sweetheart neckline and cap sleeves does double duty for you: it makes your upper body appear broader and it de-emphasizes your bottom. Watch the length though: the dress should hit you right at or above the knee for the best balance.

WINTER COAT: A belted silhouette with structured shoulders is a given to accent your waist and broaden your upper body, but you can also wear a single-breasted overcoat with vertical seams in the waist for balance.

ATHLETIC WEAR: Athletic pants can be a challenge because of the proportion of your hips to your waist. Look for pants with an adjustable waistband or a drawstring.

SWIMWEAR: When buying a two-piece bathing suit, look for bottoms to minimize and fully cover your derriere. If you buy a tankini or bikini, consider light-colored, ruffled, padded, or patterned tops to add a little volume to your upper half. Suits with wide-set straps give the illusion of wider shoulders, and dark bottoms, with moderate or high-cut legs, reduce the width of your hips, making your figure appear more balanced. If you prefer a one-piece suit, choose one with an embellished or lighter-colored bust.

3 THE RECTANGLE'S CLOSET

If you have a rectangular figure, your get-dressed strategy is to create shape by defining your waist and subtly adding a little volume to your upper body and bottom for balance. Adding volume is not the norm for a fuller figure, so when you go shopping, here are a few things to bear in mind: A wide dark belt will be your go-to accessory for defining your waist. Putting together separates is key: by combining an item with a slight fullness on your bottom half with one that billows equally on the top, you can create a more balanced and curvaceous appearance. Last, wear waist-defining shapewear.

Rectangle Wardrobe Essentials

WHITE SHIRT: Shirts with a fitted waist or that have embellishments around the bust or the shoulders will give you a little volume up top. Large buttons, ruffles at the neck, bust pockets, and structured shoulders are all good options for creating a little volume on your upper body. What is critical is that the scale of the embellishments are in proportion to your frame. In other words, the embellishment should not be so small it gets lost or seems like an afterthought, and it should not be so large that it overpowers the bust line and shoulders of the shirt.

OCCASION TOP: You have a lot of good options. Look for slightly roomy tops with a little draping in the body and a wide band of cinching at the waist. This will create an hourglass illusion. Also try peasant tops; loose-fitting, off-the-shoulder styles; and tops with embellishment around the bust.

BLACK SKIRT: Some good style choices are full, semicircle, gored, and A-line because they add fullness to your bottom. Focus on fabrics that are medium- to lightweight with movement around the hips to create an eye-catching curve without too much volume.

BLACK DRESS: Look for dresses with structured shoulders; princess, flutter, or billowing sleeves; and wide necklines to help create a slightly wider appearance on top. Your best bottom silhouette is an A-line or paneled style that forms a bell shape. A-line wrap dresses and empire dresses look good on you too. If you are full on the top and bottom, enhance your shape with waist-contouring details, such as strategic seaming and embellishments, or wear a belt.

BLACK PANT: Choose boot-cut pants with a subtle flare, and real, not faux, hip pockets to give you more curve in the thighs and hips.

GOOD JEANS: Choose boot-cut or flared jeans with a mid-rise waist. Tasteful whiskering details at the hips will add the illusion of curved hips, and buttoned, flap-style back pockets give the bottom a fuller appearance.

BLAZER: Stick to blazers with princess seams, peplums, and structured shoulders. Another way to create a shapely illusion is with a fitted blazer made in a sturdy fabric with a high stance, meaning the button is slightly above the waist. This will also create a shapely illusion.

TRENCH COAT: Good styles for this body type are those with a wide belt, an A-line silhouette, a pleated bottom with pockets, or shoulder straps and a storm flap.

BLACK HANDBAG: To enhance straight hips, choose a large, cross-body or shoulder bag that lands right at the hip.

BLACK PUMPS: Pointy, oval, and round-toe heels work for you, as they lengthen the legs and make you look taller.

KNIT DRESS: A belted knit peplum dress will redefine your shape. The peplum adds volume and curve to the hip area, while the belt contours and shapes the waist. Look for this style in a medium-weight knit.

WINTER COAT: Choose a belted coat with a flare bottom or one with a slight A-line, embellished with faux fur collar and lapels.

ATHLETIC WEAR: Your best gym look is a slightly flared workout pant and a loose-fitting jacket banded at the waist.

SWIMWEAR: Choose a one-piece with a strategically draped mid-torso and bust line, embellishments such as ruffles, or an adjustable skirt with ties at the hip. For additional enhancement on top, wear a suit with wide-set straps and a padded or push-up bra.

4 THE OVAL'S CLOSET

If you have an oval body shape, your goal is to de-emphasize your midsection and create a more defined waist. You can achieve this by choosing garments that add a little volume to your lower body and tops that contour at the waist. Tops should gently graze your midsection and form a slight A-line from the waist to the hip; this will be most flattering for your frame and give you more shape. Anything banded or belted at the waist should be worn slightly loose to avoid creating an unattractive bulge across your midsection. Generally, women with an oval body shape have great legs, so if you are one of the lucky ones, have fun with skirt lengths and interesting hemlines. But don't go too short; if you do, your midsection will appear larger. Keep skirt lengths just above, just below, or right at the knee.

Oval Wardrobe Essentials

WHITE SHIRT: Your go-to white shirt should have tone-on-tone vertical top-stitching or front princess seams. Both elongate the torso and give the midsection more definition. The length of your shirt is also very important because the roundness at the stomach and waist can cause the shirt to rise. Choose shirts that fall between the mid and lower hip.

OCCASION TOP: V-neck empire, surplice, cold-shoulder asymmetric, and tunics that skim the body are perfect for an oval shape. They create the curves you need and camouflage your middle.

BLACK SKIRT: Wear skirts that contour your shape at the waist and flare at the hem. A-line, trumpet, and gored styles all fit the bill, giving your figure more shape and definition.

DAY DRESS: Choose V- or U-neck, knee-length styles with soft vertical pleating down the center.

BLACK DRESS: The best dress silhouettes for an oval shape are empire, body-skimming shifts, and a V-neck A-line with softly pleated side panels. All three styles camouflage the midsection and provide a smooth vertical line.

BLACK PANT: Tailored, wide-leg, flared, or boot-cut silhouettes are great for you as are tone-on-tone details, such as embroidery around the hip or tuxedo stripes down the sides. These silhouettes and embellishments create the illusion of curve and shape.

GOOD JEANS: Because you are fairly narrow in the hips, slightly boot-cut flares and wide-leg jeans, with hip pockets and large back flap pockets, look good on you because they create curves on the bottom half of your body, lengthen your legs, and give you more balance.

BLAZER: Your go-to blazer should have structured shoulders, a high-stance button closure, and vertical seaming in the back. For length, make sure the blazer hits you mid to low hip. This combination will create a curvy illusion. Another option is a blazer with an open V-neck that starts just above the waistline. This silhouette draws the eye upward, making you look longer while de-emphasizing your full middle.

TRENCH COAT: Choose a single-breasted trench silhouette with a belt. This camouflages the midsection and creates shape. If you are a fan of the newer trench coat styles, a swing coat or cape, knee-length or a little longer will also work for you.

BLACK HANDBAG: Generally, your shoulders and your hips are pretty narrow, so avoid shoulder bags. Large totes and structured satchels are best for balancing your figure.

BLACK PUMPS: Pointy or oval platforms, wedges, and strappy heels work for you. All three lengthen your legs and give you a leaner appearance.

KNIT DRESS: Women with an oval body shape are often concerned about a knit garment's ability to cling properly. A surplice dress is one solution. Its faux wrap design camouflages and contours the midsection. Accessorize with a triple-strand necklace or medium-length pendant to elongate your torso and amp up the glam factor.

WINTER COAT: Belted shawl-collared wrap coats, single-button midi coats, and belted A-line styles all create shape and diminish the midsection. Don't choose coats made from a thick wool because they add bulk to the middle of the body.

ATHLETIC WEAR: The oval's best athletic look is a tunic-style T-shirt or a tank top that grazes the hips, worn with slightly flared or full-leg workout pants.

SWIMWEAR: Choose a tankini with a V-neck or sweetheart neckline, and straps that sit mid-shoulder, or a one-piece swimsuit. A-line tops that skim your midsection are also very flattering. Also choose bottoms with adjustable ties at the hip to enhance your curves. The ties offer the option of making the bathing suit bottom reach the mid-thigh or higher. Other features to look for in a one-piece swimsuit are waist-contouring details and wrapped draping across the midsection.

5 THE INVERTED TRIANGLE'S CLOSET

If you have an inverted triangle body shape, the key is to balance your broad shoulders, bust, and back with your narrow lower body. The best way to do this is to wear clothing that adds curves to your hips and bottom while creating a defined waist. In other words, you need to de-emphasize your upper body and add volume to your bottom. When looking for skirts and dresses, knee- and midi-length are the best for you. If your skirts and dresses are too short, your torso will look fuller. You also need to define your waist, so look for medium-width belts in dark or neutral hues.

Inverted Triangle Wardrobe Essentials

WHITE SHIRT: If you believe a white shirt makes your upper body appear larger than you are comfortable with, opt for ecru or black as your essential shirt. Choose shirts that have princess seams, a nipped waist, and a flared bottom to add some curve to narrow hips.

OCCASION TOP: Your occasion top should be in a dark or jewel-toned hue. Look for deep V- or U-neck wrap tops to draw the eye from the shoulders and create a more narrow illusion. Tops with horizontal details at the hip also give you more curves.

BLACK SKIRT: Choose knee-length pleated, circle, A-line, and full gored skirts. They all have lots of movement and flare and add volume around the hips and buttocks.

DAY DRESS: Choose a dress with a peplum, or an A-line surplice dress with a narrow V-neck. The deep neckline will make the upper body look more narrow, and the peplum and A-line will create more curve in the hips.

BLACK DRESS: A-line wrap dresses and dresses with strategic draping at the hips are the best style for your shape because they give the illusion of a fuller hip. Avoid dresses with detailing at the shoulders or across the bust, as they will make these two areas appear even broader.

BLACK PANT: The best pant styles for adding volume to your narrow hips are palazzo and other wide-leg styles and tailored cargo pants. Side pockets near the hips, flapped back pockets, or large pockets at the sides of the legs will all help to balance the figure.

GOOD JEANS: Look for jeans that add some shape to your hips and buttocks. Choose a mid-rise boot cut or wide-leg jean with flap-style back pockets or hip pockets.

TRENCH COAT: Belted car-coat styles that sit at the low hip and single-breasted button designs that graze the knees are flattering for you. If you purchase a coat with a tapered bottom, make sure it has visible side pockets to add volume and shape. If the bottom of the coat is an A-line silhouette, cinch the belt for definition and to create the illusion of curves at the hips. Look for coats with rounded shoulders or raglan sleeves, and avoid those with exaggerated shoulders.

BLACK HANDBAG: Cross-body and shoulder bags that land at the hip are perfect for you, because they visually add substance to this narrow part of your body. Additional options are a tote or barrel bag.

BLACK PUMPS: Choose heels with a peep toe, sling back, or cutaway arch.

KNIT DRESS: A U-neck, drop-waist dress with three-quarter-inch sleeves is knit perfection. The drop waist adds a bit of volume at the hip, and the U-neckline helps to de-emphasize your upper body. Purchase knits in a medium weight for movement and control.

WINTER COAT: Follow the silhouette guidelines for the trench coat, and make sure to purchase a coat large enough for layering underneath.

ATHLETIC WEAR: Your best athletic look is a low-hip-length jacket with flared pants.

SWIMWEAR: Finding the right bathing suit is a challenge for this body shape. Try one-piece swimsuits with bottoms that are cut straight across the hips, rather than a high-cut style. Features such as side ties, a flirty skirt, or ruffles can help create more curve and balance. Also look for designs with a narrow V-shape at the bust line. This will give you more of a vertical line at the top and de-emphasize your broad upper torso.

> If I can have any impact
> I want women to feel good
> about themselves and have
> fun with fashion.

—MICHELLE OBAMA, *VOGUE*, MARCH 2009

Your Life Is Your Runway

In this digital, always-on-camera age, policing and fashion-style commentary is ceaseless, and almost everyone has an opinion about an opinion. When it comes to curvy women, the opinions are frequently loud or antiquated. Not so long ago, for example, I read a dos and don'ts article for curvy women that said plus-size women shouldn't wear turtlenecks and fitted clothing. My response, after a major side eye, was, "Are you serious?" Yes, there are certain trends, silhouettes, and fabrications that may not be universally curve-friendly, but like everything else in fashion, what truly looks right varies from person to person. Style options for curvy women are greater than ever, and any list about what curvy women can and cannot do should reflect that, as well as our individual differences.

So, here's my personal list of dos and don'ts. My approach to what plus-size women can do is, "Yes, you can, and here's how," and my don'ts always address why some things just don't work. Neither list is exhaustive, but both are a result of my styling experience and apply to a large number of women. Of course, there are exceptions based on age and body shape. I believe every woman walks her own runway daily, and I want you to do so with absolute confidence in your wardrobe choices.

OPPOSITE: First Lady Michelle Obama—in a one-of-a-kind silver-sequined champagne gown designed by Naeem Khan—with President Barack Obama at the White House prior to the couple's first state dinner in 2009.

DON'T GO THERE . . .

DON'T BELIEVE THE HYPE

Every trend is not appropriate for every body type. It's great that women have become more comfortable with taking fashion risks and revealing more skin because they feel sexy and want to have fun with fashion. Cropped and midriff tops may be in—but they are not for every body shape. Be realistic about what looks good on you.

DON'T FORCE A LOOK

Don't wear anything that isn't you. Wearing a trendy garment or a complete look to please others or to fit in will never look right if you are not comfortable in it. Remember, you have to be you! The best trend is your personal style, which comes about as a result of having confidence in your own fashion choices.

DON'T WEAR SHOES THAT ARE TOO TIGHT

There's toe cleavage . . . and then there is foot overflow, which is often common with pointy ballerina flats. If you have a wide foot, look for the style you like in the appropriate width. Wedging yourself into clothing that is too small never works, and the same thinking applies to shoes.

DON'T WEAR LEGGINGS AS PANTS

There is way too much personal information on the streets of many cities because of this trend. Leggings are not pants. They are meant to be worn underneath clothing. That's why they are sold with hosiery and accessories in department stores.

DON'T WEAR SHAPELESS, SLOPPY GYM ATTIRE

There are way too many fashion options to choose from not to look good on the workout floor. Get rid of those awful sweats and get some haute gymwear! A great workout motivator is seeing how good you look on that treadmill when you glance in the mirror.

DON'T WEAR ATHLETIC WEAR EVERYWHERE

Even though highly styled athletic wear is made to be worn beyond the gym, athletic wear is not streetwear. Here are a few guidelines: Leave it at home for work; a first date, unless it involves physical activity; and dinner out. Athletic wear is fine for shopping, to wear to brunch with girlfriends—depending on where you go— and the gym, of course.

BLACK IS NOT NECESSARILY THE BEST CHOICE

All black everything is not automatically figure flattering. If the fit is bad, then the garment or outfit will not show your figure at its best no matter what color it is.

DON'T GET HUNG UP ON SIZES

Size does not matter; fit does. Every designer uses different-fit models when creating clothing, so it's normal to wear different sizes across brands. Then there is the issue of vanity sizing, a procedure designers use to add a few more inches to a garment without changing the size on the label. Vanity sizing is done to make the size-conscious public believe they wear a smaller size than they actually do. Don't

worry about your size: just try on a few different sizes of the garment you're interested in and buy the one that fits you properly.

DON'T ABANDON THE BELT

Every woman has a waist. There is something about a little cinching that raises the sass bar, so go for it. When purchasing belts, try on different widths, styles, and colors. You will discover a new level of confidence when you find the belt that takes your style to the next level. For more on belts, see pages 223–224.

GO HERE . . .

TAILOR YOUR CLOTHING

A good tailor is every woman's secret weapon. There's no substitute! Most department stores and boutiques offer tailoring services too. Wearing clothes that fit and hang properly on your body can make the difference between terrible and terrific, and so-so and super. It's that simple!

WEAR FITTED SILHOUETTES

"Fitted" or "close to the body" is not the same as "tight." If you do choose to wear a body-conscious dress or a sleek jumpsuit, wear the appropriate body-smoothing shapewear.

DARE TO DRESS SEXY

You can show off your curves on date night, but keep in mind that this is where achieving a balance between what you reveal and what you conceal is very important. In other words, if you are going to show a little more thigh than normal, do so with a high-slit skirt paired with a modest, less revealing top. It's all about finding equilibrium between elegance and provocation. Sexy is not the twin sister of tacky!

TRY TRENDS

New seasonal color and silhouette trends are worth trying. If you are unsure about purchasing something outside your comfort zone, utilize what I refer to as my dream rule: Don't buy it, or put it on hold. If you find yourself dreaming about the item for more than a day, go back and buy it. If you don't, let it go. You don't like it that much!

ACCENTUATE THE POSITIVE

If you have nice legs, dresses, skirts, and shorts are your friends. If your waist is your winning feature, invest in great belts. If you're unsure about what your best asset is, take this foolproof advice from designer Donna Karan, "A woman's shoulders are her best asset." After all, she put the cold-shoulder dress on the map!

PAY ATTENTION TO LENGTH

It's important to pay attention to your skirt and dress lengths. Dresses that are too short may not be appropriate. Be honest with yourself, no matter how old you are: if your thighs or knees are not your best feature, opt for skirt, dress, and short lengths that are either slightly above or about one inch below the knee. These two lengths are curve enhancers because they give the body more balance. When skirts, dresses, and shorts cut across the widest part of your thigh they generally have a shortening effect on the bottom half of your body.

Pay attention to sleeve lengths too, especially if you have a full bust. Sleeves that end at the bust line make the breasts look larger.

I think it's good to see somebody saying I have a belly and I have cellulite and I still deserve love.

—Amy Schumer, Glamour.com, July 7, 2015

ENJOY A LAYERED LOOK

Wearing layers doesn't have to be a don't for full-figured women. T-shirts, sweaters, leather jackets, and soft wovens are all great for layering. The key is to mix lightweight fabrics, fitted silhouettes, and different lengths.

Two of my favorite layered looks for curves are a fitted sweater over a long, soft T-shirt with either a high-low or handkerchief bottom worn with a great pair of jeans, as well as a high-low top worn with a pair of tailored trousers or pencil skirt fitted at the knee, and topped off with a fitted moto jacket. This type of layering works because it is the outer garment that maintains the shape and structure of the look.

SHOP THROUGH WEIGHT CHANGES

Do go shopping and invest in the essentials pieces even if you gain a few pounds. The most important thing is to wear clothes that fit and to feel you look your very best at every size. If you plan to lose weight, that's fine too, just look for garments that are easy to tailor. Conversely, you probably wouldn't want to purchase skirts and dresses with a lot of intricate seaming if you are losing weight, as they may be difficult to adjust.

BE CONFIDENT

Dress for yourself. Wear your fashion choices with flair. Don't allow others to diminish your confidence—it's your style, not theirs.

———

That last point is an important one. Curvy women have every right to feel confident and to own our style! Mainstream fashion gatekeepers have always had a lot to say about what we could and couldn't wear— and I've had a great time proving them wrong, by refuting their myths and putting the proof right out there on some of the world's biggest stages for all to see. It's been the best part of my journey, and you can do it too.

OPPOSITE: Amy Schumer is fearless, funny, and living out loud in her perfect imperfections! Photograph by Meredith Jenks for *Marie Claire*, November 2013. PAGES 144–145: From left to right: models Danielle Redman, Marquita Pringe, Inga Eiriksdottir, Julie Henderson, and Ashley Graham are not only redefining today's standards of beauty, but are encouraging woman not to let the scale determine whether they are in shape and healthy through their empowering hashtag #BeautyBeyond Size.

5

Fashion Myths Debunked

STYLE KNOWS NO SIZE

People will stare. Make it worth their while.

—HARRY WINSTON, FROM *DIAMONDS 'NEATH MY WINGS* BY DONALD HAACK, 2009

EVERY SEASON NEW TRENDS AND RECYCLED LOOKS BOMBARD THE FASHION SCENE. Between over-the-top advertising, the much smaller size of models on the runway and in advertising, and holding on to the myths about what a plus-size woman can and cannot wear, it's easy to get lost in the translation from runway to the real way and be left wondering, "Will any of this look good on me?"

Add to that the mainstream attitudes about what curvy women should not wear, and the notion of dressing fashionably becomes overwhelming. Curvy women should not wear all white or dress monochromatically. They should avoid prints, vibrant colors, close-fitting garments, feathers, fur, fringe, and any fabric with sheen or embellishment. Horizontal stripes or a two-piece swimsuit are an absolute no-no. Sound all too familiar?

Throughout my styling career I have had to ignore these dated ideas. Instead, I've always focused on putting together great looks that my clients can don with confidence. Experience has taught me there are more options for curvy women than we've had drilled into our heads. As far as I am concerned, you just need to remember three critical points: 1) choose the right silhouette for your body type in your correct size; 2) select appropriately balanced accessories and jewelry for whatever you are wearing; and 3) coordinate colors and patterns appropriately.

Getting dressed should be a pleasant experience, unbound by the style missteps of the past or "rules" set aside for curves. Today, designers are delivering on the curvy woman's demand for head-turning fashion without limits. So, let's debunk some fashion myths and shape-shift some trends.

Stripes

No more yipes to stripes! Both horizontal and vertical stripes can be very flattering on a curvy body. If wearing stripes is new to you, ease in with striped accessories like shoes, handbags, or bangles. Stripes don't have to get all the attention, either: you can layer them with a denim jacket or a blazer in a complementary tone. It's all about finding the stripe width that works best with your size. The following tips will show you how to choose the right stripes for your shape.

Most women believe that if they wear very thin stripes they will appear smaller. The reality is that curvier women need larger stripes—one inch or more. When I talk about

PAGE 146: This swimsuitsforall campaign featuring Ashley Graham shattered swimwear myths, opened up a world of sexy style possibilities, and freed the curve! Photograph by Russell James for an advertisement for swimsuitsforall that appeared in *Sports Illustrated*'s Swimsuit Issue, February 2015.

the importance of the scale of the stripe in relation to your body, I am talking about how wide the stripe is when you hold the dress or T-shirt up to your body. When you try on a striped garment and you feel like it's making you look too big, generally the stripes are too narrow or too small. The beauty of wearing stripes is that you can use them to emphasize an area of your body that you want to appear fuller or you can use them to de-emphasize an area of your body that you want to look longer and leaner. When you are wearing stripes, it is very important to pay attention to the size of the stripes and the part of your body where you are placing them. Generally, if you want to appear a little fuller, you can go with horizontal; if you want to appear longer and leaner vertical will work.

STRIPES FOR EVERY SHAPE

Hourglass

WHAT WORKS: Your naturally balanced pro-portions allow you to wear horizontal or vertical stripes, particularly tone on tone. But pay attention to the scale of the stripe against your proportions; don't go smaller than an inch. The challenge is not to go too big either, or you will look wider.

WHAT TO AVOID: If you are wearing stripes all over, go very light on the accessories. Keep your look simple and chic with a statement seasonal handbag, oversize sunglasses, and shoes with a pop of color.

GOOD LOOK: A classic suit with vertical navy and white stripes worn with a solid, fitted scoop-neck tank top and a simple medium-heel navy sandal.

Triangle

WHAT WORKS: Your torso needs to be brought into proportion to your hips, which are much wider than your shoulders. Horizontal stripes on top will get the job done. Choose garments and accessories with stripes one inch or wider.

WHAT TO AVOID: Wide horizontal stripes on both your top and bottom will make you appear much larger on the bottom and further distort your proportions. Keep the horizontal stripes on top.

GOOD LOOK: A fit-and-flare dress with black and white horizontal stripes on the top broadens the shoulders. Wearing vertical stripes on the bottom narrows the hips, giving you a balanced appearance.

Rectangle

WHAT WORKS: You can use stripes to add shape to your figure if the stripes are within a chevron configuration, which creates the illusion of curves on the body.

WHAT TO AVOID: Large horizontal stripes worn at the midsection will make your shape look straighter.

GOOD LOOK: A long-sleeve T-shirt dress in classic navy and white in a diagonal chevron configuration. Adding a belt will create even more of a curve. Wedges, an oversize day clutch, and sunglasses are stylish accessories for this look.

Oval

WHAT WORKS: Chevron and vertical stripes minimize the stomach area.

WHAT TO AVOID: Tight tops with horizontal stripes make the stomach more pronounced.

GOOD LOOK: A vertically striped empire-waist dress that grazes the knee does double duty to slim the midsection and will look great accessorized with a pair of cutout sandals with a medium heel and bangles.

Inverted Triangle

WHAT WORKS: Have fun using vertical and chevron stripes to minimize your upper body and add balance to your figure. V- and scoop necklines are your best bets because they elongate the torso.

WHAT TO AVOID: Tops with horizontal stripes make you look wider across the top of your body; if the top has a high neck, it will shorten and widen your torso.

GOOD LOOK: A solid, V-neck, three-quarter-length-sleeve T-shirt with a horizontal striped pencil skirt. A skirt with vertical-striped side panels is a real bonus, adding to the width of your small hips. Belt this look to enhance your curves, and wear a classic pointy-toe pump.

Wearing All White

All white isn't scary: it's chic and fabulous on curves. The key is to find the right silhouettes with strategic seaming and draping in substantial fabrics. When wearing all white, proper-fitting shapewear in your skin tone is the key to a seamless appearance. An all-white ensemble looks nice accessorized with a neutral handbag and matching shoes, and a bright scarf in a primary color. If wearing pure white gives you pause, try wearing a tone-on-tone look in ecru.

ALL WHITE FOR EVERY SHAPE

Hourglass

WHAT WORKS: Any silhouette that highlights your curves, especially jumpsuits and dresses.

WHAT TO AVOID: Dresses made of thin, clingy fabrics do not flatter the hourglass shape. Choose silhouettes in good-quality fabrics that have more heft so that they billow and flow around the hem and sleeves.

GOOD LOOK: A fitted white, good-quality T-shirt with wide-leg high-waist linen pants and platform sandals is a good look, especially with a stack of bangles and a long pendant necklace. Don't forget the oversize shades.

Triangle

WHAT WORKS: Fitted skirts and trousers and blouson tops in all white work well for your proportions.

WHAT TO AVOID: Trousers and skirts without a defined silhouette and shoes that are weighty, such as thick, round-toe platforms.

GOOD LOOK: A white, lightweight cotton blouson top paired with boot-cut jeans, a medium-width belt, simple silver metallic sandals, and a large white hobo bag works for your shape.

> ## Accentuate the positive and delete the negative, because that gives you confidence.
>
> —Donna Karan, Vogue.com, August 24, 2015

Oval

WHAT WORKS: Loose-fit dresses and tops; well-tailored suits with vertical seaming in the front and back of the jacket.

WHAT TO AVOID: Tops and dresses that have too much fabric around the midsection; you want a loose fit around the stomach, but not oversize or shapeless.

GOOD LOOK: Skinny jeans with a casual, loose-fitting, white button-down shirt. Add white wedge sandals to complete this look.

Rectangle

WHAT WORKS: Dresses and separates that are voluminous on top and slightly gathered at the waist or flowing on the bottom.

WHAT TO AVOID: Clothing lacking in shaping details, such as empire tops and loose-fitting layers. You need to create defined curves when you get dressed.

GOOD LOOK: A cap-sleeve fit-and-flare dress. Add a wide belt to create even more shape and a pair of nude medium-heel sandals.

Inverted Triangle

WHAT WORKS: Fitted deep V-neck tops with full skirts or palazzo pants.

WHAT TO AVOID: Cap sleeves and sleeves that end on your arm near your bust line draw attention to the bust and make you appear much larger than you are in the torso.

GOOD LOOK: Try a fit-and-flare scoop-neck midi dress, with a fitted three-quarter sleeve and a simple pair of metallic kitten-heel pointy sling backs.

Monochromatic Dressing

Monochromatic dressing is technically all about wearing one color from head to toe. You can also try wearing a couple of shades of a color as well, which enables you to use darker shades to de-emphasize and lighter shades to highlight aspects of your figure.

Monochromatic dressing is a great look for curves because it creates an uninterrupted visual line from head to toe, making you appear taller and leaner. The key to making monochromatic dressing work is to choose simple silhouettes and colors that flatter your skin tone. If you feel your ensemble needs to be livened up, try carrying a substantial-size handbag in the strongest, deepest hue of the color you've chosen—or with an equally strong color in the same tone.

MONOCHROMATIC DRESSING FOR EVERY SHAPE

Hourglass

WHAT WORKS: You can wear all one tone or variations of it. When wearing one tone, utilize texture and interesting accessories to add interest and separation, because you want to break up the continuous color without adding an additional color. The texture and accessories will also highlight your curves.

WHAT TO AVOID: Shapeless garments, especially all in one color, will disrupt your proportions and hide your natural curves.

GOOD LOOK: A fitted suit, with either a skirt or pants works for you because it makes you appear longer and leaner.

Triangle

WHAT WORKS: If you wear two tones of the same color, wear the lighter tone on top to increase or highlight your upper body and a darker shade on the bottom to de-emphasize your fuller hips. Carry a purse in the same colorway to add more color dimension to your look.

WHAT TO AVOID: If you wear two tones of a color, do not wear the lighter shade on your lower half.

GOOD LOOK: A chambray button-down shirt with darker denim pencil skirt and a camel-colored sandal.

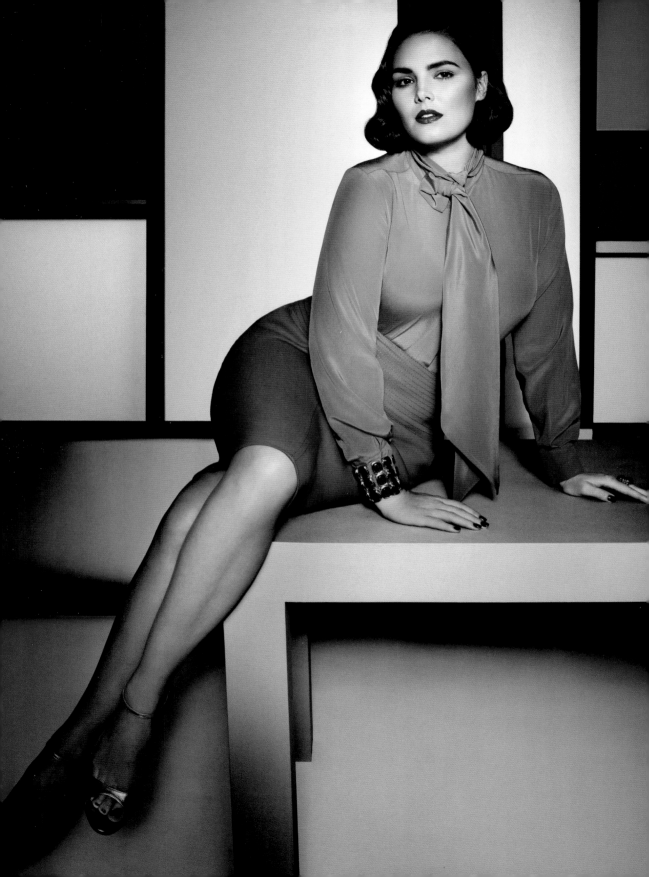

Oval

WHAT WORKS: You look good in all one color in jewel tones or rich neutrals. Wear silhouettes on top that are open at the neck to elongate your body.

WHAT TO AVOID: Light colors around the midsection when the rest of the garment is a darker tone. For example, when wearing various tones of the same color, the lightest tone shouldn't rest at the abdomen. It will make your stomach appear larger.

GOOD LOOK: A tone-on-tone U-neck tunic with capri pants and flat, snake-embossed black sandals looks sharp.

Rectangle

WHAT WORKS: Jewel-tone garments that gather and drape at the waist because they create the illusion of shape and a more defined waist.

WHAT TO AVOID: Heavy knits, as they will cling to your torso and make your figure appear straighter.

GOOD LOOK: A wrap shirt and tailored, high-waist pants will create great curves for you. Add a pair of sexy high heels and you're good to go.

Inverted Triangle

WHAT WORKS: Wearing a slightly lighter tone on your bottom half and a darker tone on top to de-emphasize your upper body and provide balance.

WHAT TO AVOID: The opposite of what works for you. See above.

GOOD LOOK: Palazzo pants with a surplice top, all in the same tone, work for your shape because the neckline of the top makes the shoulders appear narrower, and the ruching adds definition to the waistline. Platform sandals add a nice finish to this ensemble.

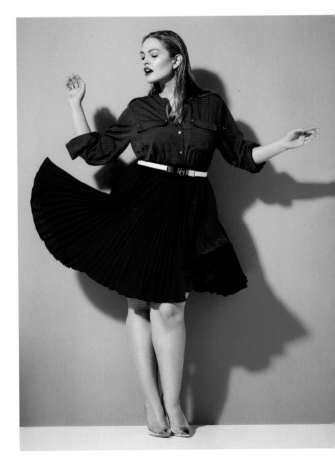

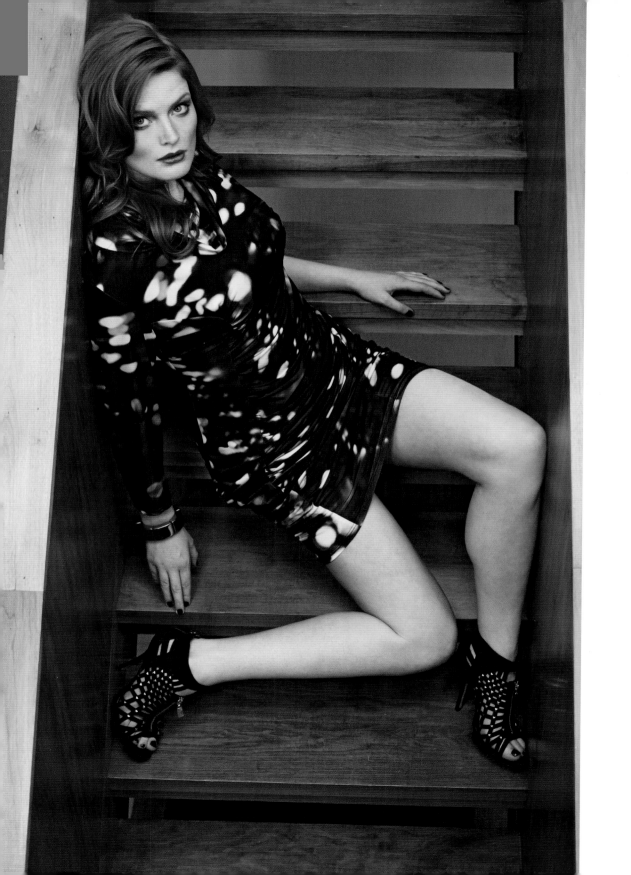

Prints and Patterns

Whether you wear a small or large print is a matter of personal taste, but what's most important for a curvy woman is to make sure the scale of the print is in proportion to the size of her body. Some prints look best in more structured silhouettes like jackets and tailored skirts, while others work better in softer shapes. For high impact, embellish prints with jewel-tone accessories that complement the dominant color.

Choosing small or large prints is really a matter of personal taste, and honestly, you will only know what looks right or wrong once you try it on, and by that I mean whether they overwhelm or underwhelm your shape and whether they make you appear larger or disrupt your proportions. One trick that works is to vary the scale: for example, if you wear a medium or large print on the smaller portion of your figure and wear the smaller print on the larger part, you will create balance—that's a great tip for triangle shapes.

PRINTS AND PATTERNS FOR EVERY SHAPE

Hourglass

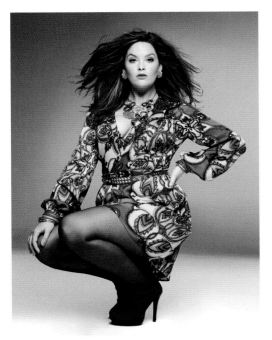

WHAT WORKS: You can wear head-to-toe prints, but you need to pay close attention to the size of the print and the silhouette in order to maintain your proportions. If you choose an all-over print that is really busy, incorporate solid color where you can. If the suit is a print, wear a solid-colored tank top or blouse underneath. This will break up the pattern and add some dimension.

WHAT TO AVOID: Very large prints and patterns; if your naturally proportioned silhouette seems to disappear when you put on a print garment, the print is too large.

GOOD LOOK: You can carry off an ethnic-inspired-print pantsuit paired with a solid tank top or blouse and shoes in a coordinating color.

Triangle

WHAT WORKS: Wear a print on top and a solid on your lower half for balance.

WHAT TO AVOID: Loud, multicolor prints on your bottom. If you really love this trend, try neutral tone-on-tone prints.

GOOD LOOK: A semifitted print jacket that curves at the hip with soft boot-cut jeans and high heels is a great look for you.

Oval

WHAT WORKS: Abstract prints and medium-size geometric patterns for your upper body.

WHAT TO AVOID: Any print that puts too much emphasis on your midsection.

GOOD LOOK: A peasant top with a V- or U-neckline in a jewel-tone, dark abstract print with a straight-leg pant works well because the top does not add volume to the midsection; ankle-strap heels complete the look.

Rectangle

WHAT WORKS: Medium-size prints on garments with great shaping details, such as jackets with princess seaming and dresses with seaming that resembles a diamond or triangle.

WHAT TO AVOID: A boxy silhouette, like a drop-waist dress, is not flattering because it does not provide any shaping.

GOOD LOOK: A belted print jacket with an A-line print skirt or pleated pant is a curve enhancer.

Inverted Triangle

WHAT WORKS: You can wear prints on your lower body with jewel tones or dark solids on top. Prints are great for balancing your proportions. If you want to wear more than one color on top, do it with your jewelry.

WHAT TO AVOID: Multicolored print tops; stick with tone-on-tone prints.

GOOD LOOK: Tone-on-tone prints in a jewel tone or dark hue on top in the right silhouettes, such as a billowing peasant top, are a good look.

PAGES 162-163: Mindy Kaling, *Vogue,* April 2014. Mindy has great style: she wears bright colors, likes to mix patterns, and chooses the right silhouettes for her shape. We can't wait to see what she wears next.

Body-Conscious Dresses

The body-conscious, or bodycon, dress took its cue from designer Herve Leger's figure-hugging bandage dress and it lives up to its name, hugging every curve and feeling like a second skin. Body-conscious dresses, especially in bright or light colors, are not for the fashionably timid at any size, and yes, you can wear one. A great fabric that supports your curves is essential, along with the appropriate undergarments. Look for dresses that graze the knee with strategic contouring, ruching, or sewn-in support, and you're good to go.

BODY-CONSCIOUS DRESSES FOR EVERY SHAPE

Hourglass

WHAT WORKS: The bodycon dress was probably created with you in mind. What works best for your curvy shape are dresses made with high-quality fabrics.

WHAT TO AVOID: Wearing bodycon dresses too short is not flattering. They look sexier and more sophisticated if they reach the knee, a length that elongates your curves.

GOOD LOOK: The signature V-neck classic bandage bodycon dress works for your curves, offering all the support you need. A metallic stiletto and an envelope-style clutch will complete your look.

Triangle

WHAT WORKS: Color-blocked dresses that are lighter on top and darker on the bottom provide balance.

WHAT TO AVOID: Solid-colored dresses or those with a lighter color on the bottom, which will make your hips look wider.

GOOD LOOK: A short-sleeve body-conscious dress with a sweetheart neckline will put the focus on your upper body, providing figure balance. This dress looks great in a deep jewel tone or black, with a pair of peep-toe heels.

OPPOSITE: Jill Scott, stunning in this white Carmen Marc Valvo body-conscious dress, photographed by Steven Gomillion and Dennis Leupold, for *Billboard,* July 2011.

> I think every girl that's a little curvy can tell you it doesn't stop you from having sex, it doesn't stop you from doing anything, unless you decide you should hide in a shame pit because you don't look like a Victoria's Secret Angel.
>
> —LENA DUNHAM, *GOTHAMIST*, JANUARY 16, 2014

Rectangle

WHAT WORKS: Because you need to create waist definition, wear a full-body shaping slip with waist contouring and seaming under a body-conscious dress.

WHAT TO AVOID: Don't try to create curves with more than one undergarment—you want to keep your look smooth.

GOOD LOOK: Try a short-sleeve bodycon with a U-neck and a flirty ruffle on the bottom. The sleeves, neckline, and the ruffle detail will create the illusion of curves. And don't forget that body-shaping slip and a sleek high heel.

Oval

WHAT WORKS: Wearing a body-conscious dress with another piece on top will help camouflage and shape your midsection.

WHAT TO AVOID: Wearing a bodycon dress alone is not for you, as it exposes your midsection.

GOOD LOOK: A knee-length bodycon dress, with a draped-front duster and a strappy stiletto.

Inverted Triangle

WHAT WORKS: Body-conscious dresses with curve-shaped illusion panels on the side, a darted bust, and three-quarter or long sleeves work for you.

WHAT TO AVOID: Sleeveless bodycon dresses aren't the best choice, as they will make you appear broader across the shoulders and bust line. Three-quarter or long sleeves are a better way to go.

GOOD LOOK: A V-neck, ombré (choose one that goes from dark to light) bodycon dress worn with a high-heel bootie.

OPPOSITE: Lena Dunham, photographed by Paola Kudacki for *Elle*, February 2015.

Skinny Jeans

Skinny jeans are not just for the skinny. To wear them, you just have to achieve the right proportion between your upper and lower body. With something so form-fitting on your lower half, you want to wear something looser-fitting on top, but not so loose that you appear shapeless. In fact, with skinny jeans, whatever you wear on top will determine the definition of your proportions, so pay close attention to the length of your tops—hip-length is often most flattering in terms of a sweater or jacket. Avoid baggy tops and T-shirts, as they are not flattering; go for those with strategic seaming. Purchase skinny jeans in a dark indigo wash so you will be able to wear them casually or dress them up. Skinny jeans work with almost every style of shoe too, including the latest athletic sneakers.

SKINNY JEANS FOR EVERY SHAPE

Hourglass

WHAT WORKS: Mid- to high-rise skinny jeans are a great choice for you because the design prevents the creation of a muffin top and helps you maintain your naturally well-proportioned shape.

WHAT TO AVOID: Jeans with whiskering on the thighs and hips will make them look larger.

GOOD LOOK: A tank top with a structured jacket that grazes your high hip and a great belt for the jeans works to accentuate your natural curves. Finish off the look with a pointy-toe heel.

Triangle

WHAT WORKS: Dark-colored jeans are a good choice because they minimize the hips.

WHAT TO AVOID: Jeans with small pockets, as they will make your bottom appear larger.

GOOD LOOK: Dark indigo or black jeans paired with a vibrant-colored, billowy blouse in a pretty print is a good choice, along with peep-toe booties.

Rectangle

WHAT WORKS: A medium to light shade of denim is a good choice because it puts more emphasis on your bottom.

WHAT TO AVOID: Jeans without side and back pockets will not give you the curve you need.

GOOD LOOK: Wear skinny jeans with a soft-shouldered, high-low top, a tunic, or peasant blouse. You can add a hip-length, well-shaped jacket, and a pair of floral-print wedges.

Oval

WHAT WORKS: Mid-rise jeans help camouflage your tummy.

WHAT TO AVOID: Any jeans that are tight at the waist, as you're prone to muffin top. You should be able to place two fingers inside your waistband after buttoning.

GOOD LOOK: Try a simple V-neck or scoop-neck soft empire-style T-shirt or a billowing off-the-shoulder peasant top with medium indigo skinny jeans and a pair of wedges.

Inverted Triangle

WHAT WORKS: A medium indigo will help highlight your bottom.

WHAT TO AVOID: Oversize tops aren't a good choice for you to wear with skinny jeans because this combination will exaggerate the disproportion of your upper and lower body.

GOOD LOOK: Try indigo jeans with a tank top, and add a loose tunic, soft high-low T-shirt, or a drape-front cardigan to provide balance. A platform brogue will finish the outfit nicely.

I wish I had invented blue jeans: the most
spectacular, the most practical, the most relaxed
and nonchalant. They have expression, modesty,
sex appeal, simplicity—all I hope for in my clothes.

—Yves Saint Laurent, *New York* magazine, November 28, 1983

Swimwear

The notion of plus-size women wearing sexy swimwear was once considered to go together about as well as oil and water. Things have definitely changed: when model Ashley Graham posed for a 2015 advertising campaign for plus-size swimsuit retailer swimsuitsforall in a black bikini alongside the slogan, "Are you ready for this beach body?" it did more than push the envelope, it was a global revolution! And Graham also appeared in *Sports Illustrated*'s swimsuit issue in 2015 (see page 146)—the first plus-size model to do so. Today, swimwear for curvier women is fantastic: from cutout and fringed to bejeweled, there are beautiful options available for every body shape. Let's look at what works specifically for yours.

SWIMWEAR FOR EVERY SHAPE

Hourglass

WHAT WORKS: One-piece suits with cut outs, one-piece halter styles, and bikinis with medium- to high-waist bottoms are perfect for your curves. In fact, most one-piece suits in a solid color will work for you. Strapless and bandeau styles will also look good on your frame for the same reason.

WHAT TO AVOID: Major print or pattern mixing in two significantly different color schemes, as this may disrupt your natural figure balance.

GOOD LOOK: A ruffle-trimmed bikini, a single-color tankini, or a one-piece banded-waist swimsuit all accentuate your figure.

OPPOSITE: This vintage-inspired high-waist bikini provides solid support and coverage, yet it's sophisticated and sexy, making it perfect for poolside posers who don't do much swimming. Photograph of Denise Bidot by Michelle Alexander for *Dare*, summer 2014.

Triangle

WHAT WORKS: Suits that accentuate your upper body and de-emphasize your lower body work well; options include a bikini with a printed top and a solid bottom or a one-piece suit with a padded bust and high-cut leg.

WHAT TO AVOID: Bright-colored bikini or tankini bottoms. They will emphasize your hips.

GOOD LOOK: A one-piece swimsuit in a geometric pattern or a floral print with a top that has a little push-up, padding, and wide-set straps to balance your lower half. You can also wear a two-piece swimsuit with a dark bottom and high-cut legs with a top in a lighter shade of the same color with padded bra cups.

Rectangle

WHAT WORKS: Swimsuits that create shape through print, pattern, trimmings, embellishments, or padding. If you choose a two-piece, go for one with a bottom that is lighter in tone than the top and that cuts straight across your body, from hip to hip, which creates the illusion of a wider hip.

WHAT TO AVOID: Solid color, non-embellished swimsuits and plain one-piece suits are not great choices, as you need to create curves through your clothing. If you prefer a one-piece suit, choose one with a crisscross front or with embellishment around the hips and bust.

GOOD LOOK: A print suit with ruffles running vertically down the sides of the suit, a padded top, and wide-set straps.

OPPOSITE: Crisscross bust detail, wide shoulder straps, and ruching throughout the midsection are flattering, stylish details for all body types.

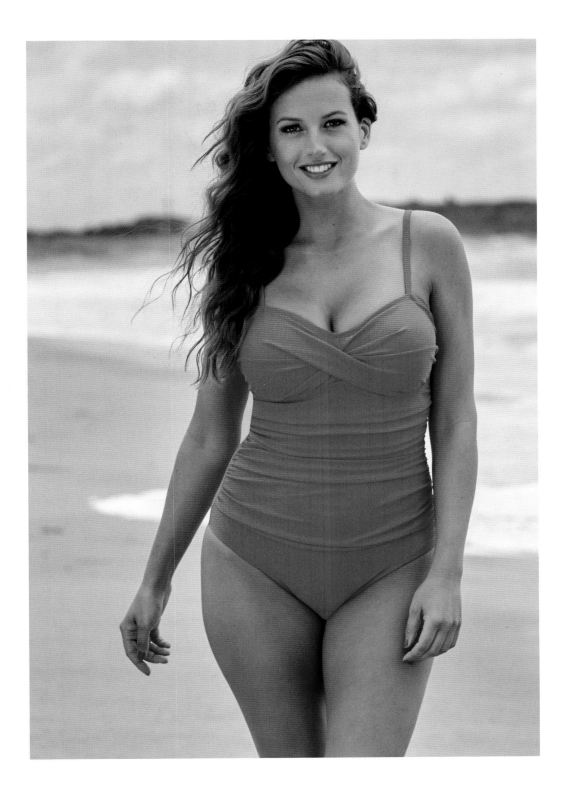

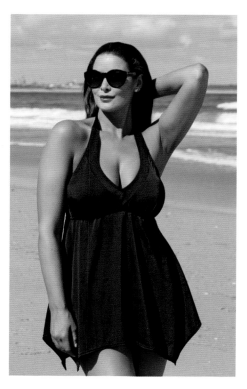

Oval

WHAT WORKS: Suits that de-emphasize your midsection and emphasize your hips are the way to go. Straps should be positioned at the middle of your shoulder to enhance your proportions. Try one-piece suits with hourglass illusion panels, matching-top-and-bottom tankinis with straps that sit mid-shoulder. Adjustable side ties will also give you more curve in the hips, and a skirted empire-waist two-piece suit with an ombré top that goes from light to dark from top to bottom is flattering.

WHAT TO AVOID: One-piece swimsuits without shaping details won't work for you because you need support in your midsection.

GOOD LOOK: Swimsuits with wrap or crisscross details create curves and give the stomach a flatter appearance.

Inverted Triangle

WHAT WORKS: Hip-enhancing details, such as swimsuit bottoms in a lighter color than your top and that are cut straight across the hips and with adjustable side ties, provide the balance you need.

WHAT TO AVOID: Swimsuits with skimpy shoulder straps only make your broad shoulders look broader; and if you have an ample bosom, you need better support than a skimpy strap can provide.

GOOD LOOK: Choose a halter-top tankini with adjustable side ties or embellished bottoms to add volume to your bottom and balance to your overall proportion. Another option to achieve the same result is a one-piece suit with a plunging neckline.

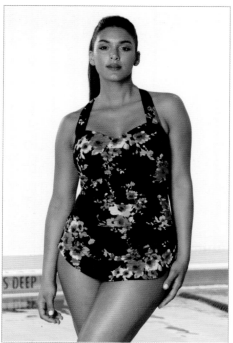

OPPOSITE: Here's proof that a white suit is not off limits for a fuller figure: you just need to find a suit with shaping details that work for your body shape.

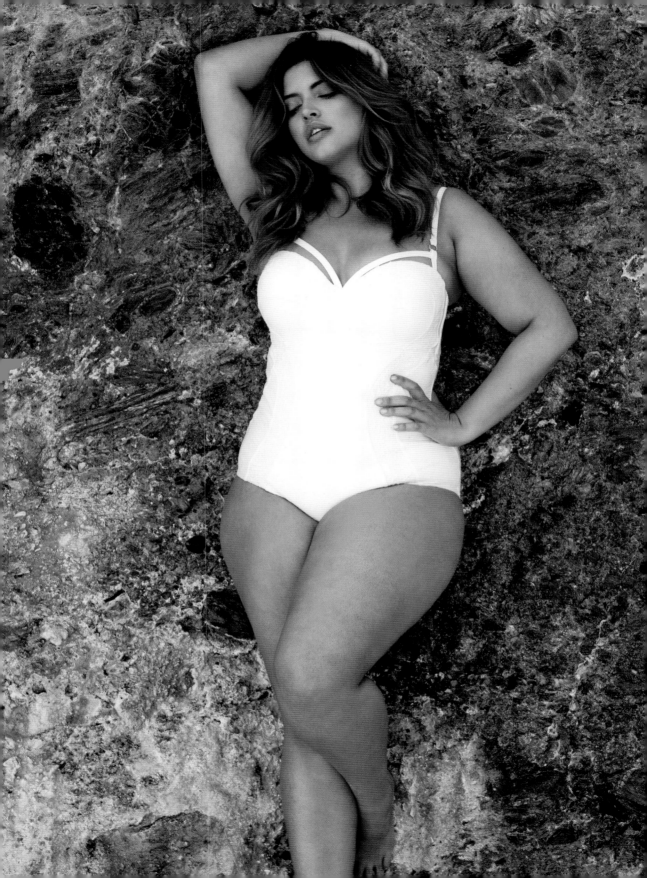

Shiny Embellishments

Paillettes, sequins, beading, metallic embroidery, rhinestone and crystal trim, and other embellishments that lend shine to a garment are no longer a full-figured fashion faux pas. Generally, embellished clothing looks best on silhouettes that are couture-inspired yet streamlined, such as sheath dresses, dolman tops, and fitted tuxedo trousers. These decorative details, mostly used as trims and accents, and sometimes throughout the entire garment, extend a garment beyond its normal wear and gives it a luxe value.

SHINY EMBELLISHMENTS FOR EVERY SHAPE

Hourglass

WHAT WORKS: Use embellishment that emphasizes what you love most about your figure. If it's your bust line, try a top with beaded trim. If it's your curves in general, look for tops and dresses that have a mixture of matte and shiny details—if you go with all beading and sequins, it could be too much.

WHAT TO AVOID: Shiny embellishments solely on your waist, such as on an obi or cummerbund, can make you appear larger in your midsection and throw off your even proportions.

GOOD LOOK: Pair a pencil skirt with a beaded, scoop-neck T-shirt that fits close to the body. A pair of cutaway kitten heels tops off this easy look for daytime shine.

FUR AND FEATHERS

Outerwear in or embellished with fur or faux fur, and shearling—and even feathers—is hot on curvy girls. The trick is to wear showy coats with fitted silhouettes underneath, such as pencil skirts or straight-leg trousers, to keep the look fashion forward and sexy and to avoid creating volume. Fur and faux fur make outerwear and accessories glamorous and fun, whether it's a pair of fur-trimmed gloves or a cashmere coat, or a full-on knee-length vest. If you are going to indulge in froufrou, go small, using it to beautifully frame your face or as an accent at the knees and wrists.

OPPOSITE: Penélope Cruz at the world premiere of *The Pirates of the Caribbean: On Stranger Tides*, 2011.

Triangle

WHAT WORKS: Tops with embellished shoulder and shiny neckline trims will broaden your upper body to create the illusion of better proportion.

WHAT TO AVOID: Skirts and pants made with shiny fabrics, or detailed with embellishments on hip or back pockets, will make your bottom look larger.

GOOD LOOK: A structured, metallic blazer with lightly padded shoulders over a little black dress for a chic, well-balanced look.

Rectangle

WHAT WORKS: Applications that create shape or volume around the torso and hips, such as sequin piping or beading, give you curves. Metallic belts do too.

WHAT TO AVOID: Dresses and jackets that are heavily embellished in the midsection because they will not help to define your shape. They will only make you appear large in that area.

GOOD LOOK: Try a metallic blouson top with black, tailored, boot-cut pants and a strappy stiletto.

And, now, I'm just trying to change the world one sequin at a time.

—Lady Gaga, Independent.co.uk, November 2010

Oval

WHAT WORKS: You can use sequins and other embellishments to draw attention away from your midsection. Try jackets, dresses, and shirts with shiny details around the neckline and wrists.

WHAT TO AVOID: Do not wear any large or shimmery appliques on your upper torso, as they will make your midsection appear larger.

GOOD LOOK: A knee-length empire-waist dress, with embellished trims is very flattering, as it will allow you to showcase your legs and give you the appearance of a higher, more defined waistline.

Inverted Triangle

WHAT WORKS: Embellished skirts, trousers, and jeans create much needed volume. Try a sequined pencil skirt.

WHAT TO AVOID: Sequined or beaded occasion tops and dresses with crew and bateau necklines make your breasts and shoulders appear larger.

GOOD LOOK: A matte-sequined or lightly beaded godet skirt paired with a princess-seamed blazer with three-quarter sleeves is a good look for you. If you prefer pants, wear the same blazer with straight-leg trousers with beaded piping. The blazer will add definition through the waist, and the shine on the pants will add volume, which will make you appear taller and more curvaceous.

Myths are myths. And rules are meant to be broken. Today's full-figured women, from the college campus to the boardrooms, the runway to the red carpet, are embracing their fashionable selves and wearing clothes they like with full confidence. So put your toe in the pool in your designer swim suit—the water's fine!

6

Your Style Personality

YOU HAVE TO BE YOU

I always felt like I was carrying a torch for women of any size to be themselves—it doesn't matter whether you're a size 2 or 22, just be who you are.

—QUEEN LATIFAH, *WOMAN'S DAY* MAGAZINE, OCTOBER 2008

EARLY IN MY CAREER I WAS VERY MUCH A FOLLOWER OF FASHION TRENDS. I have always enjoyed trying out the latest and the greatest, but as my career flourished and I began to travel with clients more frequently, I realized I couldn't be overly concerned with tending to the complexities of the look of the moment. Today, I am a minimalist who favors all black, a transition that occurred naturally; I sprinkle my look with a little bling for special occasions and don a current trend on occasion to maintain my trend-loving roots. Wearing well-fitting garments in black allows me to be dressed appropriately for starting my day as early as four in the morning in New York City and ending it in Los Angeles with a client on the red carpet. For work, I wear all black almost all the time because it allows me to visually disappear when a client and I are looking in the mirror together. I want her to always be the prominent figure and for her not to be distracted by my personal wardrobe choices.

The truth is that I really love wearing black; when I am shopping, it's what I gravitate to first. How I feel about black and why I don't discourage wearing it was eloquently defined by Diane von Furstenberg when she spoke of the little black dress. She said, "The little black dress is the true friend. You remember when you met her . . . what happened the first time you wore her . . . she travels with you . . . is patient and constant . . . you go to her when you don't know where else to go and she is always reliable and timeless."

Style is many things—personal, subjective, elusive, and intuitive. Often, but not always, it's the sum total of legacy, environment, experience, lifestyle, and perspective. And while we are not always able to grasp or define it, we know it when we see it. Style is the way in which you present yourself to the world through clothing and beauty. It is an expression of who you are—and when that expression is consistent, it becomes identifiable as you; that's why I always say your style is you being you.

> I feel good in my own skin because I've accepted the fact that I'm me. That's what's so great about being alive and being on this planet: everybody's different.
>
> —KELLY OSBOURNE, *GLAMOUR*, APRIL 2012

PAGE 186: Queen Latifah photographed by Jan Welters for *InStyle*, February 2014.
OPPOSITE: Kelly Osbourne, photographed by Kate Davis-Macleod for *Evening Standard* magazine, October 2014.

Style Personalities

It's not a new idea, but in my work over the years I've found it to be true that women fall into one of five basic style personalities: the classicist, sophisticate, minimalist, maverick, and bohemian. A woman may be predominantly one type, but she might dabble in the others too.

To follow is a profile of each personality: what she loves about fashion, how she expresses herself through fashion, the designers and brands she loves, and the iconic women who share her persona, all with the goal of helping you articulate your style.

THE CLASSICIST

The classicist is a traditionalist. No matter what the latest fashion forecast says, she aspires to timeless chic and refinement. Occasionally, she may flirt with a seasonal color, but never with trendy silhouettes. When she steps outside of her comfort

zone, it is usually a subtle move, with a twist on luxe pieces or accessories, such as a beautiful hat or a silk scarf, but she always remains true to the classic aesthetic.

She is conscientious about dressing appropriately for occasions; no one will ever say her ensemble is wrong. She loves dresses, skirts, blouses, and blazers in elegant, high-quality fabrics and understands the importance of expert tailoring to ensure an impeccable fit. Her jewelry box isn't overflowing with bijoux, but what she does own is fine, very understated jewelry—a traditional strand of pearls, a signature watch, a necklace made of precious stones, and small earrings, whether diamond or pearl studs or tiny hoops. Her shoe choices are refined, with a strong silhouette: sleek pumps, elegant tasseled loafers, and status ballerina flats.

Even when she dresses casually, the classicist is always pulled together. Her jeans are a crisp, dark wash, and designer, paired with a T-shirt made of fine-spun Italian modal, topped with a Burberry three-quarter trench coat, and accessorized with finely made leather boots and a classic tote.

Very often the classicist takes the safe and predictable route when getting dressed. To step outside her comfort zone, she needs to add new colors and sophisticated prints to her cornerstone pieces. To put a

twist on her jewelry collection, she should look for contemporary versions of her go-to accessories. Wearing onyx beads instead of pearls or a shoe with a trendy detail instead of a classic pump could add some nice variety to her wardrobe.

GO-TO BRANDS: Thomas Pink, Brooks Brothers, Ralph Lauren, Michael Kors, and Lafayette 148 are right up her alley.

FAMOUS CLASSICISTS: Michelle Obama, Carolina Herrera, Katie Couric, Nicole Kidman, Oprah Winfrey.

She's Gotta Have It!

1 SIGNATURE ENSEMBLE
A go-to ensemble that will always feel right to the classic woman is a silk button-down shirt or blouse and a pencil skirt topped with a beautiful cashmere coat and accessorized with an embossed structured handbag. This ensemble works in the most refined neutrals as well as in the high contrast of black and white. What makes this a timeless look is the combination of quality fabrics and tailored silhouettes; it takes on a contemporary flair when a print or textured accessories are brought into the mix.

2 WHITE BUTTON-DOWN SHIRTS A button-down shirt or blouse makes a very mediocre look effortlessly chic with ease, which is why it's a go-to item for the classicist. A true classicist will have more than one crisp white shirt or blouse, because as a neutral essential with tremendous versatility, it is never out of vogue and works with suits, jeans, and skirts.

3 COUTURE SHOES
The razor-sharp style that quietly yet definitively emphasizes the classicist's look is embodied in the work of Manolo Blahnik, Salvatore Ferragamo, and Roger Vivier, who all create reliable, eternally chic, and properly embellished footwear.

4 HEIRLOOM-QUALITY WATCH
A high-quality watch is an essential for any wardrobe, but it's a vital component of this style personality's look. Understated in her use of accessories, she knows her watch provides polish and signals her dedication to quality. As a signature piece, a watch should be the highest-quality you can afford. Look for fitted bands and a small- to mid-size case.

5 SIGNATURE INDULGENCE: THE EVENING GOWN
For dressing up, she turns to those on whom she can rely: Carolina Herrera, for her infamous tailored, white taffeta blouses and long black evening skirts, and Oscar de la Renta, known for exquisite gowns in silhouettes that work on every body type.

THE SOPHISTICATE

The sophisticate aspires to be the best-dressed woman in the room—and she's keen on leaving a memorable impression. She rarely leaves the house without some serious style effort. Her impeccable eye keeps her in vogue, with the runway, fashion magazines, and favorite designers as references for inspiration. Yet she is not trendy, just deeply committed to investment pieces that express her taste and personality. She loves a bit of opulence, with a penchant for a bit of froufrou and bold jewelry. This is often a woman with a signature scent that leaves a lasting impression long after she has left the room.

She aspires to elegance, preferring fitted suits with strategic seaming details, structured shoulders, and a cashmere coat or a cape with fur trim. Her jewel-tone sheaths and wrap day dresses work in a board room or for lunch with friends, but it's her beautiful silk blouses paired with jeans or tailored trousers, oversize signature shades, Dior calfskin handbag, and jewelry piled on that lets you know she is approachable and signals her connection to the urban environment in which she thrives.

It's not easy for the sophisticate to be casual. It's simply not in her DNA. In her version, she might pare down the look to a knit dress, sleek pumps, a covetable watch, and a very large and recognizable couture bag, but it's the best of Madison Avenue all the way, and her hair and makeup are always ready for a close-up.

The sophisticate needs to remember that there is such a thing as over-accessorizing. If what you have on feels like it's too much, then it is. When wearing bejeweled clothing, minimize the accessories. When wearing a statement necklace, go with small earrings or none at all, and when wearing a pair of fashion gloves, minimalize the wrist accessories. Go with a fitted, feminine watch or demure bracelets.

GO-TO BRANDS: Elena Mirò, Anna Scholz, Marina Rinaldi, and Tadashi Shoji deliver clever cuts in everything from cocktail and evening dresses to the very best outerwear in premium fabrics.

FAMOUS SOPHISTICATES: Dita Von Teese, Iman, Cate Blanchett, Jada Pinkett Smith, Charlize Theron.

She's Gotta Have It!

1 SIGNATURE ENSEMBLE

The hallmark of the sophisticate's signature look is sexy. On any given day, she might be swathed in a lightweight oversize pashmina with a solid or print, silk jersey wrap dress underneath. If her legs aren't bare she is wearing ultrasheer hosiery with simple neutral pumps. The jewels are ever present, a Cartier watch, diamond studs, and, most likely, an oversize Dior bag.

2 STATUS SHOES

Shoes are all about high fashion and fancy feet, not practicality, thus, the red-carpet regulars—Jimmy Choo, Christian Louboutin, Dior, Chanel, and Saint Laurent—are the ones a sophisticate speaks of like old friends.

3 SIGNATURE SCENT

As she is an individualist keen on making her mark, the sophisticate's wardrobe includes a signature scent, as it establishes an entrance, amplifies her presence, and lingers after her departure. Bond No. 9 is a great resource for her: this international perfumery offers a wide selection of beautiful scents as well as exclusive individual scent customization.

4 SHOWSTOPPING JEWELRY

The sophisticate loves jewelry as much as she

loves clothes, and her trademark pieces—David Yurman bracelets as well as Lanvin and Gucci fine jewelry—will be noticed. Her jewelry box is an eclectic mix, often runway- and vintage-inspired. She favors eye-catching pieces such as beautiful brooches, interesting rings, and dramatic necklaces.

5 SIGNATURE INDULGENCE

The sophisticate takes great pride in her look, which she orchestrates from the inside out. She loves to indulge in high-quality shapewear and lingerie from Elomi, La Perla, and Body Wrap.

CURVY CONFIDENTIAL

FINDING YOUR SIGNATURE SCENT

It's not always easy to find the scent that is inarguably you, but when you do, you will know it. When shopping, it's always a good idea to ask for a sample to take home—and if that's not possible, most stores will provide a scent strip or two for you to try out. Layering a scent is a great idea for a romantic evening or special occasion; try a body cream with your scent on top for a lasting impression. And remember less is more!

THE MINIMALIST

The minimalist favors neutral palettes, clean lines, and sparse details. Simple luxury is the foundation of her style DNA. Wearing all black, the most refined neutral, is a constant for her, but occasionally she might dress monochromatically in other neutral tones. Her taste in jewelry leans toward the strong and singular, perhaps an unusual, hand-sculpted necklace in a dull metal or a stack of interesting rings. A big, beautifully structured handbag as well as a pair of contemporary eyeglasses and sunglasses with frames in strong shapes are an integral part of completing her look.

Even when casual, the minimalist is a study in chic. When she shows up layered in black, with her leather moto jacket topping a soft, high-low T-shirt, skinny jeans, and a pair of black leather platform brogues, everyone wants to know who she is. For a casual afternoon walk around any big city, she's usually got an oversize structured handbag in tow and is sporting a pair of sleek shades that evoke mystery.

The minimalist is certainly the epitome of effortless style, but sometimes too much understatement can look a little plain. Experimenting with avant-garde jewelry and interesting shoes adds a little spice to the look, as does pulling a little more makeup into the mix if her wardrobe's neutral palette is washing her out.

GO-TO BRANDS: Carmakoma, the design collective for Evans; Eileen Fisher, Jil Sander, and Calvin Klein are best in maximizing the less-is-more fashion statement and straightforward, uncomplicated fashion season after season.

FAMOUS MINIMALISTS: Diana Vreeland, Rooney Mara, Carolyn Bessette-Kennedy, Miuccia Prada.

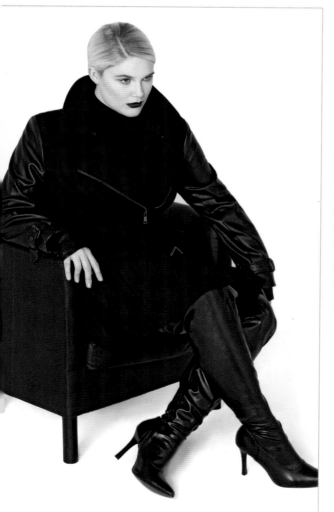

She's Gotta Have It!

1 SIGNATURE ENSEMBLE
All black, all the time!
Or almost. A mixture of
interchangeable classic
shapes in high-quality
fabrics, affordable basics
in neutral colors, and
well-constructed, luxury
accessories that make a
strong impression are the
foundation for the mini-
malist wardrobe.

2 CONTEMPORARY JEWELRY
Jewelry designers Robert
Lee Morris, Alexis Bittar,
and Iris Apfel are masters
at designing impactful
pieces that enhance the
simplicity of the minimal-
ist look. The great fashion
editor Diana Vreeland
favored strong simplicity,
her wrists always clad in
a pair of Verdura cuffs.
A choker, thick stack of
bangles, or an interesting
pendant often frames the
minimalist's style.

3 MAJOR EYEGLASS FRAMES
Black eyeglasses frames with
a strong shape, from Prada,
Oliver Peoples, Selima
Optique, and Alain Mikli
are the perfect accessory
to maximize the minimal-
ist look. All offer a wide
selection of shapes and
embellishments.

Signature eyewear not
only expresses your person-
ality but also puts a defin-
itive stamp on your look.
But be careful: you must
look like you are wearing
the statement eyewear: it
should not wear you.

**4 STRONG SHOE AND
BAG SILHOUETTES** The
minimalist has an eye
for strong silhouettes
that extend far beyond
clothing. Her bags and
shoes always have an
artful and precise line,
from Jil Sander and the
Row handbags to Robert
Clergerie platforms and
Marni leather brogues.
She may keep it simple,
but there's strength in
her choices.

5 NEUTRAL OR RED LIPSTICK
When it comes to makeup,
the minimalist keeps in step
with either a neutral or a
classic red lipstick with a
barely there approach for
eyes and cheeks. If you go
for red, though, invest in lip
liner to prevent feathering
and bleeding, and to ensure
the color stays on. M•A•C,
NARS, and Chanel all make
a great selection of reds.

Dressing in
black means
simplicity of
line, perfection
of cut, and a
touch of spirit.

—SUZY MENKES, ON THE
YVES SAINT LAURENT EXHIBITION
AT THE METROPOLITAN MUSEUM
OF ART, DECEMBER 12, 1983

THE MAVERICK

The maverick loves trying the latest trends and favors sexy silhouettes. She is the haute mix-a-lot of the latest in all things fashion, and does it like no other. For her, fashion is a unique form of self-expression: her favorite pastime is reinventing herself, and she pulls it off every time. Her wardrobe changes may include her hair color and style, dramatic nail art, and makeup. Her shoe and handbag game are always conversation

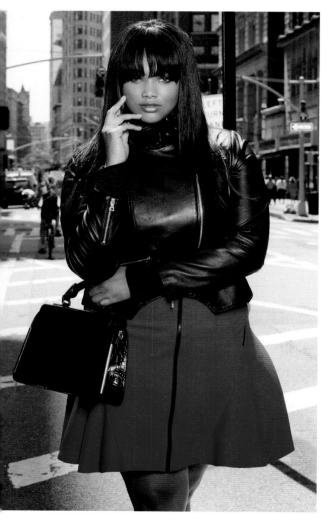

pieces, and her unpredictable style exploits are an inspiration to all who set eyes on her. She takes a daring approach to fashion, and her look is sexy, fun, and cutting-edge, all rolled into one.

Even when the maverick goes out for a little adult playtime she still manages to address the style volume and turn heads. Armed with an "I know I am so fabulous" attitude, she puts on her new James Jeans, a Rebdolls sexy T-shirt, an ASOS suede fringe cape, and towers over everyone in her Dolce & Gabbana Portofino wedges.

As the queen of reinvention, the maverick is trend-driven, and she needs to be sure not to wear all these looks at once. The best way for her to check her balance is to take a good long look in the mirror, decide on a focal point, then peel away distracting items. After all, the idea of being trendy is for the hot new item to stand out. Sometimes less is more.

GO-TO BRANDS: These days established, curve-focused brands, such as Lane Bryant, are collaborating with high-end designers such as Isabel Toledo and Christian Siriano to offer more fashion-forward pieces, and newer brands, like Eloquii and ASOS, are delivering stylish designs to keep the maverick well-dressed 24/7.

FAMOUS MAVERICKS: Tilda Swinton, Beth Ditto, Erykah Badu, Rihanna, and Lady Gaga.

She's Gotta Have It!

1 SIGNATURE ENSEMBLE

The maverick doesn't really have a signature look, although she loves to mess with traditional fashion norms, especially as they relate to her curves. Crop tops, high-waist zip-front pencil skirts, jackets with mesh inserts, oversize and unusually shaped hats, and sheer lace dresses worn with vintage undergarments all have a place in her closet. She is inspired by the archives of her life, so no one tells her what she will or will not wear, and she wears it all so well.

2 MOTORCYCLE JACKET

A leather or suede jacket, or even one that is a mix of materials, enhanced with the latest hardware, speaks to the heart of the maverick spirit.

3 CULT SHOES AND BOOTIES

The latest in footwear, from boots and booties to stilettos and stacked heels, all announce the maverick's arrival—and the higher the heel, the better. Whether strappy, peep-toe, or embellished with hardware, the maverick's shoes have attitude. Count on Giuseppe Zanotti, Burberry, Ash, and Jimmy Choo to keep the maverick in her preferred high-heel style.

4 THE LATEST SEXY DRESS

If it's not sexy, the maverick is not wearing it! So when it comes to shopping for a sexy dress, she cares more about being on trend and having an envelope to push than status, although a designer name comes in a close third in terms of her priorities. She's looking for a dress that clings to her curves and shows off the best of her legs. Whether it's a fitted midi or a fit-and-flare, Monif C., Eloquii, and Fuzzi by Jean Paul Gaultier offer the dress trend of the moment.

5 THE "IT" BAG

The "it" factor is real for the maverick, but she doesn't wait for fashion editors to crown the next hot bag; she decides for herself, whether it's hot off the runway or a timeless favorite from the back of her closet. The party cross-body bag holds appeal, not because it's a status purse, but because its chain-link strap telegraphs urban chic and high fashion all at once. This midsize gem, in either metallic or an exotic skin, is a great choice for the trend-minded.

6 SEXY SHAPEWEAR

As a fan of sexy and form-fitting silhouettes, the maverick must have every inch of what lies beneath her clothes held together with great shapewear. Control shaping slips, torsette camisoles, and high-waist briefs are priorities for her fashion arsenal.

THE BOHEMIAN

The bohemian lives in intricate prints, patterns, and bold colors that she loves to layer with interesting textures, piled-on jewelry, and the occasional oversize hat. Since the late 1960s, this eclectic style has continued to evolve, drawing from different cultures and ethnicities. While the bohemian may look to the current runway for inspiration, it is her creative free spirit that ultimately guides her.

Today's bohemian is more Coachella than Woodstock. She has traded in her oversize, shapeless maxi dresses for short, sheer peasant dresses with the dashiki-inspired motif. The jewelry is more upscale, from Ippolita or Pamela Love, and though her suede ankle boots are distressed, they're of the moment. And if the bag has fringe, it's probably Yves Saint Laurent.

Her look is casual by nature, but if she receives an invitation to a gala, she looks stunning from head to toe in a sheer, fitted print maxi dress by Anna Scholz, strappy high heels, and perfectly light and airy gold jewelry by the Row. Subdued fashion is not her style, so she'd accessorize her outfit with a print evening bag by Charlotte Olympia and a slightly tousled hairstyle.

A lover of layers, the bohemian has to be careful not to add volume to her curves. She needs to take it easy on layers and prints, and wearing her hair in a style that has a lot of volume. Balance bohemian pieces with solid colors and simple silhouettes, such as unembellished flared jeans with a fringed vest, a long-sleeve T-shirt, and ethnic jewels.

GO-TO BRANDS: Michael Kors, Ralph Lauren, Vince Camuto, and Anna Scholz are great resources for boho-inspired clothing and accessories. While Haute Hippie may not be specifically plus-size, some of their pieces are curve-friendly.

FAMOUS BOHEMIANS: Jane Birkin, Sienna Miller, Zandra Rhodes, Mary-Kate Olsen, Ashley Olsen, Lisa Bonet, and Melissa McCarthy.

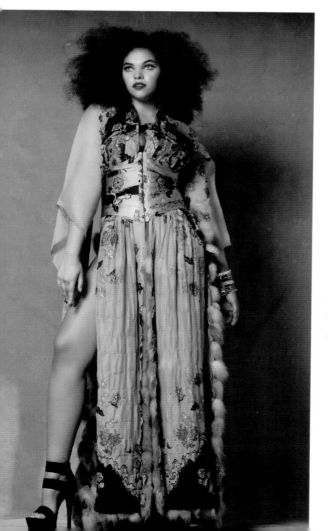

She's Gotta Have It!

1 SIGNATURE ENSEMBLE

The bohemian's quintessentially layered look is not about volume but mixing seemingly disparate colors and textures and pulling it off. The girl has cultural swagger—and her friends and family look forward to seeing what outfit she pulls off next. After all, it's not everyone who can confidently wear a pair of 1970s-inspired wide-leg jeans, a textured T-shirt, and open-toe platform wedges, then top it all off with a vintage suede-and-rawhide bag. It's a look that sets her free and makes others feel alive in her presence.

2 LAYERED JEWELRY

Clashing textures and color are the hallmark of bohemian style, and this notion of everything going with anything extends to jewelry. Commingle charm

bracelets with thin bangles, and layer lariats, pendants, and long, linked chains to get the look. Contemporary jewelry brands Ippolita, Charming Charlie, Pamela Love, and Pandora all offer a wide range of pieces for a genuine, multidimensional bohemian vibe.

3 PRINTED SCARVES, FLOPPY HATS, AND HEADBANDS

Printed scarves, floppy hats, and headbands are signature accessories for the bohemian. Look for braided and bejeweled headbands, and hats in a supple leather or a light felt. For some of the best boho accessory shopping, check out Free People, Urban Outfitters, and Lucky Brand. All three feature consistently great bohemian headwear seasonally.

4 FRINGED CROSS-BODY BAG

Fringe never seems to makes an absolute exit from fashion. A fringed cross-body bag is the convergence of nostalgia, contemporary style, and authentic boho flair. Rich camel tones and deep brown are the common go-to colors, but black, sea green, or distressed blue are good alternate choices.

5 THE NEW BIRKENSTOCKS

First popular in the 1960s, Birkenstocks have remained stylishly bohemian. Luxury designers Jil Sander and Marc Jacobs have both included the shoe in their collections, re-enlivening its popularity and raising it to iconic status. After several decades Birkenstocks still look great with contrasting patterns and fluid silhouettes.

Maintaining Your Personal Style

To effectively nurture your style, you should keep current with your closet, not only in terms of what you own, but whether the clothing still fits and whether you will truly wear it again. Knowing what you already own allows you to plan future purchases intelligently and avoid impulse buying, saving you both time and money.

TAKE INVENTORY

To keep your clothing in harmony with who you are, go through your wardrobe with the change of seasons, or at least once a year, trying everything on with the appropriate shoe in front of a full-length mirror, perhaps with the exception of pieces you wear regularly. Divide what you own into three categories: keepers, those that need repair or alterations, and those that need to be tossed and replaced.

ALTER AND REPAIR

If you find some of your favorite garments are a little tighter or you've lost a few inches and the fit is too big, get them altered. A great tailor is a personal wardrobe magician; he or she can transform the look of a garment by making subtle changes: replacing old buttons, altering the shape to update the look, or adding embellishments to create something unique.

TOSS AND REPLACE

Don't waste closet space for items that are outdated, ill-fitting, or worn-out. Donate or sell them to make room for something fresh or more style appropriate. Make a list of what you need regarding color, wardrobe essentials, extras, and statement pieces before you shop—and take it with you. Stores are seductive places, where the unnecessary item can suddenly seem urgently necessary, leading to an impulsive buy that undermines your style efforts.

———

Style is beyond size, class, and ethnicity. What we wear expresses our individuality beautifully without a sound. Whether you're a classicist through and through or a minimalist whose only accessory is a signature shade of red lipstick, your style choices speak volumes about who you are to the world. Let's turn up the volume with some great accessories in the next chapter.

Self-love has very little to do with how you feel about your outer self. It's about accepting all of yourself.

—TYRA BANKS, *WOMAN'S DAY* MAGAZINE, APRIL 2009

OPPOSITE: Tyra Banks, photographed by Joshua Jordan for *Mega* magazine, February 2014.

7

Accessories

THE STYLE MAKERS

Life is gray and dull. You might as well have
a little fun when you dress.

—Iris Apfel, from the documentary *Iris*, 2014

HANDBAGS, SHOES, STATEMENT JEWELRY, AND BELTS: THESE ARE THE FOUR accessory categories that make the most impact on every day style and expand the versatility of your wardrobe. When paired with a signature piece, a well-considered accessory can transform an ordinary look to an extraordinary one. The key points to focus on when choosing an accessory for an outfit are its color, shape, and texture as it relates to the outfit and its size.

Note that I said size, and yes, it does matter. Accessories that are too short or too small get lost on a curvaceous figure—and may even look juvenile. Substantial jewels and handbags not only add balance to a voluptuous frame but also allow the accessory to have greater visibility. Likewise, shoes that fit properly flatter the feet and elongate the legs. A belt in the right width not only enhances the figure but also creates a more defined silhouette, giving you shape.

When choosing accessories for curvy women, I lean toward bold, statement-making pieces with visible details because these items are in proportion to their figures. Most important, accessories make two vital contributions to a look: they project your personality and taste and give your style extra polish. Accessory shopping should be about filling a specific wardrobe need: whether finding a handbag for work, jewelry for a special occasion, or boots for the new season. If you don't have a real reason to go accessory shopping, you'll most likely buy items that you won't use.

Handbags

THE FASHION CALLING CARD

The handbag is a statement accessory, with fashionistas clamoring for the season's hottest creation. As a bona fide, card-carrying bag lady myself, I am always excited when seasons change and designers reveal their new collections filled with eye-catching colors, luxurious textures, and iconography—and I know I am not alone. Like celebrities, some handbags have become household names—the Hermès Birkin, the Chanel 2.55 flap, and the Prada nylon messenger are just a few examples. And who can forget Carrie Bradshaw's collection of Fendi baguettes in the film and television series *Sex and the City*? The handbag is a major component in completing a look.

Now, if like me, you get excited when setting out to buy a handbag, you'll have to learn to exercise some restraint. To start, don't get caught up in staying on trend, or getting lost in the array of colors, textures, and embellishments, or the sheer beauty of a single bag. Instead, before you go shopping, be clear on what need the handbag is fulfilling for you—in other words, determine how you want to use it and what you will need room for. Also consider color and style before you shop; if you don't, you run the risk of buying a bag that is very similar to a style you already own or being seduced by a new bag because it is trendy, not because it complements your wardrobe. It's important to bear these points in mind when shopping—and you might even want to write them down.

CHOOSING THE RIGHT HANDBAG FOR YOUR FRAME

Selecting a handbag that is in the correct proportion to your frame is not unlike shopping for clothes. Try on the bag and look in a three-way mirror. As a rule, the bag should not be so small that it looks like you borrowed it from a tween, and not so large that it adds bulk to your proportions. Body shape is important too. In general, a shoulder bag with medium to long straps that is generous in size and sits somewhere between the top of the waist and the lower part of the hips is the most flattering style for curvy women.

If you are an inverted triangle, rectangle, or hourglass shape with an ample bosom, avoid a handbag that emphasizes the upper part of the body, because it will make you look larger.

Conversely, if you have a triangle shape, strive to draw attention away from your hips by choosing a handbag that has short straps and fits with ease a few inches beneath your underarm or hangs no lower than just above your high hip.

Building a Handbag Collection

As with a wardrobe, there are essential pieces on which to build a handbag collection. Start with what you really need for work, evenings out on the town and special events, weekend fun, and travel. Base your collection on neutrals such as black, gray, camel, and beige, as these colors are easy to work into a wardrobe. Let's talk about the essential handbags and how they can work for you.

1 THE STRUCTURED TOTE

Put the structured tote at the top of your essential handbag list. The tote is an old-school everyday bag, but contemporary designers have given it some structure and style, differentiating it from its fabric or canvas past. This is the perfect handbag for a curvy woman. If you're a fashionista, it's even better, because it's available with a variety of bells and whistles—gold and silver hardware, color blocking, topstitching, tassels, floral appliques, and bling. Some totes are even lined with beautiful fabric. What was once an open bag can now be found with zippers and clasps for easy closing, and a selection of fabrications, from straw to high-grade leather. This bag easily goes from the office to weekend shopping, works for brunch or on mini getaways, and is perfect for every body shape.

2 BOWLING, BUCKET, AND HOBO BAGS

The bowling bag mimics its namesake in its style and offers the bonus of detachable straps for hands-free convenience. If you're a triangle, this may not be the best choice, as the bag falls to the hips when held and can make you look wider. For the rectangle and inverted triangle body shapes, though, adding curves to the narrow hip area is a plus.

The spacious bucket bag is also true to its name with an open top, shoulder straps, and a single pocket, which means there are no compartments. Because it is soft and unstructured, it folds onto itself when put down. Traditionally, this was a bag for casual attire, but contemporary styles are available with embellishments that open this bag up to a wider variety of uses.

The popular, crescent-shape hobo bag has a main compartment closure and fits snugly under the arm. Inverted triangle and hourglass shapes who have large breasts should stick to hobo bags with larger profiles and a longer handle, otherwise the bag will appear lost on their frames. Rectangles should carry a hobo bag with a medium to long strap.

CURVY CONFIDENTIAL

BAGS FOR THE TALL AND THE SMALL

If you're tall, a slouchier, more rounded bag will complement your frame. The bag should comfortably graze your high hip. The hobo with a long strap is perfect for you.

If you're petite, choose a rectangular-shape handbag that is taller than it is wide to elongate your body. If you prefer a clutch, choose one that is long and narrow for the same effect.

OPPOSITE, CLOCKWISE, FROM TOP: A black and white Dolce Vita tote and a North/South tote, both by Furla; a red Nencia tote by Salvatore Ferragamo.

ABOVE, FROM LEFT TO RIGHT: A bowling bag by Salvatore Ferragamo; a bucket bag by Michael Kors; and hobo bag by Marc by Marc Jacobs.

3 SHOULDER BAGS

The shoulder bag is an urban mainstay and the best choice when you need to have your hands free. All curvy women can carry a shoulder bag. This purse is generous in size and most have numerous compartments that make for easy organization of cell phones, wallets, makeup, and more. A real bonus is the ability to get into this purse without removing it from your body. The performance of the shoulder bag hinges primarily on the quality of the strap. Look for designs with a wide strap that rests comfortably on your shoulder.

There's a lot of fashion in contemporary shoulder bags: gemstones, bows, fringes, beading, and all manners of appliqué. This may lead you to believe they can go everywhere. Not so. Shoulder bags are great for work or a casual weekend event, but never for a dressy or formal occasion.

A word of caution: The disadvantage of the shoulder bag is in the behavior of the owner, not the bag itself. The temptation to overload this bag is real. Adding too much weight to the bag can lead to headaches, backache, and nerve damage in your neck and shoulders.

4 DAY AND EVENING CLUTCHES

While the day clutch is more about function, and the evening clutch is more about fashion, both bags offer clean sophistication. When buying a clutch, take it in hand and stand in front of a mirror to make sure it is readily visible against your frame; if it is not, it is too small. It should have a presence, not look like an envelope you are about to mail.

During the day you want a purse that holds all the essentials—driver's license, cash, credit cards, keys, and so on, making the day clutch a great choice, because it is designed to mimic a typical wallet or a large envelope. Zippers are the most common closures for the wallet-style

types, while envelope styles close with snaps, clasps, or toggles. In addition to traditional solid leather, contemporary designs include animal skins, metallic finishes, geometric patterns, and floral and ethnic prints as well as interesting hardware in the form of charms and logos. If you fancy whimsy, there are even day clutches covered in pop-culture motifs. Curvy women should purchase an envelope clutch that is at least fourteen inches wide by eight inches high.

When it comes to an evening clutch, be adventurous: look for unusual textures, beading, and exotic skins to complement dressier ensembles. For added interest, consider an evening clutch in a shape other than the traditional rectangle, such as an oval or teardrop. Curvy women should carry an evening clutch no smaller than eleven inches wide by six inches high.

5 THE SEASONAL TREND

Last, the essential nonessential—at least for the true fashionista—is the seasonal-trend handbag. Fashion should be fun, and your style should be a consistent evolution in fabulous, so splurge on a fashion-forward look, and enjoy it!

OPPOSITE, FROM TOP TO BOTTOM: A black ash shoulder bag with pebbled leather and stud detail by Jaeger; a day clutch by Oscar de la Renta; and a gold, embossed, textured evening clutch by Fiona Kotur.

BELOW, FROM LEFT TO RIGHT: The Prada leopard tote, the Lady Dior, and the Hermès Birkin are more than status bags; they are beautifully crafted blue-chip purchases that will last for years.

CURVY CONFIDENTIAL

THE RIGHT BAG FOR THE SEASON

Be mindful of the seasons in your bag choices. Warm weather is fine for straw, canvas, and net bags, but cooler weather calls for leather and suede. One cloth bag that may be carried during colder days is a weatherproof carpet bag.

Shoes
THE FASHION SHOWSTOPPERS

Most women would agree: you don't have to be Cinderella to romanticize a pair of shoes. The masters of contemporary and classic shoe culture, Salvatore Ferragamo, Manolo Blahnik, Giuseppe Zanotti, Brian Atwood, and a host of other designers are sustaining our love affair, while superstar artisan Christian Louboutin's signature red sole has elevated the shoe to titanium status and changed the way we look at footwear forever.

Shoes are an integral part of your look and they bear the weight of your frame, so it's important that they not only look good but also fit well. Support is key, as is correct width and a substantial heel. It's best to shop for shoes later in the day, as your feet are larger then, and be sure to fit the larger of your two feet comfortably. If you find a pair of shoes you absolutely love and they are a bit snug, try a pair a half size bigger. If the shoes feel better but are a tad loose, use a shoe pad inside to secure the fit. Give the shoes a test-run in the store, on both carpet and tile if possible, and at home before you commit to the final sale.

Adorned with 464 diamonds, Stuart Weitzman's "Million-Dollar Shoe"—the epitome of show-stopping footwear—debuted at the 2002 Academy Awards on *Mulholland Drive* star Laura Harring.

Always purchase well-crafted, quality shoes for comfort, support, and an enhanced total look. You want to remain in love, and, trust me, if your feet hurt, the love affair is over! If you have a wide foot or you require a size larger than a 10, the good news is that there are online stores, boutiques, and department stores that carry wide widths and shoes several sizes above 10; if you are looking for boots that go up to the knee or above, shop around. Many established brands now make fashion-forward, wide-calf boots.

When dressing, it's important to keep in mind the shoe and outfit color relationship. When you wear dark-colored shoes with an outfit that is in a lighter hue, for example, make sure the style of the shoe is sleek and not heavily embellished, to keep your look well balanced and the focus off your feet. Hues that match your skin tone make your legs look longer and are ideal for wearing with unusual colors and odd hemlines such as midis, maxis, and high-lows. Strapless peep-toe and pointy-toe heels in neutrals create the illusion of a longer, leaner leg, because of the long line of skin and nothing stopping the eye at the ankle.

CHOOSING THE RIGHT SHOE FOR YOUR FRAME

Body type does not necessarily dictate the size or width of your feet or the length and girth of your legs, but it does have a relationship to the style of shoe you should wear to flatter your body shape.

If you're shopping in a store, and both shoe and full-length mirrors are available, use them. The former will allow you to get a close-up view of how your feet look in a shoe, while the latter will allow you to see how the shoe is working with your entire body overall. In terms of fit, make sure your foot is seated fully in the shoe, that straps, if any, are not pressing too hard against your skin, and that your feet are not "flowing" over the top of the shoe, which frequently happens with ballet slippers. Here are some things to consider regarding body shape when purchasing shoes.

- **HOURGLASS**: Feminine, high-heel peep-toe shoes complement curves and elongate the legs.

- **TRIANGLE**: Open-toe wedges lengthen the legs and make the lower body appear leaner.

- **OVAL**: Peep-toe stilettos look good on the oval body, because she usually has long, slim legs. Shoes with ankle straps are a good choice too if she has well-defined ankles.

- **RECTANGLE**: Simple shoes work well for this body type. Classic silhouettes with pointy or round toes and high-heel pumps enhance her slight curves.

- **INVERTED TRIANGLE**: Shoes with a chunky or stacked heel, or a thick wedge help to de-emphasize the upper body. If a woman with an inverted triangle shape has thin legs or ankles, she can experiment with straps.

If you have a very large or extra-wide foot and have difficulty finding shoes that fit properly, check for retailers listed in the Style List on page 243.

CURVY CONFIDENTIAL

IT'S ALL ABOUT THAT TOE BOX

The toe box refers to the front of a shoe and styles are named accordingly. Here are the optimal styles for your shape; this is not to say you can't wear other styles, of course, but these are the most flattering.

Peep Toe: Inverted triangle, hourglass, oval

Square Toe: Inverted triangle

Round Toe: Rectangle

Pointy Toe: Triangle, rectangle, hourglass

> I firmly believe that with the right footwear one can rule the world.
>
> —BETTE MIDLER, *FAMILY WEEKLY*, 1980

The Essential Shoe Wardrobe

Like clothing, a shoe collection should be based on essentials that ensure a well-put-together look.

1 THE CLASSIC BLACK PUMP

In leather or suede, this is the go-to shoe for work, a dinner date, or a cocktail party, as it pairs well with tailored suits and sheath dresses. Whether you prefer a peep, pointy, or round toe, this classic shoe elongates your legs and projects sophistication. Worn with ultrasheer black hosiery, it will lengthen the look of your leg even further.

2 EVENING SHOES

Your first pair of evening shoes should be black peau de soie. You can wear them with virtually everything—colors, metallics, tone-on-tone prints, and, naturally, black evening and cocktail attire. When you're ready to add another pair of evening shoes to your collection, buy a strappy metallic sandal or a bejeweled pump in a color that complements your wardrobe.

3 WEDGES

This shoe style is essential because it is a great alternative to conventional heels. It supports body weight better and shifts the body weight from the balls of the feet. That's why a wedge is more comfortable, easier to walk in, and looks fabulous paired with capris, summer dresses, and shorts. They're a great choice for an upscale casual summer look. Wedged sneakers are a fierce addition to today's leisurely athletic trend too; pair them with casual pieces, such as hoodies, embellished sweatshirts, denim joggers, and a simple, sports-chic sheath dress.

4 NUDE HEELS OR FLATS

What is considered "nude" is a shoe that is closest to your skin tone. When you don't want your shoes to compete with the color or length of your outfit, this is the color to wear. In other words, footwear like this becomes essential on the occasion when you want your legs to appear longer and don't want your shoes to be the center of attention.

A good basic nude shoe is a pointy, peep-toe, or round-toe pump without straps or embellishment. This shoe is great with midi-length skirts and also comes in handy when you want to experiment with a colorful print dress and don't want to introduce another hue into your outfit.

5 BALLET FLATS

This popular shoe—available in an array of colors, prints, and materials—takes you through work and play, and even dressier events. The fit should be neat without extreme toe cleavage or foot spillage. Purchase ballet flats in a high-quality leather or substantial fabric that give your feet maximum support; they also look the best when worn with knee-length pencil skirts, midi-length circle skirts, and straight-leg pants.

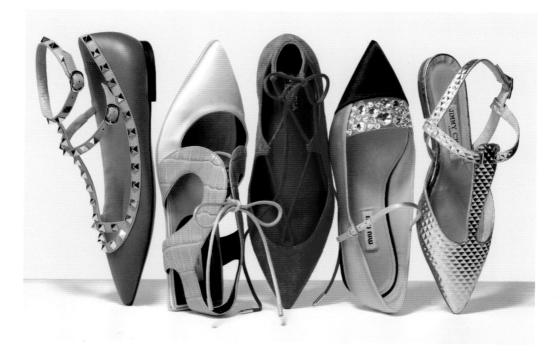

6 FLAT SANDALS

Strappy, flat, thong-style sandals with cool embellishments and the new Birkenstocks are the way to go. Buy these shoes in a neutral color so they are easy to pair with seasonal looks. Flat sandals are staples for summer: wear them with your favorite walking shorts, cropped pants, maxi dresses, and beachwear.

7 ANKLE BOOTS OR BOOTIES

Ankle boots have built-in sex appeal, work well with denim looks, leggings, and tailored pants, and when worn with the right skirts and dresses, bump up cutting-edge style a few notches. When there is no break between the boots and your garment, your legs will appear longer and leaner. Most flattering are those that are fitted or asymmetrical at the ankle and not too wide at the toe. Exposed zippers, buckles, and fringes are major ankle-boot embellishments that offer serious style. The variety of ankle boots is very wide, therefore there are styles for every body type.

8 HIGH–HEEL OR FLAT BOOTS

Knee-high, over-the-knee, or ankle boots with a heel height and style of your choice, in black, brown, or beige leather are a versatile style option. They can be worn with practically everything and make an outfit look sexy, chic, and sophisticated. If you find a pair that you love, but the fit is too tight from the knee to the calf, take them to a good shoe repair shop to be enlarged. The repair man will measure the circumference of your calves and adjust the boots accordingly.

Fall and winter used to be the seasons of the boot, but contemporary peep-toe and cutout styles have given them a place in the spring and summer seasons. If your budget allows, try something new and add this trend to your warm-weather wardrobe.

9 ALL-WEATHER BOOTS

All-weather boots are functional, fun, and these days—stylish. Wellies are versatile because they come in both traditional and bright hues. Other brands offer selections that mimic clothing embellishments, such as fleece and faux fur lining, and design elements such as buckles, laces, zippers, and bows. Knee-high and ankle boots are also offered in flat, wedge, and stacked heel styles.

10 ATHLETIC SHOES

Athletic shoes are a must, and not just for working out or walking, but for style too. Be sure to invest in a quality sneaker for adequate support. As there are so many options for a variety of activities on the market, research the right shoe for your needs. Sales staff in sporting good shops are often highly knowledge-able on these points, so don't be afraid to ask for advice.

11 PLATFORMS

The platform shoe is more than a 1970s relic. It's a shoe that offers style, height, and comfort. This design detail is great for curvaceous women because it helps to balance the body in a way that keeps all your weight from landing on the balls of your feet. Platforms are an essential extra because they never seem to go out of style, and they look good with trends that tend to do the same, such as boho-inspired maxi dresses and palazzo pants. They also look great with the ever-present pencil skirt. The perfect dimensions for a platform shoe is a two-inch platform and a four-inch heel. This is a comfortable and manageable height for walking.

12 ANIMAL-PRINT HEELS

If you want to add sultry style to your look, an animal-print heel is the shoe to get the job done. Snakeskin, zebra, and leopard can be paired with neutrals, bright colors, or even skinny jeans to enhance your signa-ture style profile.

> To wear dreams on one's feet is to begin to give a reality to one's dreams.
>
> —Roger Vivier, Marieclaire.co.uk, June 2015

TIPS ON BUYING STRAPPED SHOES, PLATFORMS, FLATS, AND SANDALS

Beware the strapped shoe! This is a style that every woman, regardless of her shape, should consider carefully to be sure they are flattering. If the straps run horizontally across the front of your feet, or are too wide or too tight around the ankle, this style can make your legs appear shorter and wider than they are. These shoes are probably not the best choice for skirts, dresses, or coats that end mid-calf, as the horizontal line of the shoe cuts across the legs, making them appear shorter and wider than they actually are. Always take a look in the mirror after getting dressed to check on proportion.

Platform styles can bring an outfit down if the front of the shoe is too large or clunky, so be sure to consider the shape and the scale of the platform when you are getting dressed. If the shoe is too bulky it will immediately draw the eye downward, away from the rest of the outfit. Remember, it's all about balance. When you dress, you want a cohesive flow from head to toe; the focus should not be just on your feet.

When choosing flat shoes, whether they are oxfords, ballet flats, or sandals, make sure they fit properly, especially across the widest part of your foot. Your feet should never spill over the sides, and your toes should never have exaggerated cleavage. In the case of sandals, be sure your foot does not spill over the front or back of the shoe in any way.

Jewelry

FASHION'S FINAL TOUCH

The jewelry we wear is often a significant part of who we are, deeply connecting us to the milestones and people in our lives. If you have pieces you wear daily, they express a part of your style personality too.

CHOOSING THE RIGHT JEWELRY FOR YOUR FRAME

The way jewelry lies on the body and its relationship to your overall size is important to it enhancing what you're wearing and flattering your figure. Important measurements to know, particularly if you are shopping online are:

- The circumference of your neck, for chokers

- The circumference of your wrists, for bracelets

- The distance from the notch at the bottom of your neck between your clavicle to the top of your bust, for pendant necklaces

- The distance between the notch at the bottom of your neck to the under bust for longer pendant necklaces

- Ring sizes

The style of jewelry you choose does have a relationship to your body, but not to your body shape. Your focus should be on what the jewelry does for the area you're adorning. When purchasing earrings, for example, consider the shape of your face and overall bone structure to determine a flattering earring shape, length, and size. Dangling or drop earrings help elongate a round face; hoops soften the bone structure of a square face; and earrings with shapes that are wider at the bottom balance the heart-shaped face. The oval face is different from all others in that the earring style of choice is oval, mimicking the shape of the face.

For necklaces, be mindful of the length and the fullness of your neck. If you have a short, full neck, for example, a statement bib necklace will be a challenge. Longer pendant styles or triple strands of chains, beads, or pearls would be better for you. The size of your bust also plays a role in necklace choices. Women with very large breasts should wear pendant necklaces that land above or below the bustline so that attention is drawn to the jewelry, not the body.

Jewelry Box Essentials and How to Wear Them

The goal of establishing an essential collection of jewels is to ensure that you have pieces for diverse occasions as well as the ability to create new looks by combining pieces effectively. An essential collection should include natural metals, such as gold, silver, titanium, platinum, and pearls.

Quality pieces in classic shapes and designs are the way to go when building a collection, both in terms of frequency of wear and timelessness. Stay clear of ornate and trendy pieces as well as faux fine jewelry when building a collection, as these pieces are not essential. They can always be added later.

EARRINGS

Earrings hold a very important place in jewelry selection because they frame the face. Whether large or small, they are a direct visual line to whomever you are speaking with. You never want them to be an annoying distraction, so choose tastefully.

Every collection should include a pair of small studs that are diamond, pearl, gold, or silver. You should also own a pair of hoops and a pair of simply designed drop earrings. All are versatile and can be worn for work, play, or an elegant evening.

BRACELETS

Bracelets add interest to an outfit and can be very stylish when worn stacked with a simple dress. Accent your wrists and boost your style personality with metal and gemstone-adorned bangles, cuffs in silver or gold, or a charm bracelet with trinkets that represent various aspects of your life.

Bracelets should have a little dangle, so avoid extremely tight fits. Sometimes it's difficult to find great bracelets if you have wide wrists or large hands. If this is your challenge, avoid enclosed bracelets; search for those with

hinged closures or adjustable links. Hinged bracelets open and close easily and are normally cut a bit wider than ones you pull over the hand. A jeweler can extend the size of hinged and link bracelets fairly readily.

NECKLACES

When looking for necklaces, it's important to make sure they are in proportion to your body size, the length of your torso, and the distance from your neck to your cleavage. The focal point of the necklace should look elegant against your body as well as enhance the bodice of your dress or the neckline of the top you are wearing.

If your neck is very short or very wide, anything worn too close to it, such as a choker or a fitted bib, will be too snug and emphasize the height or size of your neck. A better necklace choice is a pendant or lariat. If you have a very full bust, be sure the pendant falls just above or below the breasts. It should never end at the fullest part of your bust line because it will emphasize the size of your breasts.

If you prefer a heavily embellished design, make sure it has a significant drop, landing at the top of your cleavage. Another option is a linked necklace. If the fit is a bit short of perfect, you can add an extender found at most accessory boutiques.

RINGS

Rings are a fun accessory. Your collection should include at least two glamorous cocktail rings, one that glitters and one bold solid in metal or wood. Stack gold, silver, or gemstone bands for some unexpected sass, and pay attention to their fit to avoid puffiness between rings. If you have large fingers and finding rings has been difficult for you, try the stretch band, a new trend in cocktail rings, available in boutiques and online, that enables the ring to fit larger finger sizes. Stretch-band rings are available with faux gems and beads.

Big girls need big diamonds.

—Elizabeth Taylor, from "Elizabeth Taylor's 20 Best Quotes,"
The Telegraph, March 23, 2011

A DAY WATCH AND A DRESS WATCH

It pays to invest in a good watch, whether gold or steel by a reputable maker such as Rolex or Movado, or a fashionable classic by a design house such as Gucci or Hermès. Make sure the band is not too tight or too wide. If your wrists are large, you want to stay away from a tiny watch face and band. The same is true of the reverse, as all curvy women don't have large wrists. A good dress watch, also called a jewelry watch, is one that resembles a bracelet. The face of the watch and the band are usually decorative, possibly embellished with diamonds or designed with metals in contrasting finishes. If you can afford a quality dress watch, buying one is a good investment because a day watch that is too casual can bring down the glamour of a formal outfit.

STATEMENT PIECES

A statement piece is an eye-catching item that is generally bold in size or color and unique in design, such as bib necklaces, large drop earrings made of precious and semiprecious stones, or ornate cuffs. When you wear statement pieces either for everyday dazzle or evening elegance, they lend to your style personality and confidence. When you wear a statement piece, it should be your sole jewelry statement, and your clothing and other accessories should be understated so as not to compete with it.

THE BASIC JEWELRY BOX

Jewelry choices are a matter of personal preference, but a small, useful collection might consist of the following items. Also refer to the individual sections in this chapter on specific jewelry types.

EARRINGS: At least one of each: including hoops and studs in gold or silver for daily wear, dangles for evening and special occasions. Keepsake pearl or diamond studs will never go out of style either.

PENDANT NECKLACE: A small simple pendant and a long fashion pendant.

STATEMENT NECKLACE: A bib necklace, if it works for your frame; a contemporary metal pendant; or a multi-colored gemstone necklace.

RINGS: Silver or gold bands, plain and/or textured; two cocktail rings for evening; and a fun fashion ring for daily wear.

BRACELETS: Bangles, a classic link bracelet in silver or gold, a medium-width hinged bracelet with minimal embellishment.

WATCHES: A classic watch for daytime and a dressy watch for special occasions.

BELTS

Convincing full-figured women to wear a belt has been one of my most difficult challenges as a stylist. I have met many women who confided that they had not attempted to wear a belt in years, while others said they had never tried. I have heard over and over again, "I don't have a waist." Everyone has a waist, and the beauty of a great belt is that it helps define it. Belts help to maintain shape when worn with blouson silhouettes, layers, or fitted silhouettes. They add sophistication, elegance, and style to basic pieces like jackets and trousers. Belts truly take your look to a higher level in so many ways, whether you are creating more curves, working a new trendy look, or aiming to appear more polished. A belt can really finish off an outfit.

As with other wardrobe essentials, you should have a belt collection that includes fashion-forward belts to wear with your best looks, including eveningwear, as well as basic belts to wear with more casual clothes.

Shopping for the right belts can be a bit of a challenge, especially if you have not worn a belt in a long time or you are just getting more in tune with your body shape to understand how a belt can enhance it. If you don't own any belts, start with neutral tones so that you can wear them with a number of looks. Wider belts are generally more body contouring and dramatic in effect while thinner belts are more understated. Finally, if you are new to wearing belts, wait until you are comfortable wearing them to try trendier styles.

Essential Belts

With the following belts in hand, you should be able to complete any look.

- A classic black and a classic brown leather belt in a width of about one and a half inches are perfect for daily wear with jeans and tailored pants.

- A textured, thick (two and a half to three inches) leather belt adds flair and shape to loose-fitting dresses. Purchase it in a soft neutral, such as camel, so that it coordinates easily with much of your wardrobe.

- An elasticized stretch belt in black or a matte metallic provides waist definition without intense cinching for oversize shirts worn untucked, loose dresses, and pencil skirts.

- Skinny belts, those that are less than one inch wide, look best when worn directly on the waist or a little lower. They are a great way to add a pop of color to an outfit. If you try this look and the belt appears a little too skimpy for your proportions, add a second belt in the same or coordinating color. Skinny belts are best worn with skirts or dresses.

- Wide or tapered wide belts (with a four-to-six-inch-high point in the front), in black or another neutral leather, create a corseted silhouette, and thus, a more defined waist. Look for interesting front closures and hardware. For comfort, look for one with an elasticized back.

Belts for Your Shape

When trying on belts, it's vital to pay attention to scale. The belt must be in proportion to both your size and the garment it rests upon. For example, a pencil skirt is a simple garment so it can handle a wide belt. An outfit with a lot going on—ruffles, ruching, or pleating, and so on—may require a smaller belt to keep it from looking overwrought.

The other factor is your shape. Here are some basic tips for each body type to wear belts to her best advantage.

- **HOURGLASS**: Narrow-, medium-, or wide-width belts over blouses and with dresses accentuates your balanced shape.

- **TRIANGLE**: Wearing narrow-, medium-, or wide-width belts over tops and dresses helps balance your figure.

- **RECTANGLE**: Medium- and wide-width belts help give you a curvy illusion.

- **OVAL**: Medium-width belts are best. Wear low-slung belts, meaning ones that are closer to the hips, with tops that have soft gathers around the mid-section to create shape and camouflage your tummy.

- **INVERTED TRIANGLE**: Choose medium-width belts and wear them over peplum tops, shirts, and thin knits with full bottoms for a curvy appearance.

- **SHORT-WAISTED/LONG-WAISTED**: Women who are short-waisted should wear narrow- and medium-width belts to prevent shortening of the torso any further. Also, the color of the belt should be neutral, the same color, or as close in color as possible to whatever top you are wearing to create the illusion of length. The long-waisted have many options. You can definitely wear a thicker, embellished belt with a blouse or a soft T-shirt or jacket in a contrasting color without worrying about your waist looking shorter or wider.

———

The beauty of accessories lies in their versatility and transformative power, from updating a previous season's trend to turning a basic wardrobe staple into a brand-new favorite. Quality accessories are essential to completing an outfit, giving it traffic-stopping polish from head to toe. Signature pieces, whether a watch or a stack of unique rings, express who you are, putting a definitive stamp on your look and making it indisputably your own.

Glamour

THE ULTIMATE ESSENTIAL

I advocate glamour. Every day. Every minute.

—DITA VON TEESE, *BURLESQUE AND THE ART OF THE TEESE*, 2006

A most glamorous moment: Oprah Winfrey and Oscar de la Renta arrive at the Costume Institute at the Metropolitan Museum of Art's annual gala benefit, 2010.

L IFE WOULD BE SO DULL WITHOUT GLAMOUR. INFUSING OUR LIVES WITH THE LITTLE extras that make every day a bit more chic and make us feel pampered is well worthwhile. So when one day begs for a feathered boa with a favorite wool coat instead of a knit scarf, give in; and when another cries for the super chic flair of a cashmere sweater with a sequined V-neck to be worn with a pencil skirt, go for it. These touches impart a feeling of luxury to the every day, and in the end, accent your personal style.

For far too long curvy women have been left out of the high-fashion and head-turning glamour equation, but today the chiffon and sequins are blowing in your direction and the conversation is changing. Modeling opportunities are growing, and bloggers have created a plus-positive medium to counteract the mainstream fashion narrative. Industry and media have clearly arrived to the party and it looks like they plan to stay.

This final chapter celebrates the beauty of curvaceousness through a complete discussion of special-occasion glamour as well as tips that will keep you feeling stylish day to day.

Special-Occasion Glamour

The next time you receive an invitation to a special event, whether it's a wedding or a black-tie gala, a cocktail or a birthday party, there will be no need to panic about what you are going to wear. To follow is my tried-and-true prescription for special-occasion dressing. The first step is to pay close attention to the invitation. The important details are: location, start time, and requested attire. Don't forget to consider the time of year when the event will be held too. All will help you dress appropriately.

If an invitation says:

- **COCKTAIL PARTY OR SEMIFORMAL:** Your attire can be anything from an elegant suit amped up with great jewels and a sleek pair of pumps to a knee-length black dress with a jewel-embellished neckline. Also consider a flirty A-line skirt or a simple sheath.

- **FORMAL:** The newish rules for black-tie dressing include luxe-styled cocktail dresses or a drop-dead sexy tuxedo pantsuit. Floor-length gowns will always be a standard, but if you are feeling a little daring, indulge in the new, just make sure the look is impeccable.

- **WHITE-TIE OR FULL EVENING DRESS:** This is the most formal of all events. The only appropriate dress is a floor-length gown. For a white-tie event, pull out your most opulent jewels, most glamorous shoes, and a status evening bag. And don't forget the opera gloves.

- **FESTIVE:** This term is primarily used around the holidays, and the dress code is pretty inclusive. In other words, have fun with a little frill or feathers, sequins, vibrant colors, and metallic textures.

PLAN YOUR LOOK AHEAD OF TIME

Planning ahead prevents anxiety. After reviewing the invitation, begin by taking a good look through your closet and jewelry box to see what appeals to you and to avoid spending money on items you already own. If you don't have the dress, gown, suit, or accessories, look to favorite fashion magazines, blogs, and Web sites for inspiration. Once you decide on a look, or have your idea somewhat narrowed down, it's time to begin shopping. Better department stores are a good way to go; special-occasion glamour requires several elements: the dress, the shoes, jewelry, evening bag, and makeup. You will also have a far wider range of designers and styles to choose from than is possible in a boutique. Another benefit is that department store Web sites often offer items that are not on the retail floor. And, of course, the beauty of preparing early is that if you shop online you'll avoid paying for expedited shipping. Check the Style List on page 238 for major clothing retailers that carry cocktail and formalwear.

Purchase your clothing first. If you need to alter anything, wait until after you buy shoes and jewelry. The height of your shoe will determine the length for the gown or pant, and a necklace, should you want to wear one, will influence any alterations done to the bodice of your dress, gown, or top.

Next, buy the accessories to complement your ensemble, and head for the tailor. Don't forget to take your shoes and shapewear with you when having your garment altered.

Decide on a hairstyle, makeup, and nail polish. Make sure you have enough of what you need on hand. Look through magazines and online for inspiration; you might even want to go through personal photographs to repeat a look that was a hit for you in the past.

Schedule beauty appointments well in advance to avoid a last-minute crunch, or worse, not getting an appointment at all. Usually, two weeks ahead of time is sufficient. If the hairstyle you've decided on is complicated and your budget can stand a little something extra, make a test hair appointment to make certain the style will work with your outfit. You can do the same for your makeup if you're not doing it yourself.

Hair and makeup should be done as close to the event as time will permit. If your hairstyle requires a great deal of preparation, schedule your appointment for early in the morning. You want to have your makeup completed two to three hours prior to the event in case you wish to make changes. When time does not permit, have your manicure and pedicure done the day before.

I believe in manicures. I believe in overdressing. I believe in primping at leisure and wearing lipstick.

—POPULARLY ATTRIBUTED TO AUDREY HEPBURN

OPPOSITE: Kate Winslet, photographed by Gilles Bensimon for *Elle* China, April 2012.

CHECKS AND BALANCES

You've prepared for your big moment with time to spare. Don't use that spare time to dismantle all your good efforts! Sometimes this waiting period provides a space in which you might feel the need to add more accessories to the outfit or make unnecessary changes. Here's how to make sure you've made the right choices and address making proper adjustments.

- Take head-to-toe pictures of your confirmed look from the front, side, and back. Seeing that you have pulled together something really wonderful will help eliminate last-minute anxiety and changes. You will also be able to see if you need additional or new shapewear for a seamless look.

- Test-drive your shoes, especially if they are new. Wear them around the house as you do chores, or even absolutely nothing, to break them in and avoid aching feet stealing joy from the big evening.

- Review your jewelry selections again. If your dress is bejeweled, consider making some jewelry deletions. If the cuff of your dress, gown, or jacket is embellished with sequins, rhinestones, or crystals, you might eliminate bracelets and add a cocktail ring instead. If the neckline is trimmed, then a necklace may not really work or you might add a choker to enhance the neckline.

- Consider your hemline. If it has a jeweled trim, your shoes should be without embellishment.

IN A CLUTCH

Don't forget to put the following items in your evening bag: lipstick, a mirrored compact, fashion tape to manage a wardrobe malfunction, tissues, and breath mints.

THE PROPER TOPPER

Deciding what to wear on top of an evening ensemble can be a challenge. Old-school toppers pretty much revolved around fur coats, stoles, and capes. But the contemporary options include everything from couture moto jackets to jeweled cardigans. Whatever you choose should complement your dress. Here are some options.

For a cocktail dress, choose a classic trench coat or a colored trench in the same tone as your dress. The coat and dress should be the same length, or the coat can be slightly longer than your dress, but not the other way around. A beaded cardigan or a solid or embroidered cashmere shawl can lend a contemporary look. Just make sure the beading or embroidery doesn't compete or clash with the embellishment of your dress.

Formal attire can always handle a dose of high drama, so a luxe fur or faux fur stole, a velvet cape, or a beautiful cashmere maxi coat will always be in vogue. Again, make sure they are flattering silhouettes for your shape that complement your dress.

Glamour is what makes a man ask you for your telephone number. But it's also what makes a woman ask you for the name of your dressmaker.

—LILLY DACHÉ, *LILLY DACHÉ'S GLAMOUR BOOK*, 1956

Glamour Every Day

Glamour doesn't necessarily mean big, over the top, and evening gala only. You can incorporate a bit of glamour into your daily life, like eating lunch on your best china rather than waiting for guests to visit, or wearing luxurious lingerie under a very simple sheath dress to work. If you are going to take a walk on the glamorous side of fashion during the day, though, be subtle about it. You don't want to show up for work or school party-ready. It's all about striking a good balance. Here are a few ways to infuse your everyday look with glamour.

GET REGULAR MANICURES AND PEDICURES

Rings and wrist accessories look their best on groomed hands. Have your nails professionally done and wear a signature color or a neutral, as this will give you an overall polished look. Take it easy on the nail decor: distractions are not glamorous.

WEAR SOPHISTICATED MAKEUP

You can't go wrong with mascara to lengthen and thicken lashes and eyeliner to define the shape of your eyes. When it comes to daytime glamour, it's all about the lip color. Go with a strong lip color, deep or richer, but not too bright—and keep the rest of your makeup minimal.

GO WITH AN EASY HAIRSTYLE

Daytime hair should be effortlessly chic, that is, nothing that you have to fuss over and nothing too outré. If you want to go for a bit of sophistication, try a textured

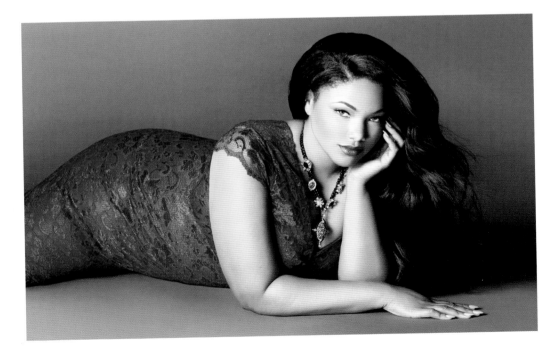

or a sleek chignon. If your days are spent in a creative environment, adding small hair accessories, such as embellished hairpins, headbands, or hair jewels can add a little daytime pizazz.

GIVE YOUR LOOK A LITTLE EDGE

Remember, daytime glamour is in the subtle details. Strike a balance between pieces that say you have arrived, and those your coworkers and colleagues will have to look at a little deeper to notice. This can be achieved with anything from a beautiful silk blouse worn under a suit, a pair of jeans worn with a statement jacket, or a pair of oversize sunglasses.

CHOOSE DELICATE JEWELRY

Glamour is about a lot of things. Charm is one of them, so small delicate pieces are a perfect expression of elegance. Choose small earrings, like classic diamond or pearl studs, or beautiful hoops that complement the neckline of whatever you are wearing. Also try a feminine watch or dainty bracelets that don't make too much noise and disturb others at the office.

WEAR SHOES THAT ADD ELEGANT PUNCH

Have a little fun with shoes that used to be thought of exclusively as a formal-evening option. Metallic sleek pointy pumps, for example, can add just the right amount of glam peeking out from a pair of tailored, black, slightly flared pants.

You owe it to yourself to live beautifully. I am.

—JILL SCOTT, *O, THE OPRAH MAGAZINE*, SEPTEMBER 2011

Jill Scott, photographed by Steven Gomillion and Dennis Leupold for *Billboard*, July 2011.

I N WRITING THIS BOOK, MY GOAL WAS TO SHARE MY LOVE FOR fashion, my belief in the importance of authenticity and confidence, and to provide styling advice to curvaceous women with full respect. *The Art of Dressing Curves* celebrates you.

I hope you have been inspired by my story, and by the gorgeous curvy women featured on these pages. But most important, I hope as you read the book and look at the images that you gain the confidence to experiment and try looks you once may have thought were out of reach for whatever the reason may have been. The simple truth is that there is no size limit when it comes to style.

I hope this book helps you express yours.

—SUSAN MOSES

THE STYLE LIST:
THE CURVY GIRL'S RESOURCE GUIDE

Fashion-minded curvy women have plenty of shopping options these days. Everything—from lifestyle attire to luxe evening wear, from shapewear to lingerie, from wide-width dress shoes to wide-calf boots—can be found at major retail stores, designer and brand boutiques, and online. This extensive list, while not exhaustive, covers my favorite places to shop, domestically and internationally, and includes a list of my favorite bloggers who focus on curvy and confident fashion.

MAJOR CLOTHING RETAILERS

The following major retailers carry plus-size clothing.

Belk
Belk offers a full range of casual, professional, and formal clothing in women's and junior plus sizes. Of the major department stores, Belk has one of the best dress selections for both day and night. www.belk.com.

Bloomingdale's
Season after season, Bloomingdale's offers a selection of bold, sophisticated looks and a wide range of iconic designer labels, from Marina Rinaldi and Calvin Klein to Vince Camuto and Eileen Fisher. If you want to modernize or rejuvenate your signature style, Bloomingdale's is a great source. www.bloomingdales.com.

Dillard's
Dillard's is a great source for special-occasion and chic daytime dresses, both online and in store. www.dillards.com.

Lord and Taylor
Lord and Taylor offers some of the same designer labels as other major retailers as well as proprietary plus lines. A notable—and great—difference is while the store buys from the same designers, the items they select are very often in different colors and with slight style modifications from competitors like Macy's and Bloomingdale's. Lord and Taylor is a great place to play dress up and discover new looks. www.lordandtaylor.com.

Macy's
The magic really does happen at Macy's! The store offers a generous variety of shapewear, bras, and statement jewelry as well as contemporary and designer clothing and shoes—all of which are available in stores and online. www.macys.com.

Neiman Marcus
Neiman Marcus's specialty sizes are offered online only, but their perfectly curated selection jumps right off the screen, making you feel like you're shopping in the lap of luxury—and you are. www.neimanmarcus.com.

Nordstrom
If purchasing essential pieces is high on your wardrobe priority list, Nordstrom is an outstanding resource for one-stop shopping. The incredible customer service makes the shopping experience even better. www.nordstrom.com.

Saks Fifth Avenue
Saks plus-size shop for women, Salon Z, offers clothes online only. It's a great place to shop for formal and special occasions. Salon Z's outerwear selection is very forward and chic, keeping you warm with impeccable style in cold weather. www.saksfifthavenue.com.

CURVE-SPECIFIC RETAILERS

These stores specialize in plus sizes and many carry shoes, boots, undergarments, and accessories.

Ashley Stewart
Ashley Stewart has consistently debunked the myths about plus-size women's figures not being right for fashion. If you're looking for up-to-the-minute runway trends or clothing that's got a chic, urban look, this is the shop for you. www.ashleystewart.com.

The Avenue
The Avenue has always been a reliable source for good basics, offering great T-shirts, jeans, and active wear. Extended sizes are not new to the Avenue; the store carries up to size 32. www.avenue.com.

Lane Bryant
Lane Bryant is the oldest curve retailer in America and remains committed to great style. Lane Bryant collaborates with designers such as Isabel Toledo, Christian Siriano, and Lela Rose to create new proprietary lines. www.lanebryant.com.

Lee Lee's Valise
This quaint boutique sells online as well as in its Brooklyn shop. It offers a variety of well-known fashion brands and private labels. www.leeleesvalise.com.

Svoboda
If you're a minimalist and trend-minded, Svoboda is a great place to shop, as it carries perfectly cut T-shirts, jeans, and streamlined dresses. www.svobodastyle.com.

Torrid

Torrid is a reliable source for contemporary fashion in sizes 14 to 28. This brand offers a great selection of accessories, fashion, and aspirational look books. www.torrid.com.

CURVE-FRIENDLY RETAILERS

These stores carry a substantial amount of plus-size clothing and undergarments.

Dress Barn

Dress Barn offers a full range of casual and professional dress options at affordable prices. You can shop online and in stores. www.dressbarn.com.

Forever 21

Forever 21 carries very trendy fashion at affordable prices. When shopping online, be sure to check the size charts; you may need to buy a size up, because some of the designs lean toward junior plus sizes. www.forever21.com.

Kohl's

Kohl's offers a comprehensive selection of lifestyle clothing for curves that includes maternity, junior contemporary, women's, and petites—and all are available online and in stores. www.kohls.com.

Old Navy

Old Navy offers a casual selection of affordably priced plus-size jeans, T-shirts, active wear, and dresses online only. www.oldnavy.com.

Talbots

Talbots offers classic casual and professional designs, which are sold online and in stores. www.talbots.com.

Target

Target offers a casual lifestyle collection that includes the blogger-inspired private label Ava & Viv, which is sold online and in stores. www.target.com.

CURVE-FRIENDLY DESIGNERS AND BRANDS

Here is a listing of designers and brands that have included plus-size lines in their seasonal collections. When a collection is sold online only, it is noted. When a collection is sold online as well as through various retailers, consult the Web site given to find stores that carry the brand where you live.

Adrianna Papell

Adrianna Papell offers great dresses for work, play, and special occasions online and through major retailers. www.adriannapapell.com.

Anne Klein

This legacy brand continues to offer beautiful suits and dresses for the professional wardrobe as well as classic jewelry. Anne Klein is available online and is sold by several major retailers. www.anneklein.com.

Calvin Klein

The hallmark of the iconic Calvin Klein brand is its minimalist silhouettes and understated sexy designs. Calvin Klein has sized up a major selection that celebrates curves. The clothing is available online and is sold by major retailers. www.calvinklein.com.

DKNY Plus

Donna Karan's DKNY Plus offers the same street chic as DKNY. It is sold online and by several major retailers. www.dkny.com.

Domino Dollhouse

Sold online only, Domino Dollhouse makes getting dressed fun and offers of bit of whimsy with 1950s-inspired dresses, some rocker-chic looks, colorful petticoats, playful prints, and whimsical accessories. www.dominodollhouse.com.

Eileen Fisher

Eileen Fisher is a great source for minimalist design and environment-conscious dressing, offering favorite wardrobe staples in organic cottons and garments made with sustainable fibers. Eileen Fisher is sold online and through major retailers. www.eileenfisher.com.

Eliza J

Eliza J's reasonably priced sophisticated dresses for day or evening in both cocktail and maxi lengths are sold by various retailers. The brand offers garments in great patterns and vibrant colors with subtle details. www.elizajdresses.com.

Eliza Parker

Eliza Parker is a great source for easy-care casual dresses, which are sold online and at several plus-size boutiques. The brand is a go-to for well-made wrap dresses, pencil skirts, and cardigans. www.elizaparker.com.

Harper + Liv

If your taste runs to the bohemian, Harper + Liv is the line for you. It is available at several major retailers. The printed kimonos and fringe tops are a personal favorite. www.harperandliv.com.

J.Crew

J.Crew is known for chic designs, but most people don't know that the brand offers a generous selection in sizes 16 to 20 online only. www.jcrew.com.

James Jeans

James Jeans is a premium denim line that offers the latest jean trends. The brand is a good denim resource with great styles for women of all sizes and for every body shape, and is sold online and at major retailers. www.jamesjeans.us.

Jessica Simpson

Jessica Simpson's lifestyle brand offers a full range of casual plus-size clothing and accessories at affordable prices. The Jessica Simpson line is very popular, but it would be wrong not to mention how stylish her shoes are. The brand is sold at several major retail locations and online. www.jessicasimpson.com.

Karen Kane

Karen Kane has consistently offered a great collection of casual and professional pieces. The designs are on trend, and she infuses her collection with great prints seasonally. The fit-and-flare dresses are always on point too. The collection is sold online and by major retailers. www.karenkane.com.

Lafayette 148

Lafayette 148 is a luxury collection of casual and professional wardrobe staples. The site's iconic White Shirt Shop and Cashmere Shop are worthy of a seasonal visit. Plus sizes are sold online only. www.lafayette148.com.

Lucky Brand

Sold online and sold by several major retailers, Lucky Brand is a casual contemporary line that offers cool jeans, tops, jackets, dresses, and accessories. Lucky Brand is known for a great selection of reasonably priced, well-fitting jeans in rich shades of indigo. www.luckybrand.com.

Melissa Masse

Melissa Masse offers great dresses in figure-flattering silhouettes and prints. If you love to mix prints, this is the brand for you. This collection is available online and sold by several major retailers. www.melissamasse.com.

Michael Kors

Michael Kors offers a line of classic and on-trend clothing and accessories, which are available online and sold by several major retailers. www.michaelkors.com.

Mod Cloth

Available online only, Mod Cloth offers a collection of vintage-inspired separates with a modern edge. www.modcloth.com.

Monif C.

Monif C. is a contemporary collection that offers edgy, fun separates and sexy dresses for curves. This collection is available online and sold by several boutiques and retailers. www.monifc.com.

Mynt 1792

Sold online and by major retailers, Mynt 1792 is a contemporary lifestyle collection of separates that are casual, stylish, and very figure flattering. Shopping the brand is a boutique experience, as it offers clothing that goes from day to night. Mynt offers great dresses, jumpsuits, and contemporary suits for the office. www.mynt1792.com.

Nakimuli

Sold online only, Nakimuli offers modern silhouettes in Afrocentric and tribal prints up to size 24. www.nakimuli.com.

Rachel Pally White Label

Rachel Pally offers chic knit dresses and separates with a luxury feel at affordable prices. The collection is available online and is sold by several major retailers. www.rachelpally.com.

Ralph Lauren

Ralph Lauren is a fantastic resource for wardrobe and accessory essentials. Ralph Lauren plus-sized clothing is sold online and by several major retailers. www.ralphlauren.com.

Rebdolls

Available online only, Rebdolls is a very trendy collection available in sizes 0 to 28. Rebdolls's mantra is #sexyforall—and they deliver! www.rebdolls.com.

ONLINE RETAILERS THAT SELL CURVE-SPECIFIC AND CURVE-FRIENDLY BRANDS

These online retailers offer vast resources for an array of curve-specific and curve-friendly brands. If you love to one-stop-shop without leaving home, these sites are for you.

Amazon.com

Amazon.com offers a generous selection of plus-size brands at a range of price points. You can find great jeans, tops, dresses, shapewear, and active wear here.

Eloquii.com

Sold online only, the popular Eloquii brand offers seasonal trends and classic pieces in modern silhouettes. None of their designs become museum pieces, so if you see an item you love, purchase it, for it will soon be gone!

FullBeauty.com

FullBeauty is a curve-specific e-tailer that not only offers a great selection of fashion in extended sizes, including the legacy brand Roaman's. The site is also an excellent source for shapewear, bras, corsets, and athletic wear.

Heygorgeous.com

This premium online boutique sells some of the most notable designers and brands for curves only. This boutique is curated with love, and it's a great shopping destination.

HSN.com

HSN is a great source for on-trend fashion and accessories at affordable prices. They have various designers and brands for curves. The majority of the designers at HSN sell up to size 3X (size 24). What's great is that they show images of the designs on a regular size model and a plus model. The network is also the home of The List, a weekly program that showcases all the hottest seasonal trends.

Igigi

Sold online only, Igigi offers a full range of casual, work, and formal dresses and skirts in sizes 12 to 32. A great feature on the site is Curve Connection, where customers can post images of themselves rocking Igigi's curve-oriented designs. www.igigi.com.

Jibri

Sold online only, Jibri designs a range of clothing for the fashion-conscious woman who loves color and pattern, and who may be looking for something edgy and sexy. This collection makes fashion fun and will inspire you to step outside your sartorial norm from time to time. www.jibrionline.com.

Jill Alexander Designs

Sold online only, Jill Alexander Designs is a great source for wardrobe staples, specializing in simple yet chic separates such as tops, skirts, pants, and dresses. This brand prides itself on great fabric and a good fit. Their designs also have open necklines, making the brand a good choice for those who love to wear necklaces. www.jillalexanderdesigns.com.

Kiyonna

Sold online only, Kiyonna offers beautifully designed separates for curves. If you love ruching, this collection has some of the most flattering tops, skirts, and dresses for plus-size women. www.kiyonna.com.

Qristyl Frazier Designs

Sold online only, Qristyl Frazier's line is known for sexy silhouettes. The wrap maxi dresses and ruched flutter-sleeved dresses are very flattering for curvy women. www.qristylfrazierdesigns.com.

QVC.com

Shopping can't get more convenient than QVC, which serves up great curvy fashion. Almost every brand on QVC is available up to size 24. The site has an alert option that lets you know what designers are on air—as well as who is shortly forthcoming—while you are online. QVC also has a fierce jewelry collection by the late Joan Rivers that is still available.

Zappos.com

Zappos offers a selection of lifestyle clothing from a variety of brands at different price points. You can find jeans, dresses, tops, and special-occasion looks here. It's a great resource for curvy fashion, and the customer service is excellent.

CURVE-FRIENDLY BRIDAL AND SPECIAL-OCCASION RETAILERS

Finding a wedding gown and other special-occasion wear has gotten a lot easier for curvy women. Here are some of my favorites.

Alfred Angelo Bridal

Alfred Angelo Bridal offers a dazzling array of beautiful gowns in different styles, colors, and exquisite fabrications up to size 26W. These gowns are available online and at major retailers. www.alfredangelobridal.com.

Badgley Mischka

Badgley Mischka is known for exquisite red-carpet gowns. But celebrities don't have to have all the glitz; you can amp up your glam factor in one of their beautiful cocktail or full-length dresses. Badgley Mischka is sold online and at several major retailers. www.badgleymischka.com.

Carmen Marc Valvo

Carmen Marc Valvo is another red-carpet favorite. He designs for all sizes and body types. His beautiful gowns and dresses can be purchased online and at major retailers. www.carmenmarcvalvo.com.

David Meister

David Meister is well known for sophisticated, glamorous, body-conscious dresses and gowns. He is a master at creating flattering curves through his clothing. David Meister is available online and at major retailers. www.davidmeister.com.

David's Bridal

David's Bridal has raised the nuptial style bar, carrying gorgeous gowns, including Vera Wang's White line. www.davidsbridal.com.

Gwynnie Bee

Gwynnie Bee is a subscription-only wardrobe rental site for sizes 10 to 32. This is a style concierge service where you can rent all the latest seasonal looks without purchasing them. If you don't have time to shop and pull a look together, this is a great resource. You can rent in rotation: when you are done with one set of looks, you return them and select another set. www.gwynniebee.com.

Kleinfeld Bridal

Kleinfeld Bridal has one of the largest collections of designer wedding gowns, and it abides by its slogan, "The ultimate bridal experience." Plus-size dresses are available to try on in the store. If you are planning to get married, Kleinfeld Bridal is worthy of an appointment. www.kleinfeldbridal.com.

Rent the Runway

Rent the Runway has the answer to the question, "Why buy a dress when you will wear it only once?" Now you can rent a fabulous dress or gown up to size 24 online or at a Rent the Runway location. www.renttherunway.com.

Sydney's Closet

Sydney's Closet is known for sizing up glamour, whether the event is a prom, a cocktail party, a formal event, or your own wedding, this is a closet that you want to shop in. This collection is offered online only. www.sydneyscloset.com.

Tadashi Shoji

Tadashi Shoji is masterful at designing for curves and a reliable source for special and formal events. You can purchase Tadashi online and at major retailers. www.tadashishoji.com.

Z by Zevarra

Sold online only, Z by Zevarra is a collection of sexy on-trend party and cocktail dresses for confident curves. www.zbyzevarra.com.

SWIMWEAR

Swimwear options for curvy women have come a long way, baby! Now we can have a suit for every day of the week. Here are some of my favorite sources.

Always for Me

Always for Me offers a unique online-only shopping experience up to size 26. You can use various options one at a time to find the perfect swimsuit (or lingerie or active wear): body type, suit style, designer, or bestsellers. www.alwaysforme.com.

Becca ETC Swim

Becca ETC Swim offers a great selection of contemporary swimwear in vibrant colors and modern prints up to size 3X (24). Becca ETC is available online and at major retailers. www.beccaetcswim.com.

Cyberswim

Cyberswim is an incredible resource for shape-enhancing and supportive swimwear. It is also the home of the Miraclesuit (listed next) and other major brands. Sizes range from 8 to 18 and go up to a DD in missy sizes, and from 16w to 24w in women's plus sizes. These suits are sold online and by major retailers. www.cyberswim.com.

Miraclesuit

Miraclesuit is one of the best figure-contouring swimsuits. Offered in sizes 14 to 24, the line is designed to support and give shape to curves in all the right places. It is available online and sold by several major retailers. www.miraclesuit.com.

Sorella Swim

Sorella Swim is a luxury collection of swimwear that is specifically designed for curves. This high-quality, high-fashion line is sold online and in several boutiques. www.sorellaswim.com.

swimsuitsforall

Swimsuitsforall offers every style imaginable, in sizes 8 to 34. This is a fantastic swimsuit-shopping destination. www.swimsuitsforall.com.

CURVE-SPECIFIC SHAPEWEAR AND LINGERIE

Shapewear and a well-fitted bra is the foundation of a polished and refined look. Here are some reliable sources for these important items.

Ashley Graham Collections

Supermodel Ashley Graham offers a gorgeous collection of lingerie designed specifically for curves that is sold online and by major retailers. www.ashleygrahamcollections.com.

Cacique by Lane Bryant

Cacique offers seriously sexy lingerie, available via Lane Bryant, online and in stores. www.cacique.com.

Curvy Couture

Curvy Couture sells an incredible range of high-quality bras and corsets in different styles up to an H cup. The site is a great source for supportive bras specifically designed for curves. Sold online only. www.curvycouture.com.

FullBeauty.com

FullBeauty is an online boutique offering a large selection of bras, corsets, lingerie, and shapewear. www.fullbeauty.com.

Hips and Curves

Hips and Curves is an online boutique with a major selection of shapewear, hosiery, boned corsets, and lingerie. www.hipsandcurves.com.

CURVE-FRIENDLY BRAS, LINGERIE, AND SHAPEWEAR

Whether your curves are slight or full, look to these size-inclusive e-tailers and brands for items that offer good quality, supportive items.

Bare Necessities
Online retailer Bare Necessities offers a variety of underpinnings by several brands. Bras are available up to a triple D (or E) cup. www.barenecessities.com.

BodyWrap
BodyWrap is a great online resource for supportive shapewear that has excellent smoothing and cinching qualities. The tank tops, high-waist thongs, and the full control slips are perfection under body-conscious clothing. www.bodywrap-shapewear.com.

HerRoom
HerRoom is an incredible resource for bras and shapewear. This online boutique offers all the shapewear essentials and extras. The site also provides a breakdown of fabric content and the levels of control for the garments it sells. www.herroom.com.

Linda the Bra Lady
Linda the Bra Lady is well known for being the best bra fitter in New York City. Her shop offers an incredible collection of bras for specific wardrobe needs. If you are in the area, she is worth a visit, but you can consult her online too. www.lindasonline.com/TheBraLadyNY.

Orchard Corset
A well-kept secret among stylists, Orchard Corset never ceases to lift you up and cinch you in. The shop offers an incredible collection of corsets, bras, and shapewear. All of the products are available online and in the store. www.orchardcorset.com.

Soma
Sold in Soma stores and online, this brand is well known for perfectly fitting bras that go up to a G cup and is a great resource for seamless and seamed bras. www.soma.com.

Spanx
Spanx garments are a reliable source for smoothing and cinching. The brand offers full-control tank tops, slips, hosiery, and more. You can purchase Spanx online, in boutiques, and at major retailers. www.spanx.com.

SHOES AND BOOTS

Here is a listing of stores and brands offering wide-width shoes and wide-calf boots above size 10.

Alonai
Online retailer Alonai offers ballerina flats, bridal shoes, platforms, and pumps at affordable prices up to size 14. www.alonai.com.

Barefoot Tess
Online retailer Barefoot Tess offers on-trend pumps, boots, and athletic shoes up to size 15. http://us.longtallsally.com/c/tall/brands/barefoot-tess.

J.Crew
J.Crew offers classic-style shoes up to size 12M online. www.jcrew.com.

MyTheresa.com
Online retailer MyTheresa.com offers luxury designer shoes up to size 12 and is a great resource for fashion-forward footwear.

Net-a-Porter
Net-a-Porter will transform your shoe closet. The perfect destination for fancy footwear, it offers shoes from various designers up to size 12. www.net-a-porter.com.

Nine West
Nine West offers moderately priced on-trend shoes up to size 12 both online and in stores. www.ninewest.com.

Nordstrom
Nordstrom has a great selection of designer shoes up to size 13 as well as wide-width options at various price points both online and in stores. www.nordstrom.com.

Nordstrom Rack
Nordstrom Rack offers designer shoes up to size 13 and wide-width shoes at discounted prices both online and in stores. www.nordstromrack.com.

The Outnet
The Outnet is a great resource for designer shoes up to size 12. www.theoutnet.com.

UGG
UGG offers its classic boot and other styles up to size 12 both online and in stores. www.uggaustralia.com.

WideCalfBoots4U.com
If you have a hard time finding boots that are wide enough for your calves, this site is for you. Here you'll find stylish boots up to size 13 from different designers.

WideWidths.com
A great resource for wide-width shoes, this site offers shoes up to size 13 and up to an E width.

Zappos
Zappos offers a full array of stylish shoes up to size 13 in wide widths. www.zappos.com.

CURVE-FRIENDLY STATEMENT JEWELRY

Bold pieces, hinge bracelets, and necklace lengths sixteen inches and longer are flattering pieces for curvy women. Here's where to find them.

Alexis Bittar

Alexis Bittar is a favorite among fashionistas and celebrities. Lucite and large statement pieces are his trademark. His collections are available online and sold in boutiques and major retailers. www.alexisbittar.com.

BaubleBar

The BaubleBar is a contemporary jewelry online boutique. The long pendant necklaces are great for curves. www.baublebar.com.

Classic Plus Size Jewelry

This plus-specific online jewelry site is a gem. Every piece has been made to fit a larger neck, wrist, or finger. This is a great resource for easy-to-fit jewelry. www.classicplussizejewelry.com.

Kenneth Jay Lane

Kenneth Jay Lane offers great statement jewelry. The pieces are not curve-specific, but the size makes it curve-friendly. This collection is sold online and by various retailers. www.kennethjaylane.com.

Rara Avis by Iris Apfel

This unique jewelry collection is curve-friendly because its proportions are stately! Iris Apfel sells her jewelry on HSN, and her pieces are affordably priced. www.hsn.com/shop/rara-avis-by-iris-apfel/8564.

R. J. Graziano

R. J. Graziano's beautiful creations include large pendants, hinged bracelets, and gemstone statement necklaces that are perfect for curves. His work is available on HSN and online, and is sold by major retailers. www.rjgraziano.com.

Robert Lee Morris

Robert Lee Morris is known for hammered metals and unique, attention-getting jewelry. His large statement pieces are perfect for curves. Morris's collections are available online and at various retail stores. www.robertleemorris.com.

Thistle & Bee

Thistle & Bee offers unique sterling-silver jewelry that includes extended-size bracelets, rings, and necklaces. The collection is available online and in stores. www.thistleandbee.net.

CURVE-FRIENDLY HANDBAGS

Here are sources for handbags that are substantial in size and designed with long straps.

GiGi New York

GiGi New York offers a fantastic array of hand-bags in rich colors and styles. GiGi is the home of the Uber Clutch, which is perfect for curves. The brand is sold online and in stores. www.giginewyork.com.

Gucci

Of course, Gucci is known for great handbags. The canvas shoulder bags, leather bucket bags, and hobo bags are proportionally sized, making them great for curves. Gucci bags can be bought in Gucci stores, online, and at major retailers. www.gucci.com.

Jason Wu

Jason Wu's handbags are classic designs with incredible style. The tote and the messenger bags are a win for curves. Wu's bags can be bought online and at major retailers. www.jasonwustudio.com.

Longchamp

Longchamp makes generously sized handbags in unique prints and textures. Longchamp bags are available online and in stores. us.longchamp.com.

Michael Kors

Michael Kors offers large satchels, totes, and shoulder bags in embossed crocodile as well as other unique textures. His handbags look great on curves and are sold online and at major retailers. www.michaelkors.com.

Net-a-Porter

Net-a-Porter has a handbag for women of every size and style personality. This online boutique offers luxury handbags from a variety of major designers. Warning: it's hard to stay focused with so much eye candy! www.net-a-porter.com.

Phillip Lim

Phillip Lim offers large architectural-shaped bags in rich colors and textures. If you are looking for a handbag with unique details, these are a must-see. The bags can be found online and at major retailers. www.31philliplim.com.

ShopStyle

ShopStyle has a very generous selection of on-trend handbags at various price points. You can find an evening tote or a bag for work at this site, which is definitely worth a visit. www.shopstyle.com.

Stella McCartney

Stella McCartney offers luxury statement handbags with fun details such as fringe, quilting, and chain links. The bags are sold in her stores, online, and through major retailers. www.stellamccartney.com.

Tory Burch

Tory Burch offers a great selection of handbags in rich neutrals and pretty pastels. The leather bucket bags and the evening clutches are curve-friendly. The bags are available online, at Burch's boutiques, and at major retailers. www.toryburch.com.

CURVE-SPECIFIC AND CURVE-FRIENDLY BRANDS AND RETAILERS BASED OUTSIDE THE UNITED STATES

There are designers, retailers, and online boutiques based all over the world that create a full range of casual and formal clothing for curves. Many ship internationally. Consult their Web sites for more information.

17 Sundays (Australia)

17 Sundays offers a great selection of casual options, particularly denim pieces and basic dresses. www.17sundays.com.

Addition Elle (Canada)

Addition Elle is a fashion destination for stylish curvy women, offering a full selection of casual on-trend clothing and great accessories. Outside Canada, they ship only to the United States. Shop online and in stores (Canada only). www.additionelle.com.

Anna Scholz (United Kingdom)

Anna Scholz is a luxury lifestyle collection for curves that offers exquisite prints and fabrications. It is available online and at major retailers in the United States and Europe. www.annascholz.com.

ASOS (United Kingdom)

Online retailer ASOS offers great on-trend casual and special-occasion wardrobe options at affordable prices. Go to the "Curve & Plus Size" tab at this site to find all of the season's runway-inspired trends in everything from dresses to coats. They offer worldwide shipping. www.asos.com.

Carmakoma (United Kingdom)

Carmakoma is a luxury line that is designed for the trend-oriented shopper. If you are looking for leather pants and pieces in unique fabrications, this is the destination for you. You can purchase Carmakoma online and at major retailers worldwide. www.carmakoma.com.

City Chic (Australia)

City Chic is Australia's leading plus-size retailer, offering a great selection of jeans, T-shirts, tops, swimsuits, and dresses for every occasion. Shop online and in stores worldwide. www.citychiconline.com.

Dea London (United Kingdom)

Dea London offers luxury clothing for curves. Expert tailoring and unique fabrications are all a part of the Dea London aesthetic. You can purchase online, but if you're in London, you can make an appointment to visit the Dea atelier. www.dealondon.co.uk.

Elena Mirò (Italy)

Elena Mirò is a luxury collection that offers exquisite clothing, shoes, and accessories. One of the only curve-oriented designers to participate in Milan's regular-size Fashion Week, Elena Mirò is sold online and in stores throughout the world. www.elenamiro.com.

Evans (United Kingdom)

Evans is a great resource for casual and upscale clothing in sizes 10 to 28 and is known for collaborations with notables such as Clements Ribeiro and Beth Ditto. You can also find great shoes and accessories here. Shop online and in stores. www.evansusa.com.

Fuzzi (Italy)

Fuzzi is a luxury brand offering beautifully designed dresses and tops. This line is made primarily of fine mesh, overlaid fabrics in stunning prints and interesting silhouettes. It is available online and in stores. www.fuzzi.it.

H&M (Sweden)

While Sweden-based H&M is a global company, its offerings for curvy women are not highly extensive. But it does offer a great selection of casual plus-size wardrobe staples: on-trend jeans, T-shirts, dresses, and skirts at affordable prices. Shop online and in stores: www.hm.com/us.

Harlow (Australia)

Harlow offers a casual selection of sweaters, dresses, jackets, tops, and jeans at moderate prices. The clothing has a minimalist edge, with easy-to-wear knit dresses and tops in simple yet refined silhouettes. Check the website for shipping destinations. www.harlowstore.com.

Jean Marc Philippe (France)

This casual lifestyle collection has a bohemian-chic vibe, with rich prints and generous silhouettes. The brand has stores in France and ships internationally. www.jeanmarcphilippe.com.

Marina Rinaldi (Italy)

Marina Rinaldi is a luxury collection that offers beautiful upscale casual clothing, well-tailored professional pieces, and gorgeous special-occasion gowns and accessories. It is also an excellent resource for beautiful coats. Marina Rinaldi is available at Marina Rinaldi boutiques, online, and through major retailers. Marina Rinaldi is a part of the Max Mara brand and has stores in New York, Beverly Hills, and in major cities internationally. www.marinarinaldi.com.

Missguided (United Kingdom)

Missguided offers a sexy, trendy, affordable selection for curves. This site is for the serious style maven who wants up-to-the-minute fashion without spending a fortune. Ships worldwide. Missguided.co.uk.

Navabi (Germany)

Navabi is a global leader in plus-size fashion that sells premium looks from designers and brands from all over the world. This is a fantastic online shopping destination. www.navabi.us.

Penningtons (Canada)

Penningtons offers a full range of casual clothing and a great selection of shoes and boots at great prices. Shop online and in stores (Canada only). www.penningtons.com.

Persona (Italy)

Edgy, on trend, and super chic, Persona, Marina Rinaldi's contemporary brand, is available at Marina Rinaldi stores, online, and at major retailers, including Saks Fifth Avenue. gb.marinarinaldi.com/persona.

Pink Clove (United Kingdom)

Pink Clove sells trendy fashion in sizes 16 to 32 at great prices. If you are a shopper who looks for new arrivals daily, Pink Clove is for you. They ship worldwide. www.pinkclove.co.uk.

Simply Be (United Kingdom)

Simply Be is an online boutique that offers several notable brands in sizes 8 to 28. It offers designs that are both classic and on trend. This boutique is a great resource for wardrobe staples. www.simplybe.com.

Taking Shape (Australia)

Online retailer Taking Shape celebrates curves with an affordable lifestyle selection of trendy shapewear, clothing, shoes, and accessories. The site lives up to its name with interesting silhouettes and shapes in vibrant colors and patterns in sizes 14 to 26. www.takingshape.com.

BLOGGERS: THE CURVY CONNOISSEURS

Curvy bloggers are the fired-up advocates on the front lines of plus fashion. These women of style have been emphatic and consistent in their demands for high-quality plus-size fashion and steadfast in their rally against fat shaming and any attempts to stand in the way of making great style available. To follow are my favorite online voices.

Alissa Wilson
www.stylishcurves.com

Alissa takes a super feminine approach to fashion. Her affinity for pretty dresses is contagious, and she wears them well.

Allison Teng
www.curvygirlchic.com

Allison keeps it real about her shopaholic tendencies. Her obsession with shoes, something many of us can relate to, is captivating, thanks to her stylish photos.

Callie Thorpe
www.fromthecornersofthecurve.com

This London woman keeps us wonderfully in touch with curvy-girl style across the pond.

CeCe Olisa
www.plussizeprincess.com

CeCe is the cocreator of the inspiring and successful theCurvycon, a leadership conference teaching women to be fearless. She leaves no stone unturned: from dating to bikini waxes, she tackles it all.

Chastity Garner
www.garnerstyle.blogspot.com

With CeCe Olisa, Chastity is the cocreator of theCurvycon. Her blog is packed with plus-size product information that includes new designers, the latest in shapewear, and commentary on all curve-related fashion. Chastity also knows how to give fierce fashion poses while wearing all the latest.

Gabifresh
www.gabifresh.com

Gabi is smart and witty, with a daring, sexy approach to fashion that I love. Her bikini shots are seriously haute!

Georgina Horne
www.fullerfigurefullerbust.com

Fuller-busted sisters will love this vibrant and relatable blog. Georgina candidly shares stories about bra fittings and her obsession with breasts and bras.

Karyn Johnson
www.killerkurves.com
Karyn is passionate about fashion, sharing her platform with beautiful curvy women worldwide and celebrating curves in all the latest styles.

Kellie Brown
www.andigetdressed.com
Kellie's experimentation with textures, lengths, and neutrals is cutting-edge, and she always has a good handbag.

Liz Black
www.psitsfashion.com
Liz is a great writer with a big personality and a genuine approach to what she loves about all things pertaining to fashion for plus sizes and beyond. Liz also gives great fashion tips, alerts readers to giveaways from brands, and turns the spotlight on other bloggers.

Marcy Cruz
www.plus-model-mag.com
The blog editor for Plus model magazine, Marcy covers new designers and brands, models, and events. If you want to know anything regarding the plus community, this is the blog where you'll find it. Way to go, Marcy!

Margie Ashcroft
www.margieplus.com
This fierce and colorful blog is evidence that Margie is unapologetically reveling in fashion to the fullest. And she sings!

Marie Denee
www.thecurvyfashionista.com
Marie's friendly tone connects art and culture with fashion and presents the latest plus-designer look books hot off the press.

Nadia Aboulhosn
www.nadiaaboulhosn.com
Nadia's blog screams body confidence! Her edgy fashion choices and sultry poses are all a part of her visual journey.

Nicolette Mason
www.NicoletteMason.com
Nicolette has a great writing style and a well-balanced blog—it's very fashion-diary oriented, and feels really personal. She is an editor at Marie Claire and pens the column "Big Girl in a Skinny World."

Reah Norman
www.styledbyreah.com
Reah delivers great videos of curvy women wearing the season's latest and greatest trends. Informative and on trend, her blog provides an inclusive, inspirational experience.

Sara Conley
www.styleitonline.com
Sara artfully packs plus fashion, beauty, and technology all into one blog. She is also not afraid to tackle issues of the moment regarding plus fashion and states her point of view well.

Sarah Chiwaya
www.curvilyfashion.com
Sarah presents a cool, laid-back perspective on plus fashion. She created the hashtag #plussizeplease to sway designers toward including larger sizes in their collections.

Tanesha Awasthi
www.girlwithcurves.com
Tanesha's chic and sophisticated style is clearly translated into the lifestyle aspect of her blog. She offers great fashion tips for travel and has designed some really great looks for curves.

Tess Holliday
www.tessholliday.com
Tess is the founder of the #effyourbeautystandards movement. She is also the first plus model above size 20 to sign a modeling contract with a major agency. She and her blog have made international headlines with an authentic message of self-love and acceptance.

Ty Alexander
www.gorgeousingrey.com
This blog is chock-full of gems covering plus fashion, entertainment, beauty, and lifestyle. Ty delivers it all in a magazine-style format, and you can't get enough.

SELECT BIBLIOGRAPHY

Books

Baron, Katie. *Stylists, New Fashion Visionaries*. London: Laurence King, 2012.

Bayou, Bradley. *The Science of Sexy: Dress to Fit Your Unique Figure with the Style System That Works for Every Shape and Size*. New York: Gotham, 2006.

Beahm, George (ed.). *I, Steve: Steve Jobs in His Own Words*. Chicago: B2 Books, 2011.

Boston, Lloyd. *Before You Put That On: 365 Daily Style Tips for Her*. New York: Atria Books, 2005.

Buxbaum, Gerda, (ed.). *Icons of Fashion: The 20th Century*. Munich: Prestel, 1999.

Chenoune, Farid. *Beneath It All: A Century of French Lingerie*. New York: Rizzoli, 1999.

Cohen, Albert. *Belle du Seigneur*. Paris: Gallimard Editions, 1968.

Design Museum. *Fifty Fashion Looks That Changed the 1950s*. London: Conran Octopus, 2012.

Dior, Christian. *The Little Dictionary of Fashion: A Guide to Dress Sense for Every Woman*. London: Cassell, 1954

Doonan, Simon. *Eccentric Glamour: Creating an Insanely More Fabulous You*. New York: Simon & Schuster, 2008.

Haack, Donald. *Diamonds 'neath My Wings*. Charlotte, NC: Pure Heart Press, 2009.

Head, Edith. *The Dress Doctor, Prescriptions for Style, from A to Z*. Boston: Little, Brown and Company, 1959.

Meyer, Joyce. *The Confident Woman, Start Today Living Boldly and Without Fear*. New York: Warner Faith, 2006.

O'Keefe, Linda. *Shoes: A Celebration of Pumps, Sandals, Slippers and More*. New York: Workman, 1996.

Reichman, Stella Jolles. *Great Big Beautiful Doll: Everything for the Body and Soul of the Larger Woman*. New York: Dutton, 1977.

Talley, André Leon. *Little Black Dress*. New York: Skira Rizzoli, 2013.

Travers-Spencer, Simon, and Zarida Zaman. *The Fashion Designer's Directory of Shape and Style*. Hauppauge, NY: Barron's, 2008.

Von Teese, Dita. *Burlesque and the Art of the Teese*. New York: It! Books, 2006.

Walker, Harriet. *Cult Shoes: Classic and Contemporary Designs*. London: Merrell, 2012.

Articles

"A History of Foundation Garments." Kuhmillion Lingerie (June 27, 2010). Accessed November 12, 2014. www.kuhmillion.com/lingerie/page/24/foundation-garments.aspx.

"Amy Schumer's Life Goals: 'I Want to Make Women Laugh. I Want Them to Use Their Voice. And I Want a Jet.'" Glamour.com (July 7, 2015). Accessed August 24, 2015. http://www.glamour.com/entertainment/blogs/obsessed/2015/07/amy-schumer-glamour-august-cover.

"Ask Them Yourself: Question for Bette Midler." *Trenton Evening Times*, Section: Family Weekly (Newspaper Supplement), January 13, 1980.

Baker, Jes. "Why the Hourglass Figure Is the Only Version of Plus Size That We See." *The Militant Baker* (November 5, 2014). Accessed January 14, 2014. http://www.themilitantbaker.com/2014/11/why-hourglass-figure-is-only-version-of.html.

Banks, Tyra. Notable Quotes (attributed to *Woman's Day*, April 1, 2009). Accessed November 28, 2015. http://www.notablequotes.com/b/banks_tyra.html

Barton, Jennifer. "Alice Temperley Debuts Lingerie in Somerset Range." *Marie Claire* (September 25, 2013). Accessed August 2, 2015. http://www.marieclaire.co.uk/news/fashion/544467/alice-temperley-debuts-lingerie-in-somerset-range.html#index=1.

Behera, Ganesh Hari. "The Evolution of Bags and Their Importance to Women." SelfGrowth.com. Accessed November 23, 2014. www.selfgrowth.com/articles/the-evolution-of-bags-and-their-importance-to-women.

Ben-Horin, Karen. "Foundations in *Vogue*: 1953–1963." *On Pins and Needles* (February 26, 2013). Accessed November 20, 2014. www.pinsndls.com/2013/02/26/foundations-in-vogue1953-1963/.

"Body Shapes." LookSmart. Accessed March 21, 2014. http://www.looksmartalterations.com.au/style-tips/body-shapes.

Bulwer-Lytton, Edward G. BrainyQuote.com, Xplore Inc, 2015. Accessed August 5, 2015. http://www.brainyquote.com/quotes/quotes/e/edwardgbu117841.html.

C., Sandra. "Cages to Cushions: 19th Century Foundation Garments Revisited." *Studio Stitch Art* (December 2, 2011). Accessed November 12, 2014. www.studiostitchart.blogspot.com/2011/12/cages-to-cushions-19th-century.html.

Carlson, Jen. "Lena Dunham Tells Us About Her 'Zen Body' Philosophy." *Gothamist*, January 16, 2014. Accessed August 5, 2015. http://gothamist.com/2014/01/16/lena_dunham_body_image_interview.php.

Colón, Suzan. "Jill Scott's Aha! Moment." *O, the Oprah Magazine* (March 2009). Accessed August 4, 2015. http://www.oprah.com/world/Jill-Scotts-Aha-Moment.

Coyne, Kate. "Melissa McCarthy: 'I've Never Felt Like I Needed to Change' (In Her Own Words!)." *People* (July 7, 2014). Accessed August 4, 2015. http://www.people.com/people/archive/article/0,,20832188,00.html.

"Donna Karan in Her Own Words: An Exclusive Excerpt From Her Upcoming Memoir." Vogue.com. August 24, 2015. Accessed August 24, 2015. http://www.vogue.com/13297624/my-journey-donna-karan-memoir-excerpt/.

"Elizabeth Taylor's 20 Best Quotes." *The Telegraph* (March 23, 2001). Accessed August 3, 2015. http://www.telegraph.co.uk/culture/film/film-news/8401001/Elizabeth-Taylors-20-best-quotes.html.

Guilder, George. "Women in the Work Force." *The Atlantic* (September 1986). Accessed November 16, 2014. www.theatlantic.com/magazine/archive/1986/09/women-in-the-work-force/304924/.

"The Handbag in History." Gleni. Accessed November 23, 2014. www.gleni.it/bag-in-history.html.

Hohenadel, Kristin. "The Eccentric Life and Fashion Philosophy of 'Geriatric Starlet' Iris Apfel." *The Eye* (April 30, 2015). Accessed August 4, 2015. http://www.slate.com/blogs/the_eye/2015/04/30/iris_is_a_portrait_of_geriatric_style_icon_iris_apfel_directed_by_albert.html.

Italie, Leanne. "History of Lingerie: 'Exposed' Offers Look at Lingerie." *Commercial Appeal* (June 16, 2014). Accessed November 15, 2014. www.commercialappeal.com/lifestyle/fashion-and-style/fashionhistoryoflingerie_30904811.

Jain, Priya. "Exclusive Interview: Queen Latifah." *Woman's Day* (October 15, 2008). Accessed August 4, 2015. www.womansday.com/life/entertainment/a3027/exclusive-interview-queen-latifah-21095/.

"Lady Gaga and the Sociology of Fame: College Course," *The Independent* (November 17, 2010). Accessed August 4, 2015. http://www.independent.co.uk/arts-entertainment/music/lady-gaga-and-the-sociology-of-fame-college-course-2136431.html.

Leaper, Caroline. "The 25 Best Shoe Quotes of All Time." *Marie Claire* (June 22, 2015). Accessed June 8, 2015. http://www.marieclaire.co.uk/blogs/546914/shoe-quotes-the-25-best-of-all-time.html.

Mackey, Nanci. "Purse History." *Purse Pixie*. Accessed November 23, 2014. www.pursepixie.com/purse-history/.

Mo'Nique. "Gabourey Sidibe." *Interview* (September 2009). Accessed August 4, 2015. http://www.interviewmagazine.com/film/gabourey-sidibe/.

Oneill, Therese. "7 Things Historical Women Wore Under Their Skirts." *Mental Floss* (July 24, 2013). Accessed November 12, 2014. www.mentalfloss.com/article/51840/7-things-historical-women-wore-under-their-skirts.

Page, Ashley. "15 Plus Size Celebrities We Love! (Bigger Is Better!!)." *StyleBlazer* (July 23, 2012). Accessed December 3, 2014. http://styleblazer.com/65285/15-plus-size-celebrities-we-love-bigger-is-better/.

Rodrick, Stephen. "Serena Williams: The Great One." *Rolling Stone* (June 2013). Accessed July 24, 2015. http://www.rollingstone.com/culture/news/serena-williams-the-great-one 20130618.

Ryan, Taylor. "Top 10 Thursday: The Evolution of the Ideal Female Body Image Over the Past 10 Decades." *Lifting Revolution*. Accessed November 16, 2014. www.liftingrevolution.com/top-10-thursday-the-evolution-of-the-ideal-female-body-image-over-the-past-10-decades/.

Settembre, Jeannette. "Lane Bryant Redefines Beauty with Its #ImNoAngel Campaign, Taking Aim at Victoria's Secret." *New York Daily News* (April 6, 2015). Accessed June 12, 2015. http://www.nydailynews.com/life-style/fashion/lane-bryant-redefines-beauty-imnoangel-campaign-article-1.2175507.

Singer, Jane. "Why Are Handbags So Important?" *The Robin Report* (March 20, 2013). Accessed November 23, 2014. www.therobinreport.com/why-are-handbags-so-important/.

Spencer, Amy. "Kelly Osbourne's DOs and DON'Ts of Body Confidence." *Glamour* (April 3, 2012). Accessed August 4, 2015. http://www.glamour.com/health-fitness/2012/04/kelly-osbourne-dos-and-donts-of-body-confidence.

Talley, André Leon. "Michelle Obama: Leading Lady," *Vogue* (March 1, 2009). Accessed August 5, 2015. http://www.vogue.com/3056753/michelle-obama-leading-lady/.

Tara. "The History of Shapewear." *The DC Metro Retro* (October 4, 2010). Accessed November 24, 2014. www.bettysvintage-musings.blogspot.com/2010/10/history-of-shapewear.html.

Thomas, Pauline Weston. "Stays to Corsets—Fashion History." Fashion-Era.com. Accessed November 14, 2014. www.fashion-era.com/stays_to_corsets.htm.

Toms, David. "We Take Our Hats Off to . . ." *Savoir Faire* (September 7, 2011). Accessed August 4, 2015. david-toms.blogspot.com/2011/09/we-take-our-hats-off-to.html.

Unger, Craig. "The Genius of Yves Saint Laurent." *New York* (November 28, 1983). Accessed August 4, 2015. https://books.google.com/books?id=hrsBAAAAMBAJ&pg=PA44&lpg=PA44&dq=genius+of+yves+-saint+laurent+new+york+magazine&-source=bl&ots=yRz60WxIfb&sig=-Jz92G6BrDNofX2zAOOMH-CFOkaY-&hl=en&sa=X&ved=0CB4Q6AEwA-GoVChMIzZXpyZuSxwIVDHQ-Ch1f_QPP#v=onepage&q=genius%20of%20yves%20saint%20laurent%20new%20york%20magazine&f=false.

Von Furstenberg, Diane. www.goodreads.
com. Accessed December 4, 2015. http://
www.goodreads.com/search?q=self-love&-
search%5Bsource%5D=goodreads&-
search_type=quotes&tab=quotes

Wasilak, Sarah. "5 Powerful Quotes
from the Model Who Showed Off Her
Stretch Marks and Cellulite in a Bikini."
Popsugar (July 28, 2015). Accessed August
4, 2015. www.popsugar.com/fashion/
Denise-Bidot-Plus-Size-Model-Interview-
37962311#photo-37962311.

Weymouth, Lally. "A Question of Style:
A Conversation with Diana Vreeland."
Rolling Stone, August 11, 1977. Accessed
via ana-lee.livejournal.com. August
5, 2015. http://ana-lee.livejournal.
com/136879.html.

Winfrey, Oprah. "What I Know for Sure
About Making Peace with My Body."
O, The Oprah Magazine (August
2002). Accessed August 4, 2015.
http://www.oprah.com/omagazine/
What-I-Know-for-Sure-Weight.

Yaeger, Lynn. "The Bottom Line: A Profile
on Spanx Founder Sara Blakely." *Vogue*
(March 19, 2012). Accessed August 4,
2015. http://www.vogue.com/865364/the-
bottom-line-spanx-founder-sara-blakely/.

Video and Film

Apfel, Iris. *Iris.* Directed by Albert Maysles.
2014.

Gunn, Tim. "Tim Gunn on Shapewear."
HuffPost Video (February 23, 2013).
Accessed August 4, 2015. http://
videos.huffingtonpost.com/food/
tim-gunn-on-shapewear-517683052.

Rivers, Joan. *Late Show with David
Letterman* (February 26, 2013). Accessed
August 4, 2015. https://www.youtube.com/
watch?v=Am1o587VaG4.

ACKNOWLEDGMENTS

I am a dreamer, with a spirited and vivid imagination, who knows my dreams are realities in waiting. This can be a hard sell for those who love me. So Craig David Williams, my loving husband and best friend, I thank you for your genuine zeal and encouraging words that continue to remind me to go big with purpose. I could not imagine life without you. Virginia Moses, what an amazing woman and mother you are! Thank you for showing me how to get up, to press on, and for allowing me to be me—always. Ashley and Amanda Christopher, my beautiful nieces, I thank you for sharing me with the world of fashion without protest. I'm inspired as I observe you explore your own creativity and pursue your hearts' desires.

My incredible journey is, and always has been, filled with amazing people. To the celebrated women I dress, thank you from the bottom of my heart for placing some of your biggest moments in my hands. Marc Beckman, Sam Sohaili, and Nancy Chanin of DMA United, special thanks for turning a conversation into an awesome opportunity. Jelani Bandele, this was bigger than I ever imagined. I thank you deeply for turning hours of conversation and piles of notes into a safe, curve-loving, celebratory place for women. Carmen Giordano, my legal counsel, deep thanks for your immeasurable and greatly appreciated guidance. Emme, I can't remember when I didn't know you. To the world you're a supermodel, but you're a superfriend to me, and I thank you from the bottom of my heart for it.

Styling is about pulling it all together, and so, I've learned, is writing a book. Elizabeth Viscott Sullivan, my editor, I am grateful for your guidance and extraordinary passion to deliver a "killer" book. You said, "We'll get there," and here we are. I'd also like to thank art director Lynne Yeamans, designer Tanya Ross-Hughes, illustrator Amy Saidens, and production director Susan Kosko for making this beautiful book come to life.

To photographer David Oldham and the lovely Tara Lynn, genuine thanks for a jacket cover image that sizzles and your enthusiasm for making it happen.

Creativity feeds creativity, so to those with whom I've spent a great deal of time at the table, I offer warm thanks: Issam Bajalia, Bradley Bayou, Abbie Britton, Carlo Dalla Chiesa, Corynne Corbet, Stanley Desbas, Sam Fine, R. J. Graziano, Nicole Brewer Gurganious, Linda Heasley, Dusty Hope, Rodney LoveJones, JaNina Lee, Nancy LeWinter, Julie Lewit-Nirenberg, Sandra Martin, Frank Pulice, Sunil Ramchandani, Camille Henriquez Sears, Timothy Snell, Carmen Marc Valvo, Joyce Washington, Danielle Wright, and Sheneen Zee.

Raised in faith, I know that much comes from above. I send a heavenly shout-out to my beloved friend and legendary makeup artist, the late Roxanna Floyd: you were so generous with your wisdom and guidance. I can still hear you saying, "This is a fabulous dress rehearsal; the best is yet to come." And most of all, I thank God for giving me courage, resilience, and a gift that allows me to do what I love. I am eternally grateful.

PHOTOGRAPHY AND ILLUSTRATION CREDITS

Dedication

Courtesy of Susan Moses.

Introduction

Pages 10, 11, 12, left and right: Courtesy of Susan Moses. 12, center: Vintage advertisement, courtesy of Lane Bryant. Page 15, left: Cleo Sullivan, *Vibe*, April 1998, courtesy of *Vibe* magazine. Page 15, right: Courtesy of Susan Moses. Page 16, all except top left: Courtesy of Susan Moses. Page 16, top left: Marc Baptiste, *Mode*, October 1999, courtesy of *Mode* magazine. Page 18, left: Kevin Mazur/Wire Image. Page 18, right: Paul Winter/Getty Images. Page 21: Paul De Luna, courtesy of Paul De Luna.

1: Body Talk

Page 22: Sølve Sundsbø, *V* magazine, January 2010/ Art + Commerce. Page 24: Susan Bowlus, courtesy of Susan Bowlus. Page 26: Peter Chin, *Ebony*, March 2010, courtesy of Peter Chin. Pages 28–29: Beate Hansen/ Corbis. Page 30: Keith Major, courtesy of Keith Major. Pages 31; 32, top left and bottom right: Stanley Desbas, courtesy of Stanley Desbas. Page 33: Lucas Jones for Lucas Pictures, courtesy of Qristyl Frasier Designs for qristylfrazier.com.

2: Shapewear

Page 34: Joshua Jordan/Trunk Archive. Page 36: Rafael Clemente, *Curva*, Issue #5, 2015, courtesy of *Curva* magazine. Pages 38–39: Bruno Gaget, *Mode*, February 1998, courtesy of Bruno Gaget and *Mode* magazine. Page 41: ullstein bild/ullstein bild/Getty Images; Gina Lollobrigida, *Crossed Swords*, 1953. Page 43: Marilyn Monroe, *River of No Return*, 1954/20th Century Fox **R.C. Page 45: Amy Saidens. Page 46: Keystone View/ FPG/Getty Images. Page 49: Lily Cummings, courtesy of Lily Cummings. Page 50: Txema Yeste/Trunk Archive. Page 52: Maxime Bocken, courtesy of Maxime Bocken. Pages 54 and 55, top: Courtesy of Lane Bryant. Page 55, bottom: Courtesy of firstVIEW.com. Page 57: Courtesy of Violeta by Mango. Page 58: Francesco Benson, courtesy of *Avenue*. Page 59, top and bottom: Courtesy of Lane Bryant. Page 61, top left: Francesco Benson, courtesy of *Avenue*. Page 61, top right: Courtesy of Lane Bryant. Page 61, bottom left: Courtesy of firstVIEW.com. Pages 61, bottom right; 62, top left: Francesco Benson, courtesy of *Avenue*. Page 62, top

right: Infit-05/INFphoto.com/Corbis. Page 63: Stanley Desbas, courtesy of Stanley Desbas. Page 65: DFree/ Shutterstock.com. Page 66, bottom left: Francesco Benson, courtesy of *Avenue*. Page 66, bottom right: Infit-05/INF photo.com. Page 67: ACP/Trunk Archive. Page 68, top left: Courtesy of Lane Bryant. Page 68, bottom right: Infit-05/INF photo.com/Corbis. Page 69, top: Francesco Benson, courtesy of *Avenue*. Page 69, bottom: Courtesy of firstVIEW.com. Page 71: William Carter, courtesy of Grisel for Rebdolls.

3: Bras

Page 72: Chris Nicholls, courtesy of Chris Nicholls Photography. Page 75: Joshua Jordan/Trunk Archive. Pages 77 and 78, bottom left: Amy Saidens. Pages 80–81: Courtesy of Lane Bryant. Page 82: Frank Edwards/Fotos International/Getty Images. Pages 84–87: Courtesy of Curvy Couture. Page 88: Courtesy of Lane Bryant. Pages 89; 91, top left and 91, bottom right: Courtesy of Curvy Couture. Page 90: Shutterstock.com. Page 93: Joshua Jordan/Trunk Archive. Page 95: Ferdinando Scianna, Magnum Photos/Trunk Archive. Page 96: Marc Baptiste, *Washington Post*, August 13, 2015, courtesy of Marc Baptiste. Page 98: Joe Shere/MPTV Images. Page 99: Chris Nicholls, courtesy of Chris Nicholls Photography.

4: Wardrobe Essentials

Page 100: Craig McDean/Art + Commerce. Page 103: Marcelo Krasilcic/Trunk Archive. Page 105, top left: Jeff Randall/Getty Images. Page 105, bottom right: Courtesy of Violeta by Mango. Page 106: Philippe Rohdewald, courtesy of Eloquii.com. Page 107, top left: Courtesy of Lane Bryant. Page 107, top right: Philippe Rohdewald, courtesy of Eloquii.com. Page 107, bottom left: Joshua Jordan/Trunk Archive. Page 107, bottom right: Courtesy of Lane Bryant. Page 108: Philippe Rohdewald, courtesy of Eloquii.com. Page 109, top right: Courtesy of Lane Bryant/Isabel Toledo collection. Page 109, bottom left: Bradford Wilcox, courtesy of Kiyonna Clothing, Inc./ www.kiyonna.com. Page 110: David Oldham, courtesy of David Oldham. Page 111: Paul Bellaart/Trunk Archive. Page 112: Courtesy of firstVIEW.com. Page 113, top left: Meagan Harding Photography. Courtesy of Harlow-Australian Fashion Label/harlowstore.com. Model: Chanel Fucile/Bella Mgmt. Page 113, bottom right: Enrique Vega, courtesy of Enrique Vega. Page 114: Courtesy of Lane Bryant. Page 115: Elton Anderson, © 2015 swimsuitsforall LLC. Page 117: Dusty Hope. Page 119: Courtesy of firstVIEW.com.

Page 120: Joshua Jordan/Trunk Archive. **Page 123:** Courtesy of firstView.com. **Page 124:** Michelle Alexandra, courtesy of Michelle Alexandra. **Page 127:** Courtesy of firstVIEW.com. **Page 128:** Philippe Rohdewald, courtesy of Eloquii.com. **Page 131:** Courtesy of firstVIEW.com. **Page 132:** Courtesy of Anna Scholz for www.annascholz.com. **Page 135:** Courtesy of firstVIEW.com. **Page 136:** Philippe Rohdewald, courtesy of Eloquii.com. **Page 138:** Nicholas Kamm/AFP/Getty Images. **Page 143:** Meredith Jenks/Trunk Archive. **Pages 144–145:** Yumna Al Arashi, "The Alda Women," courtesy of Yumna Al Arashi.

5: Fashion Myths Debunked

Page 146: Russell James, *Sports Illustrated*, February 2015, © 2015 swimsuitsforall LLC. **Page 148:** Rebecca Greenfield, *Wall Street Journal*, June 3, 2015, courtesy of Rebecca Greenfield. **Pages 150–151:** Philippe Rohdewald, courtesy of Eloquii.com. **Page 152:** David Oldham for *Elle* France, courtesy of David Oldham. **Page 154:** Infit-05/INF photo.com/Corbis. **Page 155:** Emma Tempest/Trunk Archive. **Page 157:** Lorenzo Bringheli/Trunk Archive. **Page 158:** Emma Summerton/Trunk Archive. **Page 159:** Genevieve Charbonneau, *Elle* Quebec, May 2013, courtesy of Genevieve Charbonneau. **Pages 160–161:** Katie Walker, courtesy of Anna Scholz for www.annascholz.com. **Pages 162–163:** trunkarchive.com. **Page 165:** Timur Emek/Getty Images. **Page 166:** Gomillion and Leupold/Contour by Getty Images. **Page 169:** Paula Kudacki/Trunk Archive. **Page 171:** Claudia Knoepfel & Stefan Indlekofer/Trunk Archive. **Pages 172–173:** Kevin Tachman/Trunk Archive. **Page 174:** Michelle Alexandra, *Dare*, Summer 2014, courtesy of Michelle Alexandra. **Pages 175–178:** Michael Edwards, © 2015 swimsuitsforall LLC. **Page 179:** Michelle Alexandra for *Dare*, Summer 2014. **Page 180:** Michelle Alexandra, courtesy of Michelle Alexandra. **Page 181:** Infit-05/INFphoto.com/Corbis. **Page 182:** Jason Merritt/Getty Images. **Page 183, top:** Infi-05/INFphoto.com/Corbis. **Page 183, bottom left** and **right:** Stanley Desbas, courtesy of Stanley Desbas. **Page 184:** Infit-05/INFphoto.com/Corbis. **Page 185:** Courtesy of firstVIEW.com.

6: Your Style Personality

Page 186: Jan Welters/Trunk Archive. **Page 189:** Kate Davis-Macleod, *Evening Standard*, October 2014/Reduxpictures.com. **Page 190:** Emma Summerton/Trunk Archive. **Page 191:** Chanel handbag: courtesy of Jens Mortensen Photography; black pumps by Stuart Weitzman; Cartier watch: courtesy of Mark Platt. **Page 192:** Txema Yeste/Trunk Archive. **Page 193:** Evening shoe: courtesy of Mark Platt; Bond No. 9 bottle: courtesy of Bond No. 9; diamond earrings: courtesy of Gabriel & Co./Mark Davidovich Communications. **Page 194:** Stanley Desbas, courtesy of Stanley Desbas. **Page 195:** sunglasses: Shutterstock.com; cuff: courtesy of Robert Lee Morris; lipstick: courtesy of M•A•C Cosmetics. **Page 196:** Stanley Desbas, *PLUS Model Magazine*, September 2014, courtesy of Stanley Desbas. **Page 197:** Boots by Sergio Rossi; handbag by Jean Paul Gautier; corset: courtesy of Va Bien. **Page 198:** Stanley Desbas, *PLUS Model Magazine*, September 2014, courtesy of Stanley Desbas. **Page 199:** Fringed handbag by Frye, animal print scarf by Just Cavalli; copper Birkenstocks by Birkenstock; feathered fringed earrings by Panacea: courtesy of Lyst.com. **Page 201:** Joshua Jordan/Trunk Archive.

7: Accessories

Page 202: Jennifer Livingston/Trunk Archive. **Page 204:** Emma Tempest/Trunk Archive. **Page 206, counterclockwise, from top:** Dolce Vita tote and North/South tote by Furla; red Nencia tote by Salvatore Ferragamo. **Page 207, from left to right:** Bowling bag by Salvatore Ferragamo; bucket bag by Michael Kors; hobo bag by Marc by Marc Jacobs. **Page 208, from top to bottom:** Shoulder bag by Jaeger; clutch by Oscar de la Renta; clutch by Fiona Kotur. **Page 209:** Mark Platt, courtesy of Mark Platt. **Page 210:** Vince Bucci/Getty Images. **Page 212, top:** Courtesy of Lane Bryant. **Page 212, bottom:** Silver pumps by Stuart Weitzman. **Page 213, top left:** Tommy Ton/Trunk Archive. **Page 213, bottom right:** Mike Marsland/Wire Image. **Page 214, top:** F. Martin Ramin, *Wall Street Journal*, April 3, 2015. **Page 214, bottom:** Sandals by Giuseppe Zanotti. **Page 215, top:** Boots by Salvatore Ferragamo. **Page 215, bottom:** Boots by Stuart Weitzman. **Page 217:** Sebastian Mader/Trunk Archive. **Page 218:** Carlo Dalla Chiesa, *Mode*, April 2000, courtesy of Carol Dalla Chiesa. **Page 221:** Robert Erdmann/August Images. **Page 223:** Infit-05/INF photo.com/Corbis. **Page 225:** Courtesy of firstVIEW.com.

8: Glamour

Page 226: Marc Baptiste, *Washington Post*, August 13, 2015, courtesy of Marc Baptiste. **Page 228:** Larry Busacca/Getty Images. **Page 231:** Gilles Bensimon/Trunk Archive. **Page 232, top:** Courtesy of firstVIEW.com. **Page 232, bottom:** Courtesy of Mark Platt. **Page 233:** Stanley Desbas, courtesy of Stanley Desbas. **Page 234:** Kenneth Willardt/Trunk Archive. **Page 235:** Carlyle Routh, courtesy of Dare, Winter 2013. **Page 236:** Gomillion & Leupold/Contour by Getty Images, *Billboard*, April 2011.

HarperCollins books may be purchased for educational, business, or sales promotional use. For information please e-mail the Special Markets Department at SPsales@harpercollins.com.

First published in 2016 by
Harper Design
An Imprint of HarperCollins*Publishers*
195 Broadway
New York, NY 10007
Tel: (212) 207-7000
Fax: (855) 746-6023
harperdesign@harpercollins.com
www.hc.com

Distributed throughout the world by
HarperCollins*Publishers*
195 Broadway
New York, NY 10007

LB1
ISBN 978-0-06-236203-2
Library of Congress Control Number: 2014937017

Book design by Tanya Ross-Hughes/Hotfoot Studio
Art direction by Lynne Yeamans

Printed in Malaysia
First Printing, 2016

ABOUT THE AUTHOR

Susan Moses is a celebrity stylist who has styled for magazines, television, film, and the red carpet, and whose clients have included Britney Spears, Destiny's Child, Queen Latifah, Kathy Bates, Wynonna Judd, and many others. A former contributing stylist for *Mode* magazine, she was the host of *Style Study* at Penningtons, the largest plus-size retailer in Canada. In 2014, *Ebony* named Susan one of the "Six Plus Fashion Power Players on the Rise." She has appeared on HSN to help the network's plus-size customer dress as well. She lives in Brooklyn, New York.